MOMOYAMA

Japanese Art in the Age of Grandeur

This catalogue has been made possible
through the assistance of The JDR 3rd Fund.

We are grateful to Japan Air Lines,
which has made a special grant to the
Momoyama exhibition.

MOMOYAMA

Japanese Art in the Age of Grandeur

AN EXHIBITION AT

THE METROPOLITAN MUSEUM OF ART

ORGANIZED IN COLLABORATION WITH

THE AGENCY FOR CULTURAL AFFAIRS

OF THE JAPANESE GOVERNMENT

ON THE COVER:

Four sliding doors, Crane and Pine,
by Kanō Eitoku, Number 4

Copyright © 1975 by The Metropolitan Museum of Art
Design by Peter Oldenburg
Maps by Joseph Ascherl
Composition by York Typesetting Co., Inc.
Printing by Jaylen Offset Lithography

LIBRARY OF CONGRESS CATALOGING IN PUBLICATION DATA

Main entry under title:

Momoyama, Japanese art in the age of grandeur.

 Bibliography: p.
 1. Art, Japanese—Exhibitions. 2. Art, Japanese—
Kamakura-Momoyama, 1185-1600. I. New York (City).
Metropolitan Museum of Art. II. Japan. Bunkachō.
III. Title.
N7353.4.M65 700'.952 74-31186
ISBN 0-87099-125-6

Contents

Foreword

Since 1951 there have been six exhibitions of Japanese art organized by the Japanese government and shown at American museums. These exhibitions, which have visited more than twenty museums altogether, have fulfilled significant roles in the cultural exchange and mutual understanding between our two countries. It is with great pleasure that we now present this exhibition of the arts of the Momoyama period at The Metropolitan Museum of Art.

Although the period referred to in Japanese history as the Azuchi-Momoyama period covered less than half a century, from 1568 to 1615, it was a distinctive one, for during this time of upheaval the transition was made from nationwide civil war to peace. It was an eventful period in international affairs as well, with Europeans visiting Japan for the first time and Japanese venturing into the outside world.

The Momoyama period saw the birth of a brilliant, heroic culture, typified by magnificent castles with exuberant wall and screen paintings and interior finishings, represented among the pieces here. At the same time, as if in resistance to this trend for the luxurious, a new aesthetic attitude based on the esteem for simple beauty arose among the newly influential warrior and merchant classes. One of the important motivating factors in this development was the tea ceremony *(cha no yu)*, a Japanese cultural accomplishment represented by the great Momoyama tea master Sen no Rikyū. Tea room architecture and tea ceremony utensils exhibited a distinctive artistic quality best characterized by the term *sabi,* meaning "quietude, simplicity, and absence of ornament."

European culture, accompanying the introduction of Christianity into Japan, also had an immediate influence.

The generous, cheerful culture created in the Momoyama period placed humanistic interests over religious ones. It marked the opening of the premodern age and can easily be called a period of renaissance.

In the present exhibition selected masterpieces convey the characteristics of the arts of the Momoyama period. We sincerely hope that the American people will deepen their interest in Japanese culture through their viewing of these works.

Adachi Kenji

Commissioner
The Agency for Cultural Affairs
Tokyo

Many individuals have volunteered their help in regard to the Momoyama exhibition, notably:

Ambassador Masao Sawaki, the previous Consul-General of Japan in New York, and Ambassador Nobuyuki Nakashima, the present Consul-General. Mr. Mitsuhiko Hazumi, Counselor, at the Japanese Embassy in Washington, D.C.

Mr. Peter Solmssen, Advisor on the Arts, U.S. State Department, Washington.
Mr. Frank Tenny, Deputy Public Relations Officer, U.S. State Department, Tokyo.

Mr. Toshiharu Kido, President of the Japanese Chamber of Commerce, New York.

The staff of the Japan Society, Mr. David Mac-Eachron, Executive Director, and Mr. Rand Castile, Director of the Japan House Gallery.

Mr. Rodney Armstrong, Senior Advisor Public Affairs, Toyota Motor Sales USA, Inc.
Mr. Porter McCray, Director of The JDR 3rd Fund.

Mr. Kiichi Ito, Vice President, the Americas, Japan Air Lines, and Mr. Yui Kittaka, Assistant to Vice President, the Americas, Japan Air Lines.

Mr. Tomozo Yano, New York Office Representative for the Japan Foundation.

Mr. K. S. Wu, Tokyo.

Preface

This is the first time that a major loan exhibition from Japan has attempted to present a complete view of the arts of a single period. Although of short duration, the Momoyama period saw the growth of modern urban centers, the advent of strong leaders, and the development of almost incomparable artistic creativity. It was a time of discovery and originality for great artists of the capital and provincial craftsmen alike. The tone of the period is predominantly secular, with an immediate visual appeal. For all of these reasons we believe that this exhibition is uniquely suited to extend across cultural barriers and present to the American public the finest qualities of a rich and complex tradition. The sheer variety of the works assembled here will dispel any facile generalizations concerning the nature of Japanese art.

The first good look the West had of Japan was during the Momoyama period, and with this exhibition we can appreciate for ourselves the special sensibility and the splendors that so impressed those early travelers.

The greatest examples of Momoyama art are seldom seen outside Japan, and it is a rare privilege to find gathered here works from twenty-two temples, eight shrines, eight museums, three libraries, one university collection, and nineteen private collections. More than a third of these works have been designated by the Japanese government as National Treasures, Important Cultural Properties, or Important Art Objects.

In the fall of 1972 The Metropolitan Museum of Art sent Japan a selection of over one hundred "Treasured Masterpieces" from our collection, the largest loan exhibition in the Museum's history. In response to our loan, the present exhibition was organized by The Agency for Cultural Affairs of the Japanese Government. We owe a great debt of gratitude to the Agency's Commissioner, Adachi Kenji, and Counselor, Kurata Bunsaku, for the care they have taken in the selection of the objects.

Thomas Hoving

Director
The Metropolitan Museum of Art

Acknowledgments

Preparing this catalogue has been a richly rewarding and exciting experience for all of us who have been involved in it. We are deeply appreciative of the great care and knowledge with which The Agency for Cultural Affairs, under the guidance of its Counselor, Kurata Bunsaku, selected the works and created an exhibition that is unique in its content and deeply meaningful as a re-creation of one of the finest moments in Japanese art history. We wish to thank in particular Hamada Takashi, Chief of the Agency's Division of Fine Arts, for the preliminary research assistance, photographs, and measurements that he and his assistants provided.

This catalogue is very much a joint effort, and I wish to acknowledge the many contributions that I received from friends and colleagues during its preparation. Andrew Pekarik, who worked with me throughout the project, coauthored the calligraphy section, translated the poems in No. 34, and wrote Nos. 4–8, 10, and 16–19. In addition to writing No. 28 and assisting with several other painting entries, Sarah Bradley wrote the section on Nō masks and Nos. 72–78 in the Arms and Armor section. Louise Allison Cort of the Fogg Art Museum contributed the section of ceramics with Samuel Crowell Morse, an undergraduate at Harvard University, who wrote Nos. 59–62.

For assistance with translation in the early stages of our work, I wish to give special thanks to Princeton graduate students Carolyn Wheelright, Ann Yonemura, and Bonnie Abiko, and Harvard graduate students James Kenney and Christine Guth Kanda. Rand Castile of the Japan Society kindly offered suggestions for several portions of the manuscript.

Among the many Metropolitan Museum staff members who helped, I am especially grateful to Lauren Shakely for her patient and skillful editing and to Associate Curator Jean Mailey and Associate Conservator Nobuko Kajitani for their advice on textiles. Morihiro Ogawa, Research Associate in the Department of Arms and Armor, generously provided information for the last section. The Chinese poems in No. 23 and No. 35 were translated by Assistant Curator Marilyn Fu. Thanks are due also to Wen Fong, Special Consultant for Far Eastern Affairs, for his encouragement and support. The catalogue was prepared for publication by Teddy Sanchez and Marise Johnson. I am responsible for the initial editing of the entries credited above, and wrote the remaining entries and introductory essays.

Julia Meech-Pekarik

Assistant Curator, Department of Far Eastern Art
The Metropolitan Museum of Art

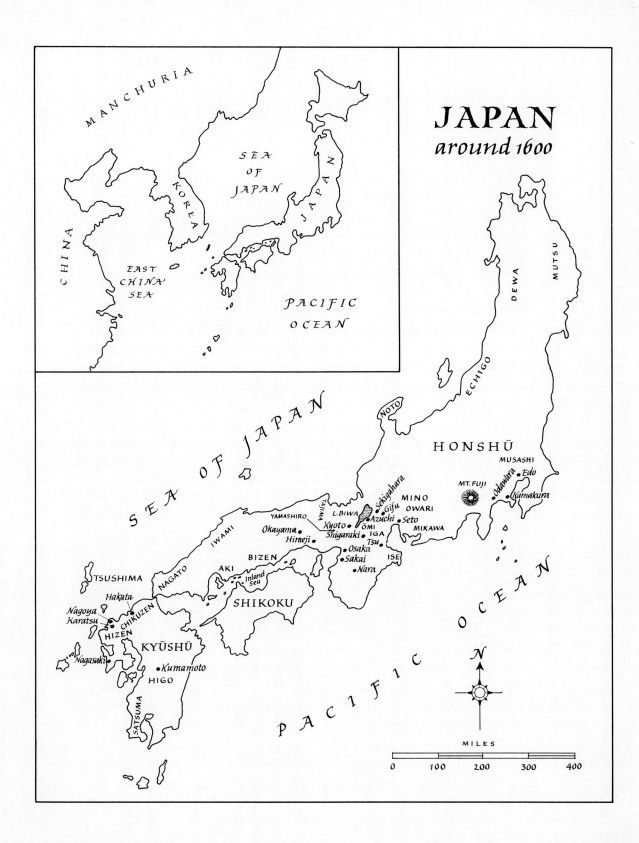

JAPAN
around 1600

Introduction

Spanning only forty-seven years, the Momoyama period (1568–1615) was one of the most dramatic in Japanese history. As a handful of tough, ambitious warriors struggled to unite the country after a full century of continuous civil war, Japan emerged from the medieval into the modern age.

By the end of the preceding Muromachi period (1392–1568), some two hundred daimyo, or feudal lords, had achieved absolute control over their local territories. The formidable task of reunifying the country was initiated by the strongest of these regional daimyo, Oda Nobunaga* (1534–1582), and completed by his successors, the generals Toyotomi Hideyoshi (1536–1598) and Tokugawa Ieyasu (1542–1616). This trio of military men dominated the arts as well as the politics of the age. They were enthusiastic and discriminating patrons who encouraged Nō actors, set the trend in fashions, ate from exquisite gold lacquer bowls, collected the finest of ceremonial arms and armor and priceless tea ceremony utensils, and chose the best artists to paint the screens and walls of the magnificent castles they erected as symbols of their authority. The name of the period is taken from the site of one of Hideyoshi's castles, a hill at Fushimi, just south of Kyoto. Because it was a visible reminder of the power of their rival, the building was soon dismantled by Hideyoshi's successors, and the hill planted with peach trees, hence the name "Peach Tree Hill" ("Momoyama").

The Momoyama period began when Nobunaga, the daimyo of Owari, made a triumphant entry into the capital city of Kyoto, ostensibly to install Ashikaga Yoshiaki as shogun, or military overlord, but in fact to make known his intention to rule the country by force. Five years later he deposed Yoshiaki, the fifteenth and last member of the Ashikaga family to hold the hereditary shogunal post, and not long afterward he began construction of an enormous castle strategically located at Azuchi, a few miles northeast of Kyoto.

Ruthless and pragmatic, Nobunaga seriously undermined organized Buddhism in 1571 by systematically slaughtering thousands of monks and setting fire to their temples. In the increasingly secular and materialistic culture of Momoyama Japan, priests were no longer the primary arbiters of taste, and it is not coincidental that among the objects assembled here only one, a painting by the emperor Go-Yōzei (1571–1617) (No. 31), has overtly religious content.

Luis Frois, a Portuguese Jesuit resident in Japan, wrote of Nobunaga that he was tall, thin, warlike, "sensitive about his honour, reticent about his plans, an expert in military strategy, unwilling to receive advice from subordinates, highly esteemed and venerated by everyone, does

*Japanese names are cited, as is standard in Japan, with family name first. The suffixes *ji* and *in* indicate monasteries, temples, or "hermitage" subtemples.

not drink wine and rarely offers it to others, [is] brusque in his manner, despises all the other Japanese kings and princes and speaks to them over his shoulder in a loud voice as if they were lowly servants . . ." (Luis Frois, "Portrait of Nobunaga," in Michael Cooper, S.J., *They Came to Japan: An Anthology of European Reports on Japan, 1543–1640,* Berkeley, 1965, p. 93).

Such a man naturally made enemies, and at the peak of his career, with a third of the country under his control, Nobunaga was assassinated by one of his own generals. He was immediately succeeded by his chief military strategist, the brilliant general Toyotomi Hideyoshi, who eventually rose to become ruler of all Japan, defeating the Hōjō clan of Odawara with 200,000 troops in 1590.

Doubtless the most colorful and dynamic figure in the entire history of Japan, Hideyoshi came to power at a time of unprecedented economic prosperity. The nation's population had reached nearly eighteen million (four million more than that of contemporary France), and Kyoto had become one of the largest cities in the world. The Jesuit João Rodrigues, who arrived in Japan in 1576, observed that the people of the capital were "well dressed, exuberant and . . . much given to continual recreation, amusements and pastimes, such as going on picnics in the countryside to enjoy the sight of the flowers and gardens. They entertain each other to banquets, comedies, plays, farces, and various other shows which are performed according to their fashion" *(This Island of Japan: João Rodrigues' Account of 16th-Century Japan,* ed. and trans. Michael Cooper, S.J., Tokyo and New York, 1973, p. 120).

It was Hideyoshi who devised the grandiose plan of conquering Korea, China, and the Philippines. Although the first invasion of Korea in 1592 was countered, Hideyoshi arrogantly demanded that the Chinese resume official and private trade and that the Ming emperor send a daughter to Japan as an imperial consort. When the Chinese envoy finally arrived at Fushimi Castle, his message was far from submissive: the Chinese offered only to invest Hideyoshi with the official title of King of Japan. Hideyoshi's response to this patronizing gesture was to order another attack through the Korean peninsula, but his death in 1598 cut short this second effort.

Although Hideyoshi is justly criticized for failing to give his army adequate naval support, he should not be dismissed as a misguided megalomaniac. This charismatic leader seems to have had the backing of the entire nation for his Korean invasion, as though it were Japan's destiny at that moment to step onto the stage of world history. Not only famous generals like Tōdō Takatora (1556–1630) (No. 3) and Kobayakawa Hideaki (1577–1602) (No. 48) but also courtiers like the calligrapher Konoe Nobutada (1564–1614) (No. 32), who tried desperately to join the army at Nagoya, were caught up in this mood of imperialism.

The third great Momoyama general, Tokugawa Ieyasu, daimyo of Mikawa Province, was allied with Nobunaga for two decades. Later, Hideyoshi found him to be a vassal of such dangerous strength that he transferred him from Mikawa to Musashi, further east, where Ieyasu could, in theory, be checked by Hideyoshi's most loyal daimyo followers. One of the few to remain aloof from the Korean invasions, Ieyasu concentrated instead on building a castle town at Edo (modern Tokyo) and enlarging his circle of allies. Although he was among the five daimyo whom the dying Hideyoshi appointed as regents to his young son and sole heir, Hideyori (No. 27), Ieyasu wasted no time in establishing his superiority. He won a decisive victory over the Toyotomi faction in the Battle of Sekigahara in 1600 and in 1603 revived for himself the title of shogun, which he passed on to his son in 1605, founding a family dynasty and a rigid feudal

government centered at Edo that endured for the next three centuries. Hideyori, the last of the Toyotomi, was killed in 1615 when Ieyasu destroyed Osaka Castle. Both 1603 and 1615 are cited as the arbitrary political dates that end the Momoyama period. Nonetheless, despite the gradual increase of restrictive and often repressive domestic legislation, including the prohibition of Christianity and expulsion of foreigners, the positive spirit of freedom and optimism characteristic of this era lingered on in the arts as late as the 1630s.

During the Momoyama period, the enfeebled imperial court saw a temporary revival of its influence. The emperor, who traced his ancestry to the Sun Goddess, and the courtiers, an elite hereditary aristocracy, were still universally regarded as the loftiest stratum of society. The sovereign's role in bestowing coveted court titles and ranks, the "proof" of legitimacy, made him attractive and vital to daimyo newly arrived from the provinces. Hideyoshi, for example, not only enforced conquests through feudal bonds, such as oaths of fealty and a system of hostages, but relied also on the more traditional sanction of high court rank delegated by the emperor (No. 2). Hideyoshi took particular pains to befriend Emperor Go-Yōzei, inviting him to visit his Jūraku-dai ("Palace of Pleasures") and spending immense sums to refurbish the Imperial Palace.

The need for the intermediary role of the court tapered off toward the end of the Momoyama period. Once Ieyasu received the commission of shogun from the throne in 1603, responsibility for proposing the recipients of important titles was shifted to the shogunate, which virtually monopolized all authority.

The court was not permitted to administer the government and was expected to rule only through such peaceful and highly civilized skills as scholarship and the arts. Court families had always played a crucial role in preserving and transmitting the ancient classical traditions of music, dance, history, religious ritual, poetry, writing, and other more esoteric pursuits, each of which required a lifetime to master. Courtiers, for example, stand out as the superior calligraphers of their time (Nos. 25, 31, 32, 37).

Although the Kyoto aristocracy retained close control of many traditional aspects of culture, the warriors set their own aesthetic standards in their generous patronage of innovative contemporary artists and in their development and promotion of the tea ceremony. The paintings they commissioned often reflected their special interests, such as horses (Nos. 12, 20, 30), hunts, falconry, hawks (No. 23), and battles. The architecture they sponsored was original and impressive. The multistoried castle that Nobunaga built on the shores of Lake Biwa at Azuchi in 1576 was the first of many that sprang up around the country during this short period. From Frois's first-hand account, we learn that the façade was painted red, white, and blue and embellished with gold, and "as regards architecture, strength, wealth, and grandeur [it] may well be compared with the greatest buildings of Europe. . . . As the castle is situated on high ground, and is itself very lofty, it looks as if it reaches to the clouds and it can be seen from afar for many leagues. The fact that the castle is constructed entirely of wood is not at all apparent either from within or from without, for it looks as if it is built of strong stone and mortar" (Luis Frois, "Azuchi Castle," in Cooper, *They Came to Japan*, p. 134).

Careful training in the judgment of sword guards (Nos. 74–78) and blades, lacquer saddles and ceremonial armor (No. 79) insured that even the most provincial samurai was attuned to the nuances of proportion, color, shape, and design.

In the tea ceremony Momoyama warriors found both a focus for their aesthetic interests

and their main leisure pastime. This ritual had never been restricted to the nobility and involved the appreciation of what were often quite ordinary objects. The simple, but disciplined manner in which the strong, bitter tea was prepared, served, and drunk, combined with an atmosphere of close comradeship and social equality, created a private cult among warriors that was as meaningful and refined as the poetry parties of the court.

It is an indication of the influential role of tea that tea utensils were among the most costly gifts with which a victorious general could honor his vassals. The well-known pieces were valued as much for their carefully documented pedigree as for their unique and subtle beauty. A small ceramic tea caddy or iron trivet, if it had come from the collection of a famous general, commanded an extraordinary price and gained political significance. Passing on the family treasure of tea utensils to his son was one way a father could legitimize the line of succession.

Sen no Rikyū (1521–1591) (No. 57) was the gifted tea master who served Nobunaga for twelve years and Hideyoshi for nine. Believing that beauty could be found even in the commonplace, Rikyū replaced imported celadons with simple domestic ceramics and reduced the setting for tea drinking to a humble ten-foot square hut with rough unplastered walls, a few small windows, and a tiny guest entrance only two and a half feet high. He conceived of a special low-fired hand-modeled ware called Raku, which has been used ever since for tea bowls admired for their somber hues and shapes.

Hideyoshi's tea taste accorded with that of Rikyū. Though the autocratic ruler of a nation, Hideyoshi served tea for his favorites with his own hands before dawn in the two-mat (six-foot-square) thatched cottage called Yamazato ("Mountain Village Retreat") at Osaka Castle. He selected the appropriate subdued ink painting for the alcove (his favorite is said to have been a landscape by the Chinese Zen monk Mu Ch'i), skillfully arranged one or two flowers of the same color in a vase, chose a harmonious group of utensils, and prepared a menu for the meal.

Hideyoshi's passion for tea reached its peak when he officially invited literally everyone, "even those from China," to join him in a ten-day outdoor tea ceremony in the pine grove at Kitano. In notices posted throughout Osaka, Kyoto, and Nara, participants were required to bring no more than a kettle with suspending chain and a tea bowl. Those who could not afford the tea were urged to substitute roasted barley.

The relationship between Hideyoshi and Rikyū had a tragic, but perhaps inevitable outcome. As the closest confidant to the most powerful figure in the country and the instructor of hundreds of generals and nobles, Rikyū was in a position to wield considerable political influence and may have abused his privileges. Although we do not know the precise causes for Rikyū's disfavor, he committed ritual suicide at Hideyoshi's command in 1591.

The quiet side of Momoyama taste, the warlord's personal restraint as reflected in the dignified tea ceremony and ink paintings, was balanced with calculated public ostentation. Hideyoshi, who was the most talented showman of his day, best exemplifies this aesthetic dualism. In 1586 he had a goldsmith in Sakai construct a portable golden tea room in which he served tea to the emperor and his retinue at the Imperial Palace. The pillars, walls, and all of the utensils, with the exception of the bamboo whisk and ladle and the cloth for wiping tea bowls, were gold. This tea room later accompanied Hideyoshi to the battlefront for the entertainment of his generals.

Visiting dignitaries were given personally guided tours through the seven stories of Hide-

yoshi's Osaka Castle. Describing for them the riches stored on each floor, he would explain, "this room which you see here is full of gold, this one of silver; this other compartment is full of bales of silk and damask, that one with robes, while these rooms contain costly [swords] and weapons" (Luis Frois, "A Tour of Osaka Castle, 1586," in Cooper, *They Came to Japan,* pp. 136–137). From the balcony of the top story the guests were invited to look down on the five or six thousand men toiling below on the construction of defenses and large warehouses.

Merchants and daimyo from whom he hoped to obtain financial or military support were given preferential treatment. Hideyoshi would appear wearing a white jacket trimmed with crimson over long crimson robes that covered his feet and trailed behind him. On his head he would wear a jaunty pale green crepe hat and thrust through his sash a small dagger in a black leather sheath with gold ornaments. A young girl walked at his side with her master's long sword resting over her shoulder. First, tea would be served by Rikyū in the all-gold tea room, followed by a viewing and handling of the finest of the host's collection of tea caddies, each in its own brocaded bag. Finally, a banquet would be served in the spacious inner apartments, where Hideyoshi presented his guests with short swords of rare craftsmanship.

These exhibitions of wealth and power had obvious political implications: on one occasion Hideyoshi held a party at his mansion in Kyoto to distribute piles of gold and silver pieces among the distinguished guests. Similarly, the dedication of a Great Buddha Hall, the Hōkō-ji (No. 28, right screen) in 1589 was surely inspired less by religious conviction than by pure self-glorification. The heroic structure housed a 160-foot wooden statue of the Buddha, larger than either of its two mammoth predecessors—the eighth-century statue in Nara or the thirteenth-century statue in Kamakura.

To turn to another aspect of the Momoyama period, we find that it was an age of aggressive expansion and travel. After the devastation of Kyoto during the Ōnin War in the late fifteenth century, new centers for the arts sprang up in castle towns around the country. Wealthy local daimyo invited actors of the leading schools of Nō theater to entertain at their castles, constructed elegant gardens, and accumulated large libraries. Some Momoyama painters, like Hasegawa Tōhaku (1539–1610) (Nos. 12–15), were raised in the provinces; others, like Unkoku Tōgan (1547–1618) (Nos. 19–20), spent part of their lives in residence at the castle towns. Most traveled freely to fill commissions wherever there was a demand. Even "Kyoto" artists like Kanō Mitsunobu (1565–1608) (No. 7) could be found working as far west as Nagoya on Kyūshū and as far east as Edo. Documents such as Karasumaru Mitsuhiro's travel diary (No. 37) and the mobility of so many of the great artists give evidence of the continual flow of traffic from about 1600 between Kyoto and the eastern capital at Edo.

Through the first half of the sixteenth century some unofficial trade had been carried on with China, most often sponsored by wealthy western daimyo, who placed Zen monks such as Sakugen Shūryō (1501–1579) (No. 1) in charge of their missions. With the development of new mines in the provinces of Iwami and Tajima in the 1530s, Chinese demand for Japanese silver increased, and, in exchange, several hundred junks carrying silk arrived each year from Fukien and Chekiang. By the 1560s, however, the Chinese government, long harassed by Japanese coastal pirates, became openly hostile to Japanese traders and virtually ended this traffic. From the mid-sixteenth century, the Portuguese, from their outpost at Macao, monopolized the silver and silk trade between China and Japan.

The first Portuguese merchants sailed into the harbors of Kyūshū as early as 1543. They were followed by a few Spaniards in the 1590s and by the Dutch and British after 1600. These exotic foreign visitors, based at Nagasaki, could soon be seen parading in the streets of the capital (Nos. 28, 62). Because of their arrival via countries to the south of China, they were collectively identified by the Japanese as *Nambanjin,* or "Southern Barbarians."

Unwilling to jeopardize lucrative economic gains, a skeptical Japanese government tolerated the influx of Jesuit and Franciscan missionaries debarking from the annual Western trading vessels. By 1600 there were 300,000 Christian converts in Japan, as well as a church in the center of Kyoto. In 1582 four sons of Christian daimyo in Kyūshū made an eight-year voyage to Europe, highlighted by an audience with the pope. They returned with illustrated books and maps and first-hand observations that must have astonished their contemporaries. The period from the arrival of St. Francis Xavier in 1549 to the final expulsion of the Portuguese in 1639 is popularly known as Japan's "Christian Century."

The *Nambanjin* are not themselves conspicuous in the works assembled here, but their careful records of the appearance, customs, and culture of their hosts help us reconstruct the details of life in sixteenth-century Japan. Some of the Portuguese Jesuits spent up to three decades in close contact with the ruling hierarchy. João Rodrigues, for example, served as interpreter for both Hideyoshi and Ieyasu.

Japan's own effort at overseas expansion is marked not only by the abortive invasions of Korea but by the government-licensed ships which families like the Suminokura (No. 33), the elite of a new urban merchant class, were sailing as far as Hanoi and the Philippines. As wealthy and sophisticated traders, financiers, tea men, and shopkeepers, the merchants of Sakai, Osaka, Kyoto, and every major castle town played a vital role in stimulating Momoyama arts. With the advent of the Edo period, however, they found themselves relegated to the lowest rung of the clear-cut class system enforced by the Tokugawa shogunate. Samurai continued to constitute the upper class, but the stimulus for the creative arts began to shift to the lower-ranking townsmen of the larger cities.

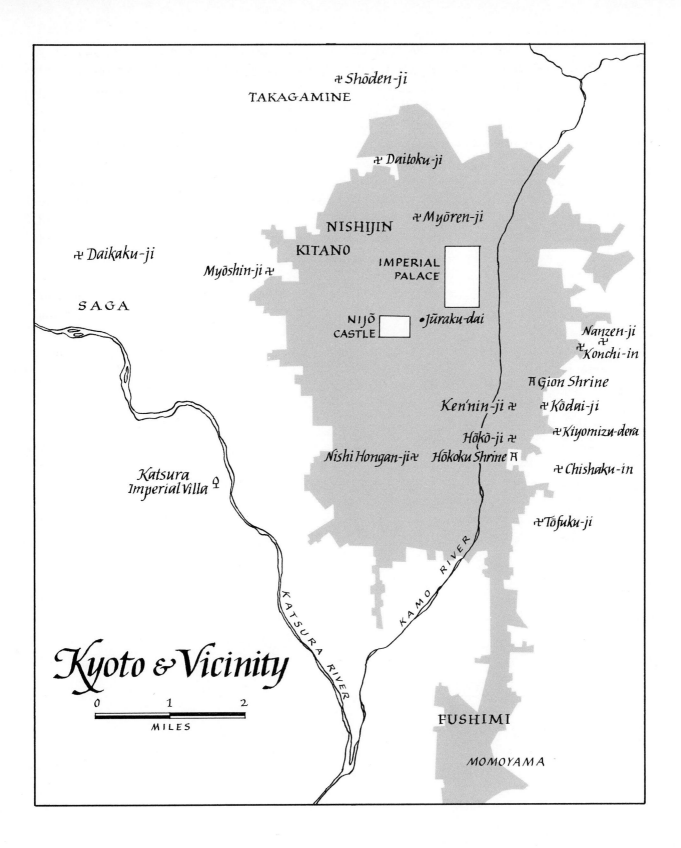

卍 *Shōden-ji*
TAKAGAMINE

卍 *Daitoku-ji*

卍 *Myōren-ji*
NISHIJIN
KITANO
IMPERIAL
PALACE

卍 *Daikaku-ji*

Myōshin-ji 卍

SAGA

• *Jūraku-dai*

NIJŌ
CASTLE

Nanzen-ji
卍
卍 *Konchi-in*

卍 *Gion Shrine*

Ken'nin-ji 卍 卍 *Kōdai-ji*

卍 *Kiyomizu-dera*

Hōkō-ji 卍

*Katsura
Imperial Villa*

*Nishi Hongan-ji*卍 *Hōkoku Shrine* 卍

卍 *Chishaku-in*

卍 *Tōfuku-ji*

Kyoto & Vicinity

0 1 2

MILES

KATSURA RIVER

KAMO RIVER

FUSHIMI

MOMOYAMA

Chronology

1549 Arrival of St. Francis Xavier, first Jesuit to reach Japan.

1566 Kanō Eitoku's Crane and Pine in the Jukō-in, Daitoku-ji (No. 4).

1568 Oda Nobunaga enters Kyoto, appoints Ashikaga Yoshiaki shogun.

1570 Approximate date of Hasegawa Tōhaku's Rounding Up Horses (No. 12).

1571 Suwa-asugi Shrine Nō mask: *tenjin* (No. 40).

1573 Ashikaga Yoshiaki deposed by Nobunaga.

1574 Tenkawa Benzaiten Shrine Nō mask: *ōkina* (No. 38).

1576 Nobunaga commissions paintings from Eitoku and his pupils for walls of Azuchi Castle.

1577 Portrait of Ashikaga Yoshiteru (No. 1).

1582 Assassination of Nobunaga, destruction of Azuchi Castle.

1583 Hideyoshi commissions paintings from Eitoku for walls of Osaka Castle.

1586 Emperor Go-Yōzei ascends throne.

1587 Hideyoshi's grand tea ceremony at Kitano Shrine. Kanō artists decorate Hideyoshi's Jūraku-dai mansion in Kyoto.

1588 Emperor and retinue are invited to spend five days in April at Hideyoshi's Jūraku-dai. Unkoku Tōgan's Seven Sages in the Bamboo Grove and Landscape in the Ōbai-in, Daitoku-ji (No. 19).

1589 Hideyoshi dedicates Great Buddha Hall of Hōkō-ji.

1590 With defeat of Hōjō clan of Odawara, Hideyoshi completes military unification of Japan. Tokugawa Ieyasu constructs castle in Edo. Death of Kanō Eitoku. Hideyoshi dedicates Long sword with scabbard (No. 72) to Gōkōgu Shrine.

1591 Death of Sen no Rikyū.

1592 Hideyoshi's first invasion of Korea. Hasegawa Tōhaku's paintings of flowering trees for the Shōun-ji, constructed by Hideyoshi as mausoleum for his infant son Sutemaru. Hideyoshi begins construction of castle in Fushimi, south of Kyoto, commissions paintings by Kanō artists.

1594 Hideyoshi's cherry blossom viewing party at Yoshino. Hideyoshi performs Nō plays for Emperor Go-Yōzei at Imperial Palace.

1595 Hideyoshi dismantles the Jūraku-dai.

1596 Kōdai-ji set of lacquer articles (No. 67) from Fushimi Castle.

1597 Hideyoshi's second invasion of Korea.

1598 Hideyoshi's cherry blossom viewing party at Daigo. Death of Hideyoshi. Study for portrait of Toyotomi Hideyoshi (No. 2).

1599 Kaihō Yūshō's Landscape (No. 16) and Plum and Pine (No. 17) from the Kennin-ji.

1600 Battle of Sekigahara establishes preeminence of Tokugawa Ieyasu.
Approximate date of the *jimbaori* (No. 48) worn by Kobayakawa Hideaki.

1603 Ieyasu sets up military government *(bakufu)* at Edo, assumes title of shogun.
Okuni, a woman, stages first 'Kabuki Dance' at Kitano Shrine, Kyoto.
Ieyasu builds Nijō Castle in Kyoto.
Approximate date of the *dōbuku* from Seisui-ji, Shimane Prefecture (No. 49).

1605 Ieyasu's son Hidetada becomes second Tokugawa shogun.

1606 Approximate date of *Sagabon,* printed Nō texts by Hon'ami Kōetsu and Suminokura Soan (No. 33).

1610 Death of Hasegawa Tōhaku.

1611 Emperor Go-Mizunoo ascends throne.

1614 Approximate date of Activities in the Capital (No. 28).

1615 Destruction of Osaka Castle, downfall of Toyotomi family.
Tokugawa Ieyasu grants land at Takagamine to Kōetsu for artist's colony.
Death of Kaihō Yūshō.
Kanō Mitsunobu's disciples and relatives decorate the Tokugawa family's Nagoya Castle.

1616 Government restricts foreign trade to Nagasaki and Hirado.

1619- Tokugaka family arranges marriage of Ieyasu's
1620 granddaughter Kazuko with Emperor Go-Mizunoo.
Kanō Sanraku's Maple and Ink Landscape (No. 9) in the Daikaku-ji.

1620 Prince Toshihito begins construction of Katsura Villa southwest of Kyoto.

1622 Major persecution of Christians signals end of Christian movement in Japan.

1623 Hidetada's son Iemitsu becomes third Tokugawa shogun.

1625 Kanō Sanraku's Votive Pictures of Horses (No. 10).

1626 Kōetsu's transcription of *Anthology of Chinese and Japanese Poems for Recitation* (No. 35).

1629 Abdication of Emperor Go-Mizunoo. The shogunate bans Women's Kabuki.

1630 Empress Myōshō, daughter of Go-Mizunoo and granddaughter of a Tokugawa shogun, ascends throne.
Portrait of Tōdō Takatora (No. 3).

1631- Plum Tree and Pheasant by Kanō Sanraku or
1632 Sansetsu (No. 11) in the Tenkyū-in of Myō-shin-ji.

1635 Travel to foreign countries banned.

1639 Expulsion of foreigners.

COLOR ILLUSTRATIONS

Detail of a sketch of Hideyoshi Toyotomi, Number 2

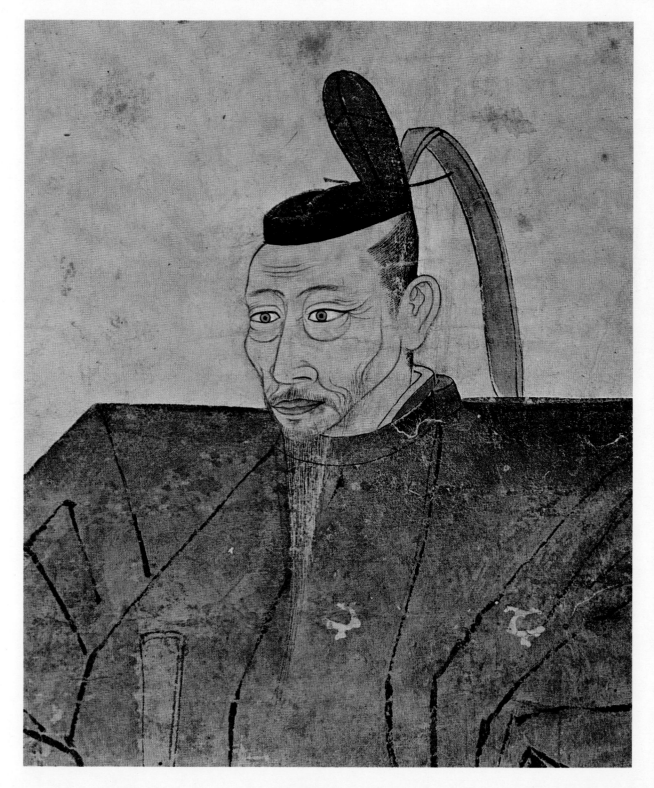

Detail of Rounding Up Horses by Hasegawa Tōhaku, Number 12

Portrait of Tōdō Takatora's wife, Number 3

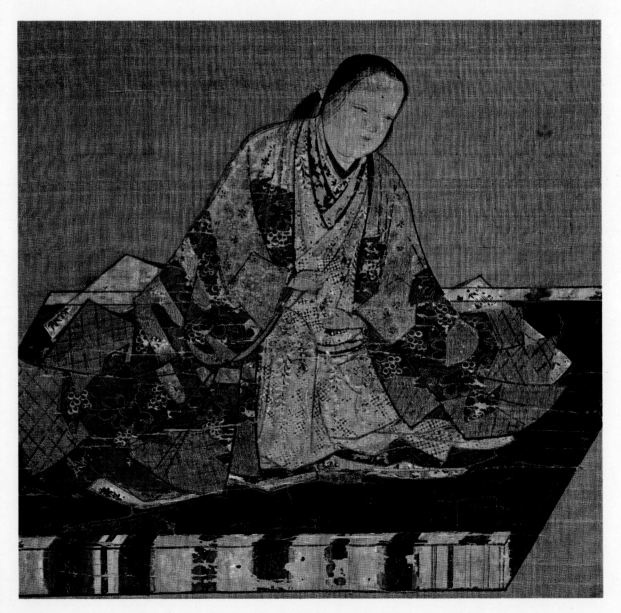

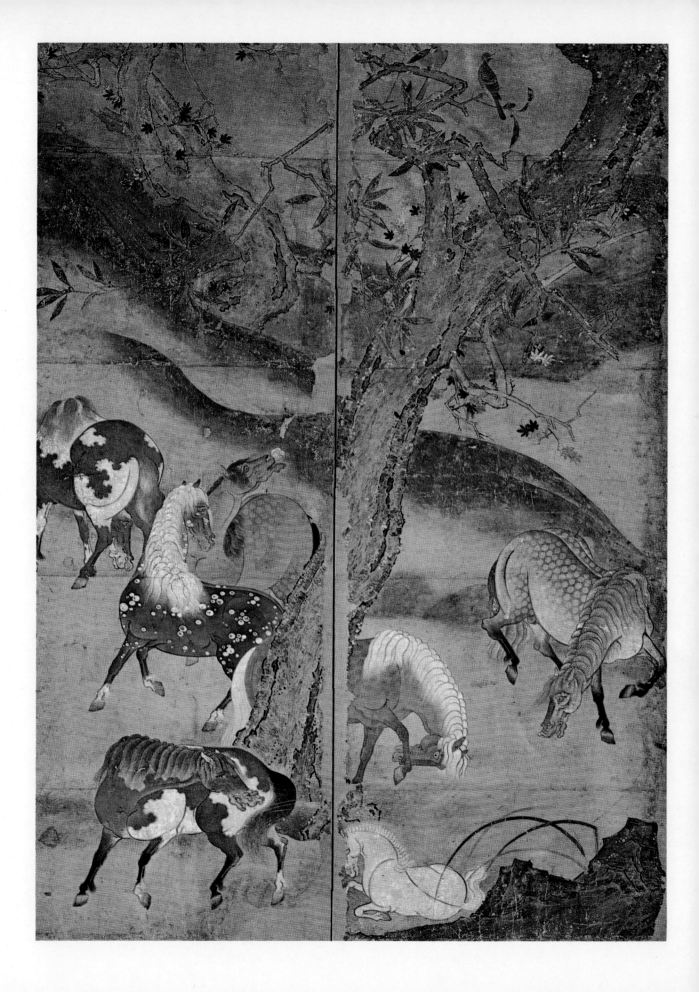

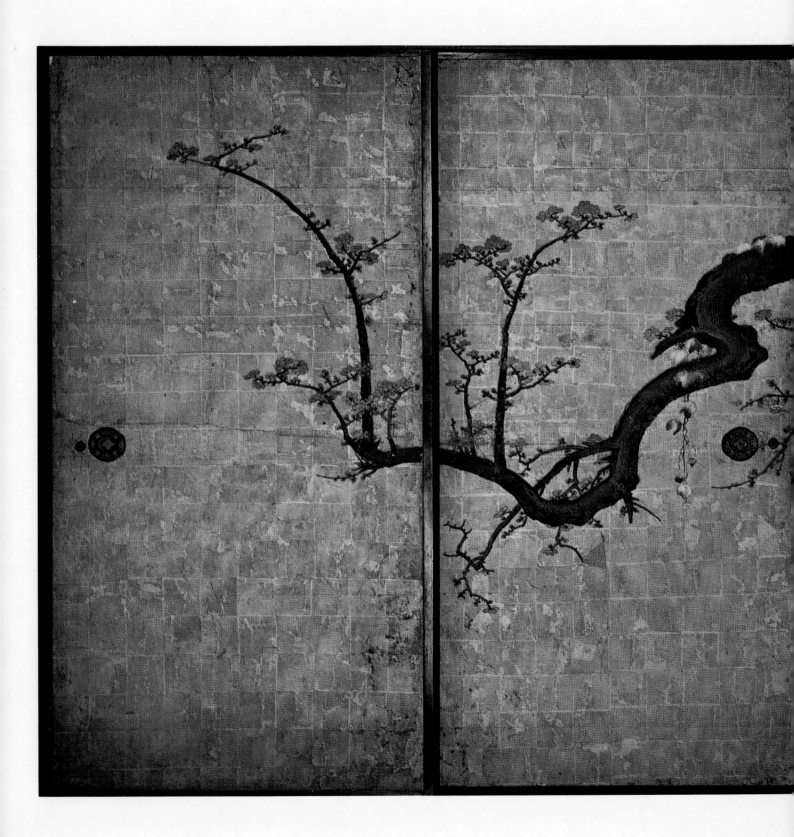

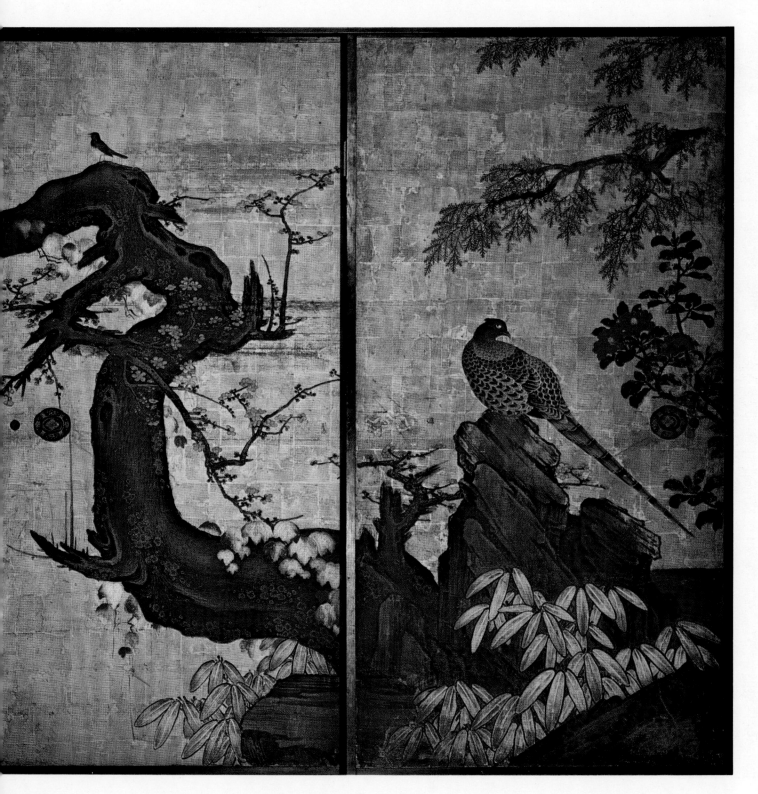

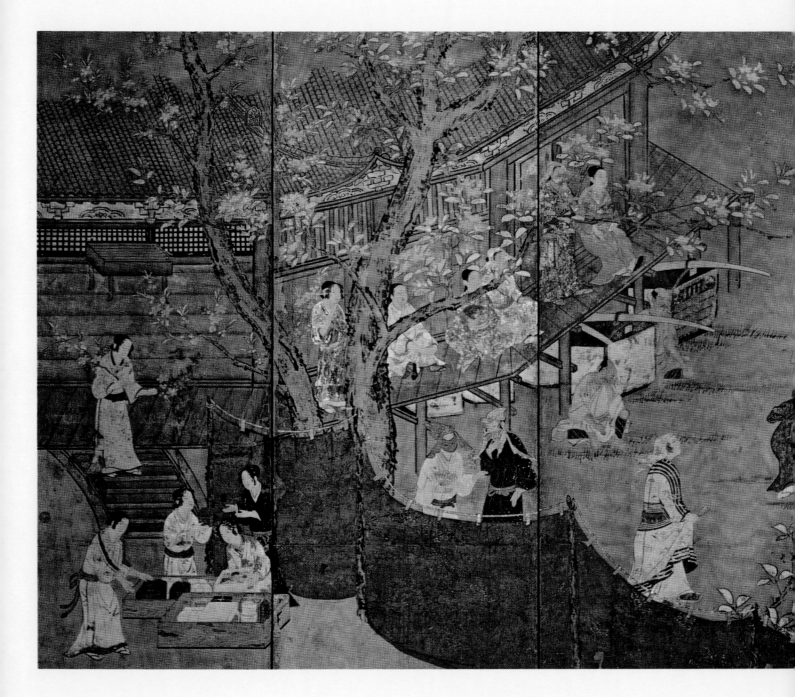

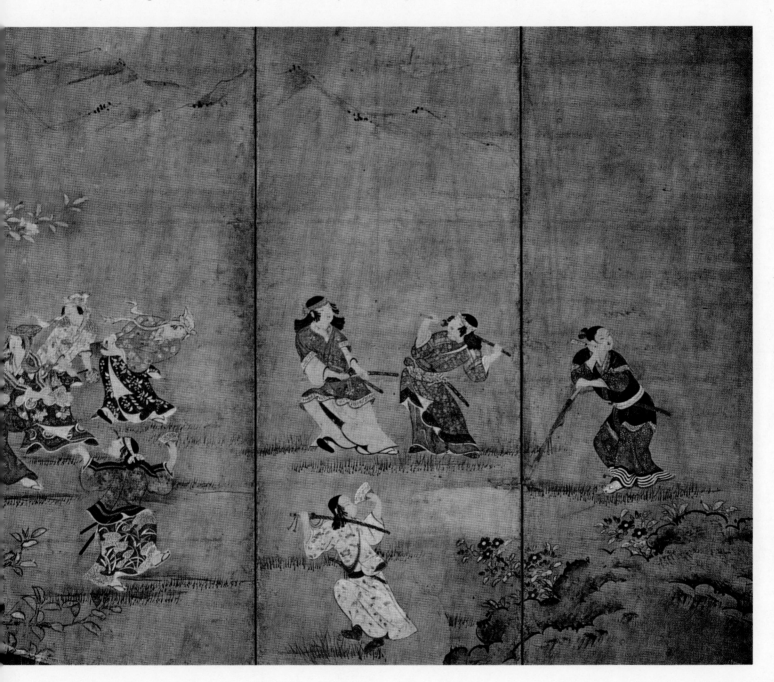

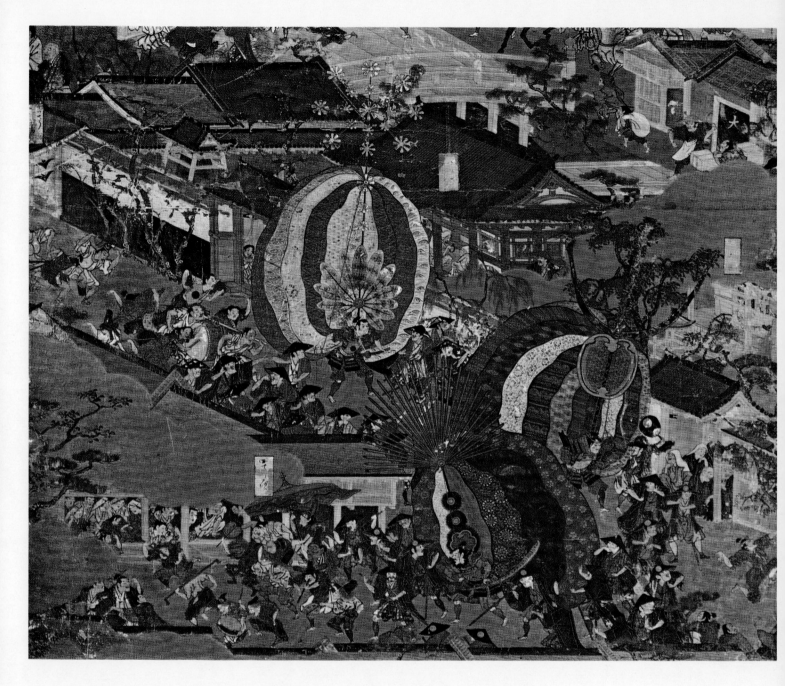

Warriors *(horo musha)* carry brightly colored cloth balloons, talismen to ward off disaster, in the Gion Festival procession. Detail from left screen, Activities in the Capital, Number 28

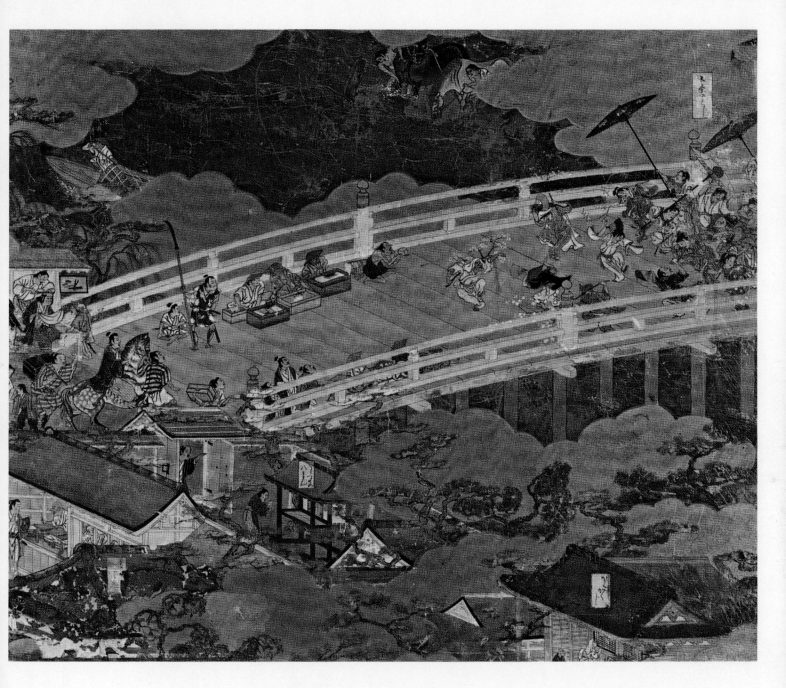

A mounted samurai encounters *furyū* dancers on the Fifth Avenue (Gojō) bridge. Detail from right screen, Activities in the Capital, Number 28

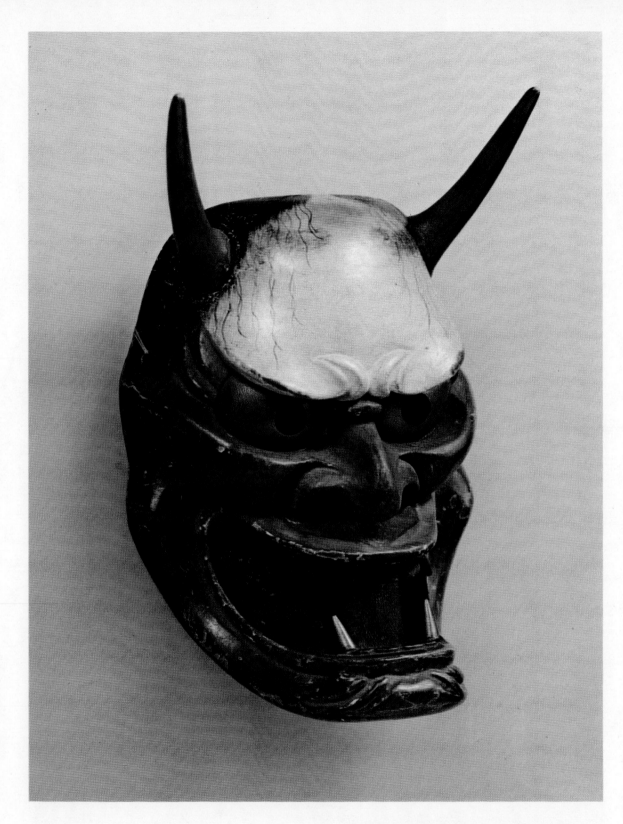

Nō mask of demon *(ja)*, Number 45

Nō mask of boy *(dōji)*, Number 42

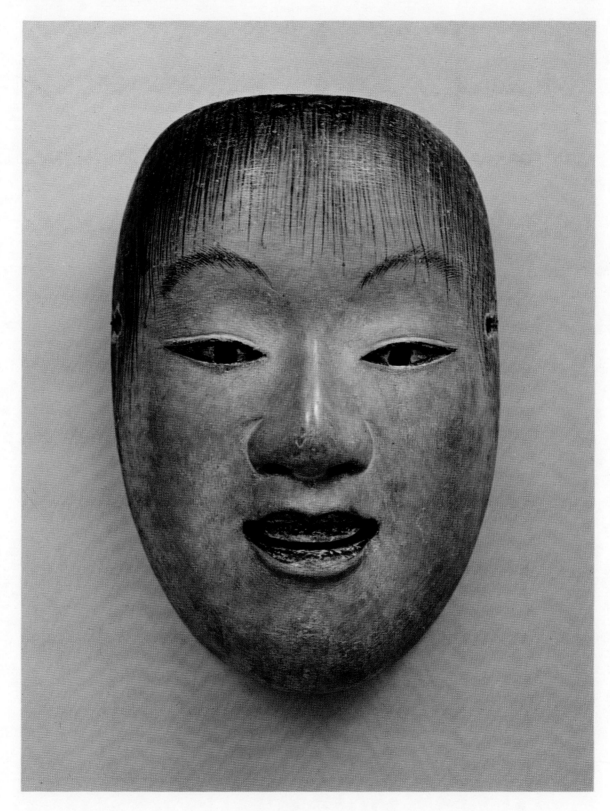

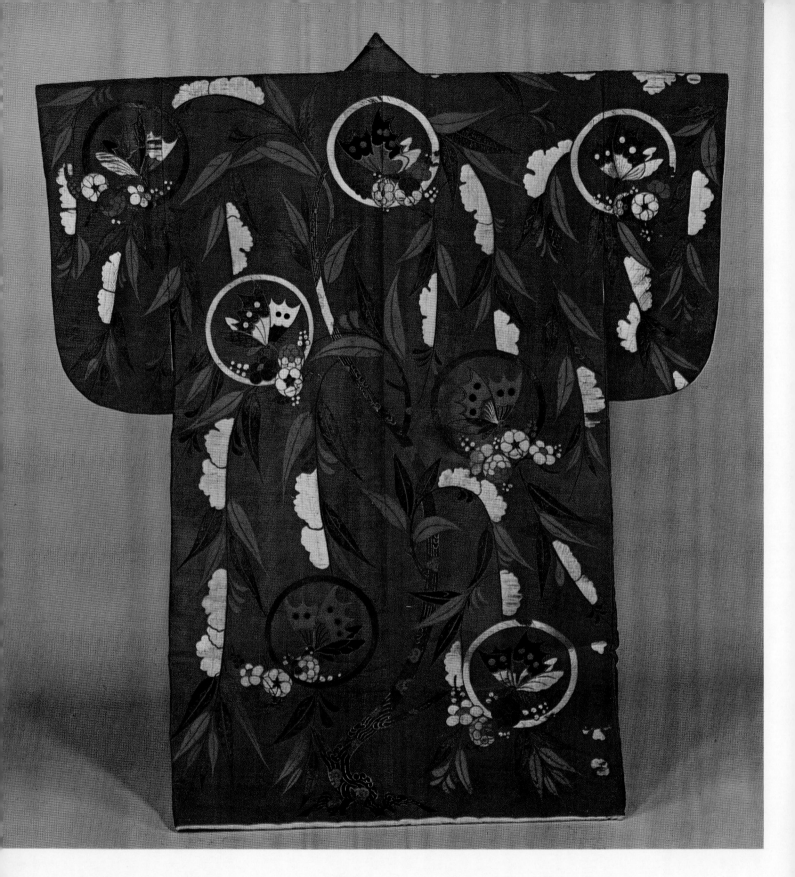

Nō costume with design of snow-covered willows and swallowtail butterflies, Number 53

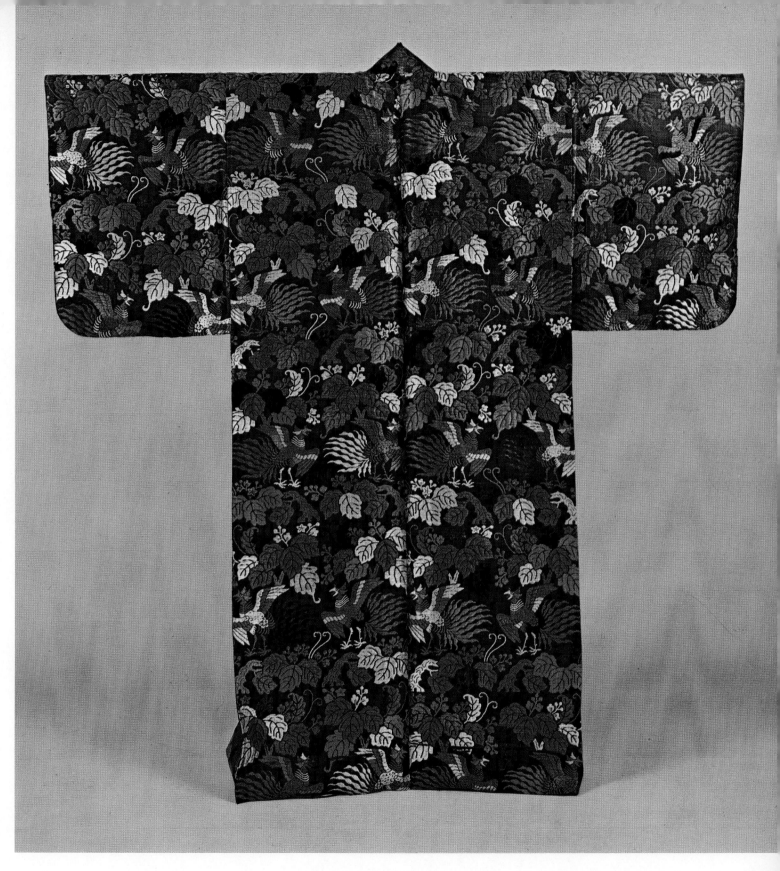

Nō costume with design of paulownia and phoenix, Number 55

Campaign jacket *(jimbaori)* with design of crossed sickles, Number 48

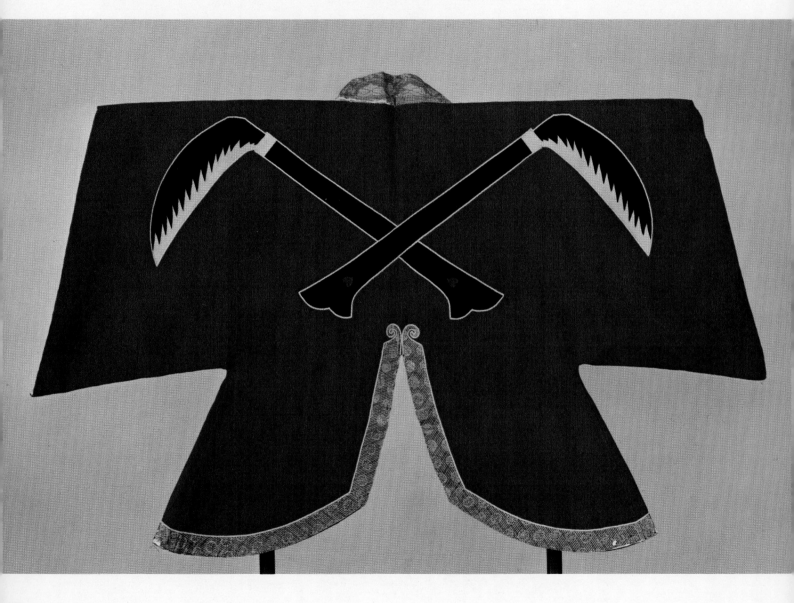

Sword guards *(tsuba)*

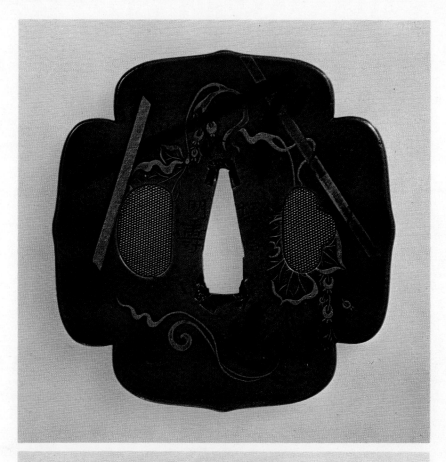

Design of grapevines and
trellis, Number 76

Floral design in cloisonné,
Number 77

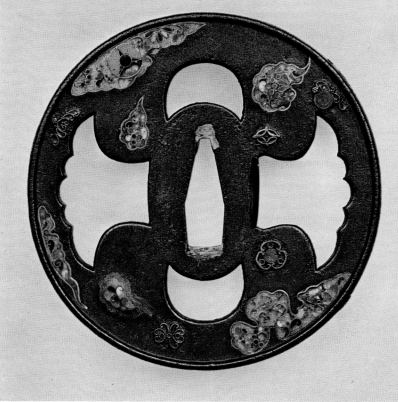

Shigaraki fresh-water jar, Number 57

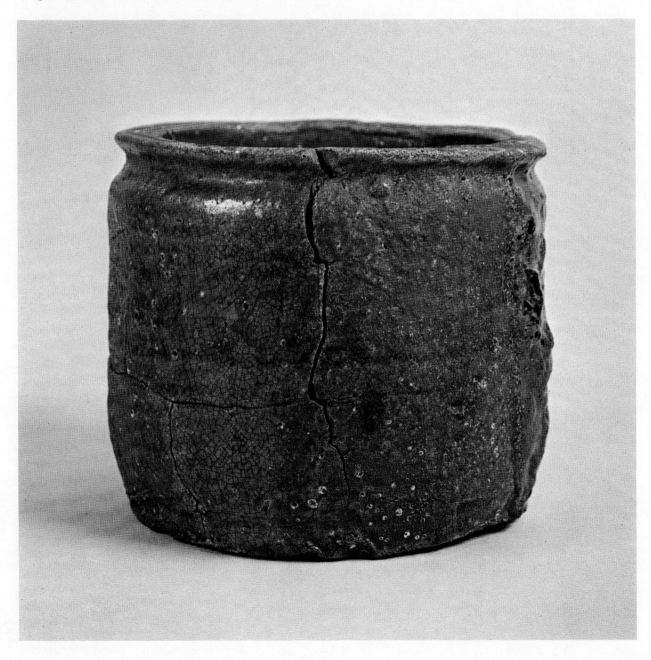

CATALOGUE

Painting

Admired and protected by their patrons and imitated by their less gifted descendants, the painters of the Momoyama period were prominent at a time when all artistic endeavors were benefiting from Japan's emergence from political chaos into unified prosperity. Sharing in the sense of self-confidence and liberation that accompanied this transition, the major painters were encouraged by the generous patronage of warlords, who recognized the arts not only as aesthetic pleasures but as symbols of power and prestige.

Nowhere is this appreciation for the political value of art more obvious than in the grand castles of men like Nobunaga and Hideyoshi. Their halls often reached spectacular proportions with enough floor area to hold two hundred three-by-six-foot *tatami* mats. Uncluttered by furniture, these open spaces easily accommodated countless rows of kneeling vassals, and provided a clear view of the magnificent paintings on their walls. Since Heian times (794–1185) such interior walls were made of light partitions called *fusuma,* which were painted on one or both sides with continuous scenes of landscape or figure subjects. These partitions, or sliding doors, ran along wooden tracks in the floor and transom, and could easily be opened or removed altogether to expand a room (see ill., opposite). Another type of traditional room partition that provided a surface for paintings was the free-standing portable folding screen *(byōbu).* These were usually designed in pairs, each half having six, or sometimes two (No. 30) or eight (No. 21), panels. Chief differences between folding screens and sliding doors are the overall frame of silk brocade and the paper hinges of the former and the metal door pulls *(hikite)* of the latter. The materials and manner of their construction are basically the same: over a simple latticework frame *(hone)* of cryptomeria wood, the mounter applies seven separate layers, each consisting of many small overlapping sheets of paper made from the bark of the paper mulberry *(kozo).* On alternate layers the sheets are pasted down only around their edges, rather than across their entire faces, leaving air pockets that increase the strength and durability of the screen. The outermost layer *(wabari)* on both sides serves as the painting surface.

Two basic styles characterize the large-scale paintings of the castles: an ink style used primarily in private living chambers, where the lords gathered to talk and drink tea, and a color and gold style favored for such public spaces as audience halls and vestibules. The ink painting style had evolved under the influence of Chinese models during the Muromachi period (1392–1568) and was the more traditional and personal medium of expression. The striking color and gold style was, like the castles themselves, intended to arouse a sense of awe in the beholder.

By the late sixteenth century even temples, which had been strongholds of monochrome ink painting for hundreds of years, began to commission walls in the color and gold style for their reception rooms (Nos. 11, 15). Although a few artists worked almost exclusively in the ink

medium, all were versatile enough to adjust their styles and themes to the function of their art. For paintings in the monochrome style, artists continued to use conventional themes, but relied on selective focusing and impressive brushwork to make a more direct and emotional impact. In flamboyant paintings for public display, however, subjects were limited to those most easily understood and enjoyed, such as flowering trees or birds and flowers.

The scope and complexity of the color and gold paintings led to an efficient system of mass-production. The head artist would first execute an underdrawing for the composition. Then his assistants (usually his sons) prepared the inks, mixed the colors, and carefully painted in the mineral pigments for such details as the flowers according to color notations written directly on

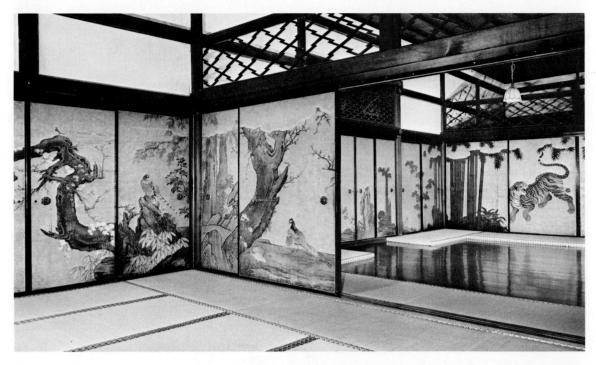

Abbot's quarters of Tenkyū-in (Myōshin-ji), Kyoto, showing *fusuma*

the paper. The final overdrawing of ink lines was left to the hand of the master, whose confident control of the brush gave life to the painted forms.

Kanō Eitoku's (1543–1590) (Nos. 4–6) future as head of the capital's most influential school of painting may have been decided when, at the age of nine, he was formally presented by his grandfather Motonobu (1476–1559), then the official painter to both shogunate and court, to the Ashikaga shogun. Eitoku's drive and ambition brought him in contact with all of the great warlords of his time. One of his earliest and most acclaimed projects, the Jukō-in (No. 4), was commissioned as a memorial chapel by Miyoshi Yoshitsugu, a steward of the Hosokawa family, the governor-generals of Kyoto.

The artist's ties with the first hero of this generation, Oda Nobunaga, were especially strong, and from 1576 Eitoku and his pupils spent four years decorating the enormous audience rooms of Azuchi Castle. From here Eitoku went on to Hideyoshi's Osaka Castle in 1583, the Jūraku-dai in 1587, and Fushimi Castle in the early 1590s. In the 1580s he was summoned to work in

the Imperial Palace. As his fame increased his commissions multiplied, and overwork may have been the cause of his early death after a career of less than thirty years.

Eitoku lived in a turbulent era, and most of his paintings suffered the fate of the men who owned them: with Nobunaga's assassination in 1582, for example, Azuchi Castle was looted and burned to the ground only two years after the artist had finished his work there.

Eitoku's eldest son Mitsunobu (1565–1608) (No. 7) and adopted son Sanraku (1559–1635) (Nos. 8–11) maintained the patronage of the Toyotomi and later the Tokugawa families. Unlike Eitoku, they lived into an era of increasing stability and relative peace and these changed conditions are reflected in their work.

It must not have been easy for Mitsunobu to follow in the footsteps of a dominating personality like Eitoku, and he seems to have rejected the extroverted forcefulness of his father in favor of a calmer mood. Hideyoshi called him to Hizen Province in Kyūshū in 1592 to decorate the temporary military headquarters in the port of Nagoya, and by 1603 Mitsunobu was working for Tokugawa Hidetada. He apparently commuted regularly between Kyoto and Edo and died while en route on one of these trips.

Sanraku was not a Kanō artist by birth, but rather the son of Kimura Nagamitsu, a vassal of Asai Nagamasa (1545–1773). When Nobunaga defeated the Asai clan in 1573, Nagamitsu switched his allegiance to Hideyoshi, and Sanraku entered the general's service as a page. At the age of sixteen or seventeen he was recommended to the Kanō studio, adopted by Eitoku on Hideyoshi's advice, and probably came into his own in the 1590s after Eitoku's death. The fall in 1615 of the Toyotomi family, with whom he had been so closely associated, was a severe blow to him, and he shaved his head and became a lay Buddhist, changing his name from Shūrinosuke Mitsuyori to Sanraku. Before long he was working with equal enthusiasm for the Tokugawa family, though he never moved to Edo, choosing instead to establish the Kyoto branch of the Edo-period Kanō school. His son-in-law Sansetsu (1590–1651) was adopted into the Kanō family around 1620.

More than sixty years separate Eitoku's Crane and Pine in the Jukō-in (No. 4), painted in 1566 on the eve of the Momoyama period, and the Tenkyū-in Plum and Pheasant (No. 11), painted by either Sanraku or Sansetsu at the end of the period in 1630. Both works might be called transitional. The style of Eitoku's Crane and Pine still shows the influence of his grandfather Motonobu's works painted in the 1540s on the same subject in the Reiun-in at Myōshin-ji. The hard linear stylization of the Plum and Pheasant is more characteristic of the early Edo period. Mitsunobu's Birds and Flowers of the Four Seasons (No. 7) lie midway between these two and have the relaxed opulence of the turn of the century, the Indian summer after Hideyoshi's death and before the siege of Osaka Castle.

In an age when ambition and ability often overshadowed family origins, three artists, Unkoku Tōgan, Kaihō Yūshō, and Hasegawa Tōhaku rose to prominence in the late sixteenth century outside the mainstream of the Kanō school. Perhaps in a deliberate reaction to the flamboyance of the Kanō artists, they cultivated styles that were either severely conservative, as in the case of Tōgan, or highly personal, as in the cases of Yūshō and Tōhaku. Working primarily in the ink medium favored by earlier generations, they turned to conventional Chinese subject matter and studied Chinese paintings in the collections of the great monasteries.

Tōgan (1547–1618) (Nos. 19, 20) was the most conservative and serious of the ink

4

painters. He rarely worked in color and was most at home with carefully structured landscapes in the manner of Sesshū (1420–1506). Born the second son of the lord of Nogomi Castle in the province of Hizen in Kyūshū, Tōgan lost his entire family in the battles of the Tenshō era (1573–1591). The daimyo Kobayakawa Takaage of Chikuzen and, later, his nephew Mōri Terumoto of Aki, both allies of Hideyoshi, patronized this artist, and he must have spent much of his time in their distant provinces. Tōgan seems never to have attained the popular acclaim of Tōhaku, perhaps because his style was too stern, without the lush sensual appeal of that of his contemporaries. A branch of the Unkoku school continued to flourish in Hagi in Nagato Province (now Yamaguchi Prefecture) throughout the Edo period.

Hasegawa Tōhaku (1539–1610) (Nos. 12–15) was raised in a family of dyers in Nanao in Noto Province and arrived in Kyoto with high ambitions. He had built a reputation for himself by the 1580s and is said to have painted alongside the Kanō family in Hideyoshi's Jūraku-dai in 1587. Competitive by nature, he soon found himself in rivalry with the Kanō school and drew close to the astringent, more reticent ideals of his friend Sen no Rikyū, who was also estranged from the Kanō artists. Tōhaku found another powerful patron in Nange Genkō, a priest on close terms with both the military dictators and the emperor. Like so many of his generation, this artist felt the need for a distinguished ancestry, and discarded his earlier name of Shinshun (or Nobuharu) in favor of Tōhaku, using the character "Tō" of Sesshū Tōyō. He was actually involved in a legal dispute over the Sesshū lineage with the more serious contender, Unkoku Tōgan. His answer to the success of the Kanō school was to form an atelier of his own that worked on large-scale commissions in the bold color and gold style (No. 15). In the decade after Eitoku's death in 1590 he and his assistants probably surpassed in quality and demand the work of his rivals. He achieved official recognition with the titles *Hokkyō* in 1604 and *Hōgen* in 1605 and was even invited to Edo by the Tokugawa family, but died before he could take advantage of this offer.

Most of Kaihō Yūshō's (1533–1615) (Nos. 16–18) extant works are ink paintings produced during his late sixties for the Zen temple Kennin-ji in Kyoto. The fifth son of a vassal of Asai Nagamasa, he was fortunately already a ward of the Zen temple Tōfuku-ji in Kyoto when his entire family, like that of Tōgan, was killed in a siege by Nobunaga in 1573. Despite early training in the Kanō school, he retained a fierce sense of independence and a self-conscious pride in his samurai heritage. His interests included Zen (he meditated at Daitoku-ji with the priest and tea master Shunoku Sōen), swordsmanship, tea, and poetry. As a man of education and spirit he was respected by Hideyoshi, who gave him free access to his Fushimi Castle after meeting him at a tea ceremony. In his last years he had entrée to the homes of the aristocracy as well, and his fame apparently even spread as far as Korea. He died at the advanced age of eighty-two, in the year Ieyasu finally laid siege to Osaka Castle.

The Tosa and the Soga schools, both conservative and traditionalist in outlook, were encouraged and revitalized during the Momoyama period by the open and free spirit of the thriving port city of Sakai, just south of Osaka.

Working in a finely detailed miniature style the Tosa school had long dominated the official painting bureau of the imperial court. The family prestige declined along with that of the old aristocracy during the power struggles of the sixteenth century. Overshadowed by the more innovative Kanō school, the Tosa moved to Sakai and survived on the fringes of the Momoyama

art world. Mitsuyoshi (1539-1613), whose style was best suited to handscrolls and albums, responded to the demands of his times by painting a number of large screens not only on the classical theme of the *Tale of Genji* (No. 24) but also on contemporary subjects such as the Battle of Sekigahara.

Soga Chokuan (Nos. 21, 22), who was active around 1600, also sought his fortune in Sakai, adapting the ink style that was the specialty of his family to the taste of a new clientele. His son Nichokuan (No. 23), in particular, stands out as an eccentric loner, a disturbing but compelling personality whose portraits of birds have strength and tension tempered by a refined sensitivity for detail.

Most of the great schools could not maintain the momentum of their Momoyama founders. The Kanō school was the most successful because of its relationship with the Tokugawa shogunate, but it was Sōtatsu, Kōetsu, and their followers, the Rimpa school, who with a combination of modernity and sentimentality, struck the deepest nerve in the Japanese soul and gave most impetus to the development of Japanese painting.

Sōtatsu, active between 1600 and 1630 (Nos. 25, 26), very likely began his career as the proprietor of a fan shop in Kyoto called Tawaraya. He rose among the class of newly rich city merchants, the *machishū,* and was led into court circles through his connections with Hon'ami Kōetsu (1558-1637) (Nos. 33-35, 65) to whom he was reportedly related by marriage. Many of the gold and silver underpaintings on Kōetsu's scrolls of calligraphy dating from the first two decades of the seventeenth century have been identified as unsigned early works of Sōtatsu. Emerging gradually as an independent artist, he exhibited the *machishū* preference for strikingly novel effects, but for his subject matter he ignored the contemporary world, focusing on themes from classical antiquity. Compared to the work of the older Tosa Mitsuyoshi (No. 24), for example, Sōtatsu's version of the *Tale of Genji* displays an entirely original approach to a standard theme.

Sōtatsu looked to the past as both a defiant and romantic escape from the increasingly repressive measures of the Tokugawa shogunate and as a joyous rediscovery of a magnificent classical heritage. He had the opportunity to study a large body of late Heian paintings at first hand in 1602, when one of Ieyasu's victorious generals, Fukushima Masanori (1561-1624) of Aki, decided to celebrate his new fame and fortune by restoring and rededicating a twelfth-century illustrated set of scriptures belonging to the Itsukushima Shrine. Masanori commissioned six new paintings from Sōtatsu to replace lost originals, and the experience may well have served as a springboard for the young artist's career. The interest in Heian ideals was shared by many of the cultured elite of Kyoto. Merchants like Suminokura Soan (1571-1632) (No. 33) and calligraphers like Kōetsu and the aristocratic Karasumaru Mitsuhiro (1579-1638) occasionally collaborated with Sōtatsu (Nos. 25, 34).

The serious and official "public" art of this period was balanced by a healthy sense of humor and iconoclasm. In the back rooms of castles and city mansions genre paintings entertained the citizens of an increasingly bourgeois society with scenes from their daily lives. The frenzied optimism and unlicensed pleasure of the early decades of the seventeenth century left their mark on the screens of Activities in the Capital (No. 28).

From the young lords of the upper classes (No. 27) to the bookbinders and weavers (No. 29), citizens of Kyoto all enjoyed the good life.

1

Portrait of Ashikaga Yoshiteru (1536–1565)

Dated 1577
Hanging scroll, color on silk
H. 3 ft. 11/16 in. (93.2 cm) x W. 17⅜ in. (43.7 cm)
Private collection: Sakai Sadao, Tokyo
REGISTERED IMPORTANT CULTURAL PROPERTY

Yoshiteru was only ten years old when he was appointed the thirteenth Ashikaga shogun and twenty-nine when he was forced by his enemies to commit suicide together with his wife and mother in their burning palace in Kyoto. Throughout his short career he was at the mercy of ruthless warriors like Miyoshi Chōkei (1523–1564) and Matsunaga Hisahide (1510–1577), who were struggling over control of the capital city. Yoshiteru's duties were largely ceremonial: it was he, for example, who around 1560 officially welcomed Father Gaspar Vilela, one of the first Jesuit missionaries to reach the capital. Since the late fifteenth century the shoguns had been no more than a succession of puppets, and Yoshiteru was nearly the last of the line: his younger brother Yoshiaki was appointed shogun in 1568 by Nobunaga only to be deposed five years later, leaving the post empty until 1603, when Tokugawa Ieyasu founded a new family dynasty.

Yoshiteru looks dignified, pensive, and a bit melancholy in this posthumous portrait. His gentle, aristocratic features are probably idealized here, but he is clearly a cultivated and distinguished young man. The several layers of his loose, soft robes, with their subdued colors and exquisite patterns, fall graciously around his body. While his fourteenth-century ancestors preferred to be shown as dynamic men of action, mounted on horseback in full armor, Yoshiteru is depicted here in the informal attire of a courtier, with a conical black hat (*eboshi*), fan, and dagger (*aikuchi-koshirae*). Sheltered and powerless, Yoshiteru probably never used this weapon, except possibly on himself in his final moments.

We know this to be a memorial portrait from the lengthy inscription by Sakugen Shūryō (1501–1579) dated to the eleventh month of 1577

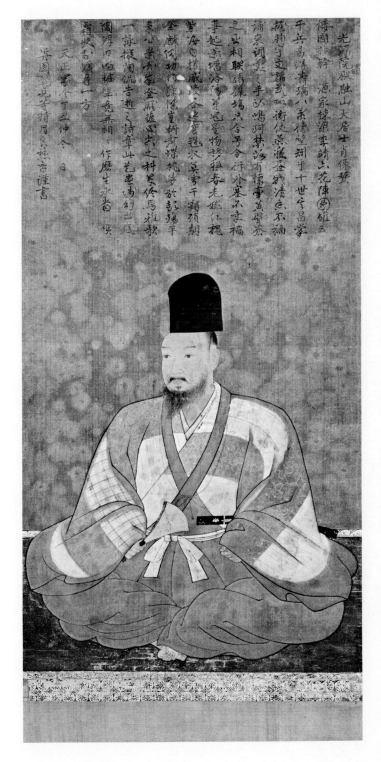

(Tenshō 5). Sakugen was a Zen priest and abbot of the Myōchi-in, a subtemple of Tenryū-ji on the western outskirts of Kyoto. He was also an urbane traveler. Partly through his personal interest in Chinese literature and partly through a desire to improve the economic standing of his temple, Sakugen twice commanded large trade fleets sent by the western daimyo Ouchi to the southern Chinese port of Ning-po, spending a total of five years on the continent. This is one of the rare extant examples of his writing, which was much admired in his day.

2

Sketch for a portrait of Toyotomi Hideyoshi (1536–1598)

Around 1598–1599
Hanging scroll, ink and color on paper
H. 21 in. (53.3 cm) x W. 23⁷⁄₁₆ in. (59.5 cm)
Itsuō Art Museum, Osaka
REGISTERED IMPORTANT CULTURAL PROPERTY

Hideyoshi, the foremost hero of a golden age, was not a handsome man. His large protruding ears, sharp angular features, and narrow jaw accentuated by a carefully trimmed, pointed beard characterize

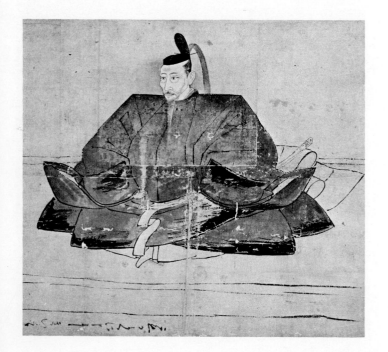

the "monkey face" for which he was notorious. The sunken cheeks and wrinkles in this portrait are those of a sixty-two-year-old man whose health was rapidly failing, but the intensity of an indomitable inner spirit still burns in the wide-open eyes with their disconcerting golden irises.

To legitimize his role as the ruler of Japan, Hideyoshi fabricated an aristocratic ancestry, claiming direct descent from the illustrious Fujiwara family. In 1586 he induced the new emperor, Go-Yōzei, to sanction this pedigree by appointing him to the highest court office open to those outside the imperial family, that of *Dajōdaijin,* or Prime Minister. Thus it happens that the man who rose from a modest social background and who spent his life on battlefields at the head of vast armies is seen here in the full ceremonial dress traditionally reserved for titled nobility of highest court rank. His stiff black silk gauze hat is the formal *kanmuri* worn by gentlemen of the fifth rank and above. He is dressed in a black double-breasted outer robe with narrow circular collar and an inner robe with a long train, which is shown folded behind him. These voluminous robes greatly amplify Hideyoshi's slight frame, making his hands seem unreasonably tiny. Loose billowing trousers, white silk socks, a wide band called *hirao* attached to the front of the sword belt, a long sword *(tachi)* at his left side, and the *shaku,* a flat baton symbolizing authority carried in the right hand, complete his costume.

There are many formal portraits of Hideyoshi, but all seem to have been executed within a few years following his death in 1598. He is often shown seated at the entrance to a Shinto shrine as an idealized and deified cult image, a tribute to his lifetime of heroic exploits, but this sketch is quite exceptional in daring to reveal something of the human frailty of the aging despot. It is a preliminary drawing on paper, probably one of six or seven prepared by the artist for the approval of his patron, possibly a close friend or member of Hideyoshi's family. We know that this is the final choice because there is a notation in the lower left corner that it is a very close likeness. The raised ceremonial mat *(agedatami)* on which he sits is indicated only with simple outlines; the artist has concentrated on the facial features. The upper torso and head are drawn on a separate piece of paper pasted onto the sheet, perhaps as a correction for an earlier mistake.

3

Portraits of Tōdō Takatora (1556–1630)
and his wife (d. 1615)

Early seventeenth century
Two hanging scrolls, ink and color on silk
H. 3 ft. 4⁹⁄₁₆ in. (103 cm) x W. 17¹¹⁄₁₆ in. (45 cm) each
Shitennō-ji, Mie Prefecture
REGISTERED IMPORTANT CULTURAL PROPERTY

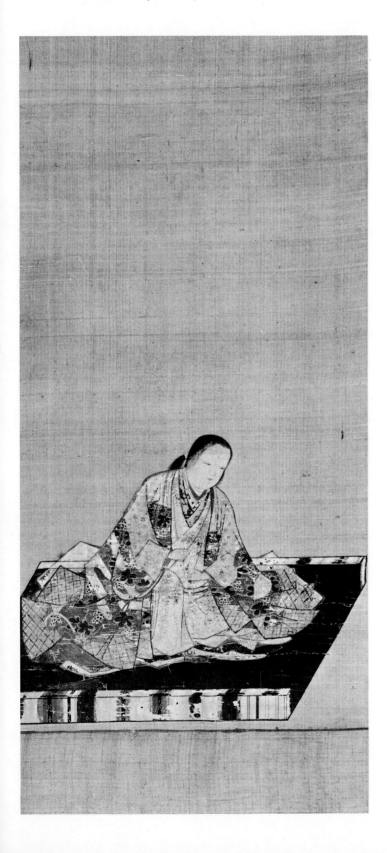

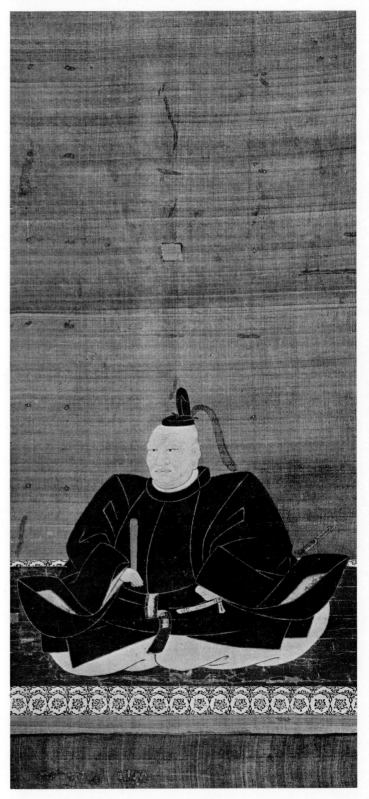

Tōdō Takatora spent his life as a commander of troops for Nobunaga, Hideyoshi, and Ieyasu, gradually amassing great wealth and property. In 1600 Ieyasu rewarded him with the provinces of Iga and Ise, and Takatora moved to Tsu Castle in Ise with his wife, whom he had married in 1581. She died there in middle age in 1615 while he was fighting in the decisive Osaka summer campaign, the final siege of the mightly castle of the Toyotomi family, in which he earned the prestigious court rank of Junior Fourth Grade, Lower Class. Takatora's portrait, which was commissioned at the time of his death fifteen years later for a Buddhist memorial service, depicts him as a white-haired old commander. Stocky, robust, and coarse-featured, he is seated in the formal three-quarter view on a thick straw mat, the *agedatami,* proudly wearing his best black ceremonial court robes with the usual accessories (see No. 2).

If his wife were not fingering a rosary, one would never imagine that the portrait of this gentle woman, half-kneeling on her green mat and fashionably dressed, was also painted for a memorial service. With her plump face, a hint of a double chin, elongated slit eyes, small prim mouth, white complexion, and hair parted at the center and pulled back in a ponytail, she approaches the ideal of feminine beauty captured in contemporary Nō masks (No. 43). Her *uchikake,* the outer robe she wears as a loose mantle, is decorated with a lush grapevine design against a bright red ground with gold-leaf cloud bands and gold tendrils. The robe beneath this, a *kosode* belted with a narrow sash, has a large blue and green wisteria motif against an allover tie-dyed pattern of tiny white squares called *kanoko.* Three more red and green robes are visible beneath the *kosode.*

Both portraits were given to the Shitennō-ji in Tsu, but may not have been intended as a pair. There are discrepancies in the use of color, the quality of ink lines, the design of the mats, the treatment of backgrounds, and even in the original dimensions, suggesting that the wife's portrait may have been painted soon after her death.

With the exception of paintings of a few devout nuns and idealized representations of famous poetesses, women had heretofore been all but ignored in portraiture. During the Momoyama period, however, the wives and daughters of the daimyo elite were portrayed side by side with their men. Nearly three thousand portraits of women are recorded for this brief era, compared with only a few hundred just before and after it, but this statistic probably reflects a new enthusiasm for portraiture in general, rather than a larger role for women.

While earlier portraits had illuminated the character of Buddhist monks with penetrating and subtle insight, Momoyama paintings of powerful daimyo emphasize their social status, outward appearance, and adornments. The conventional poses and small format remained, however, and it may be that the warriors hoped to show themselves as successors to a venerable tradition.

4

Crane and Pine

Kanō Eitoku (1543–1590)
Around 1566
Four sliding doors, ink and gold on paper
H. 5 ft. 9 ⅛ in. (175.5 cm) each x W. 3 ft. ¼ in. (92 cm)
 left two panels, 2 ft. 5 ⅛ in. (74 cm) right two panels
Jukō-in (Daitoku-ji), Kyoto
REGISTERED NATIONAL TREASURE

The Jukō-in, a subtemple of Daitoku-ji, is famous as the burial place for successive generations of the Sen family, the hereditary line of tea masters founded in the Momoyama period by Sen no Rikyū (1521–1591) (see No. 57). It is even more renowned for the sets of sliding doors in each of three rooms that form the south half of the abbot's quarters. The set in the east room on the theme of the Eight Views of the Hsiao and Hsiang Rivers is attributed to Kanō Shōei. The set in the west room on the theme of the Four Accomplishments and that in the central room on the theme of the Four Seasons are both attributed to his son Kanō Eitoku.

The four panels here, which represent summer, form the left half of the north wall of the central room as a part of a continuous fifty-nine-foot composition of pines, plum, bamboo, and various birds that extends around three walls.

One can immediately appreciate in this painting the confidence and grandeur that characterize Eitoku's best work and that had such strong influence

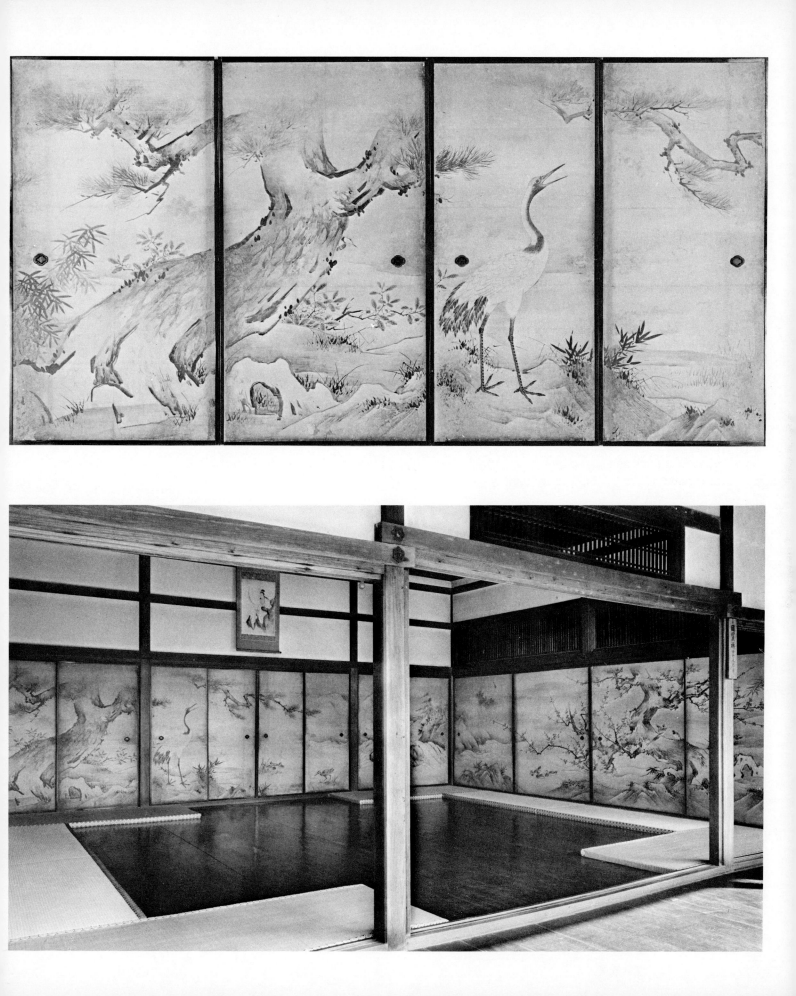

on later and lesser Momoyama screen painters. The abbots and generals who dictated the taste of the period could easily respond to the strength and individuality of the pine tree; from roots that clutch the ground like powerful fingers, it leans back into the picture space, stretches gracefully yet firmly to the right, and throws out two sweeping branches to embrace the four panels. The massive trunk is freely drawn, with its bark clearly delineated only at the center. In comparison, the crane is slender and fragile, but its delicately detailed feathers and alert stance give it an air of noble dignity that is just as compelling as the forceful gesture of the pine.

Unsigned, this work is considered the first of Eitoku's masterpieces and was probably painted in 1566, the year the temple was founded and Eitoku turned twenty-three. The strong and individualistic composition, the sure yet vigorous brushstrokes are those of a self-assured young artist who was destined to become the greatest painter of his era.

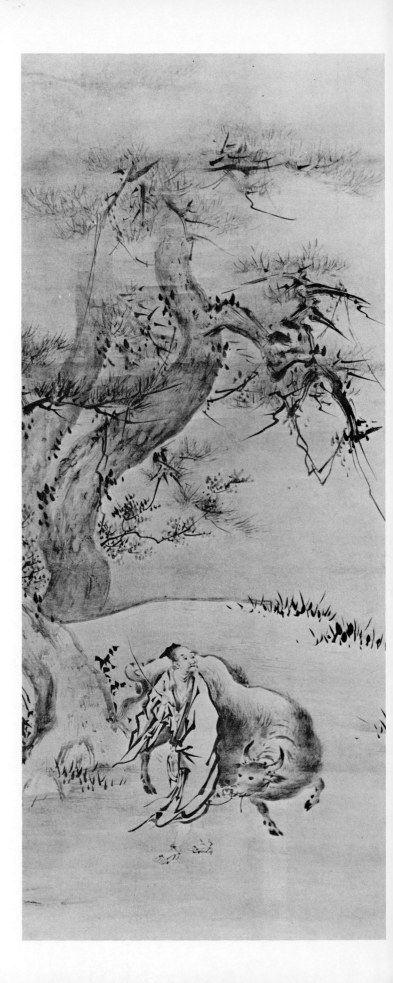

5

The hermits Hsiu-yu and Ch'ao-fu
Kanō Eitoku (1543–1590)

1580s
Two hanging scrolls, ink on paper
H. 4ft. 1⅞₆ in (125.5 cm) x W. 20¹¹⁄₁₆ in. (52.5 cm) each
Tokyo National Museum

This pair of hanging scrolls represents the legendary Chinese hermits Hsiu-yu and Ch'ao-fu (called Kyoyū and Sōha in Japanese), said to have lived during the reign of the emperor Yao (2357–2255 B.C.) According to tradition, the emperor, having heard that Hsiu-yu was a great sage, decided to turn over to him the rule of the state. Hsiu-yu, however, emphatically refused the offer and, believing himself defiled by the very suggestion, went to the river

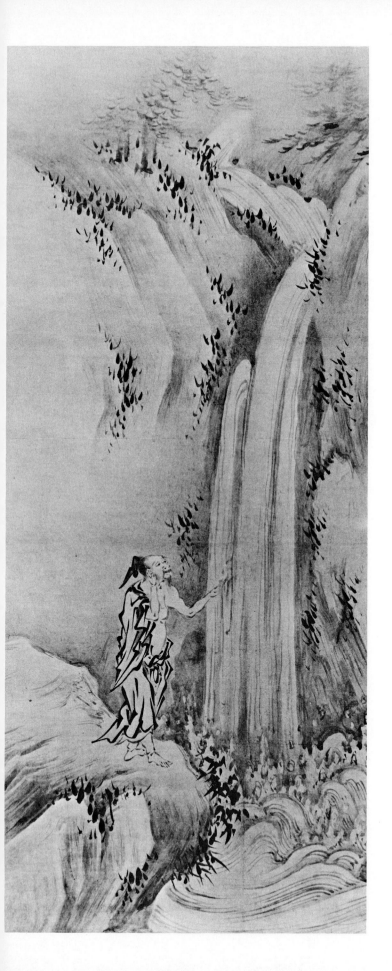

to wash out his ears. When his scrupulous friend Ch'ao-fu saw that the river had been polluted by the emperor's proposition, he considered it to have become so foul that he would no longer water his bull there or even cross it.

Paintings based on such conventional moral tales were common in the homes of Chinese royalty. In the Momoyama period this fashion also seems to have taken hold among Japanese aristocrats and feudal lords. Perhaps the fastidious disdain for power demonstrated by the two hermits seemed relevant to Eitoku and his contemporaries in an age of political struggle and ambition. It is recorded that Eitoku first used this theme on the walls of Nobunaga's Azuchi Castle.

The artist gives each form an individual character and potency. In the painting of Ch'ao-fu and his ox, the coarse and scratchy lines of the pine dominate the upper half of the painting. In contrast to this impression of confusion, Ch'ao-fu and his ox stand out as models of purposeful resolve. The animal turns only too gladly from the tainted water, while Ch-ao-fu, his feet set unwaveringly on the path leading from the river, looks back with an expression that is both upright and distant. His robe, drawn in sharp, pulsating lines that give the figure prominence, appears to recoil from the offensive waterfall. This sort of versatile and charged brushwork conveys the same sense of strength and spontaneity as the more monumental Crane and Pine (No. 4), and the traditional attribution of this work to Kanō Eitoku is entirely reasonable.

The painting surface is made up of many smaller pieces of paper joined together, suggesting that these two scrolls were probably originally part of a larger screen or sliding door painting. If this is true, then the two jar-shaped red seals within a circle, inscribed with Eitoku's personal name, Kuninobu, were added later.

Among the developments credited to Eitoku is the emphasis of foreground compositions. In this example, distant views have indeed been eliminated, and such details as the tall pine, the towering waterfall, and the scattered dark accents called "moss dots" are brought into sharp focus against the soft background, confining our attention to a relatively shallow space.

6

Chinese hermits

Style of Kanō Eitoku (1543–1590)
Late sixteenth century
Pair of six-fold screens, ink and gold on paper
H. 5 ft. 7/16 in (153.5 cm) x W. 11 ft. 9 9/16 in.
 (359.5 cm) each
Private collection: Ofuji Uichiro, Kyoto

These screens depict Chinese immortals and sages. Two of the figures, one with a long staff and the other with an umbrella, are servants. Of the remaining six, identities can be suggested only for two: the fisherman is Lu Shang (1210–1120 B.C.), who, according to legend, was fishing one day in quiet contemplation when Wen Wang, father of the first Chou emperor, discovered him and, impressed by Lu Shang's wisdom, immediately appointed him chief minister; the figure with the iron crutch seated on the tree trunk is the Taoist immortal T'ieh Kuai, patron of the sick, whose gourd of magic medicines is carried by the man at his left. Since there is no legend that associates Lu Shang with T'ieh Kuai, their appearance together here probably signifies no more than their status as important Chinese figures who were recognizable and popular in Japan.

The figures on the right all look away from the left, an unusual feature for a screen composition, and small restored areas, most visible in the left screen, indicate that door handles may have been removed. For these reasons, it is likely that this work was originally painted on sliding doors and later remounted onto screens. Since only the right screen is swept by a strong wind, the two halves probably met in a corner of the room.

The artist skillfully varies the structure of his designs without disrupting their continuity. The left screen is spacious, with a predominantly diagonal design that is stressed by the shape of the rocks and the position of the figures, while the right screen is more tightly arranged in a horizontal network of crosses and triangles.

The style of these screens is very close to that of Eitoku's hanging scrolls (No. 5), but individual strokes seem less intense. The contrast is especially noticeable in the expressiveness of facial features,

14

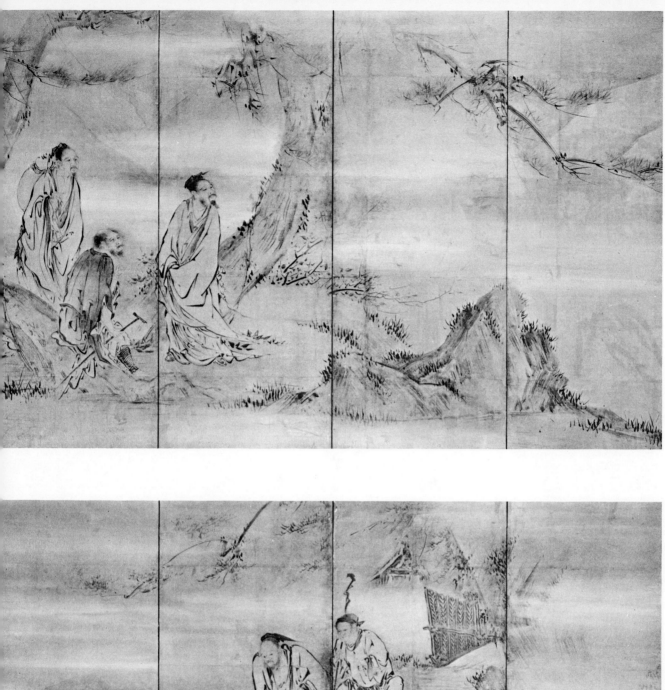

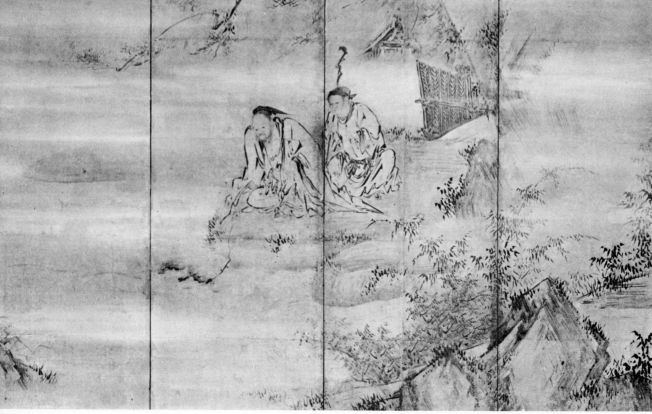

spontaneity of the scratchy brushwork in the pines, and the accented rhythms of the strokes forming the grass clumps. Even with respect to the undulating folds of the drapery—clearly the major feature of the style—the lines in the present work, although lively in themselves, do not seem to have the drive and flourish that animate Ch'ao-fu and Hsiu-yu. Although Eitoku's Kuninobu seal, seen on No. 5, appears again here, these screens may have been painted by a close follower.

Additional gold wash was applied during a later restoration.

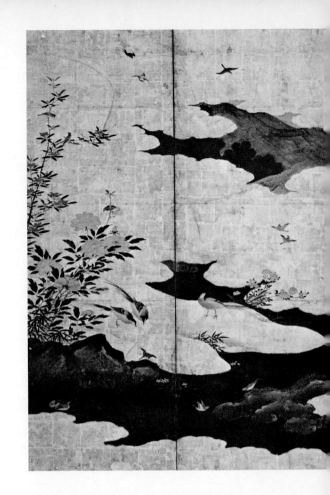

7

Birds and flowers of the four seasons

Attributed to Kanō Mitsunobu (1565–1608)
Around 1600
Pair of six-fold screens, color and gold leaf on paper
H. 5 ft. 4 ¾ in. (164.5 cm) x W. 11 ft. 7 in. (353 cm) each
Private collection: Higashiyama Chūji, Kyoto

The flowers and birds of every sort scattered liberally across these screens represent the four seasons, beginning with cherry trees, which blossom on the far right, and ending with the snow-covered cypress on the left. This work represents an extension in scope and size of a long tradition in Japan that celebrated the cycles of nature in bright paintings with prominent seasonal symbols. The use of broad areas of gold leaf is perfectly suited to this subject. Although the background glimpsed through the clouds is naturalistic and the scene is coherently structured, the discrepancies in scale—between, for example, pines and peonies—and the use of gold for both drifting clouds and solid ground encourage abandonment to a fantasy of light and color.

On the basis of the Kuninobu seal (see Nos. 5, 6) in the lower outside corners, the screens are sometimes attributed to Kanō Eitoku. Yet in the diffuse composition and in the elegant and sensitive painting of the trees, rocks, and birds, we see the characteristics not of the forceful Eitoku, but of his son Kanō Mitsunobu. Mitsunobu, whose career began at the age of eleven when he assisted his father with the pictures on the walls of Azuchi Castle, paints with an unmistakable grace and lyricism that

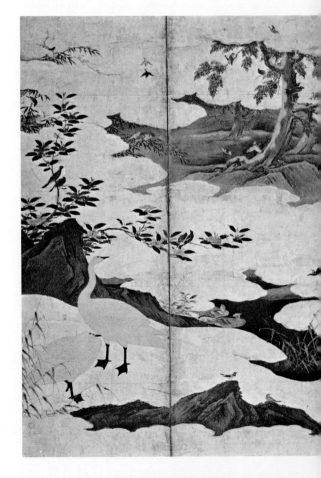

16

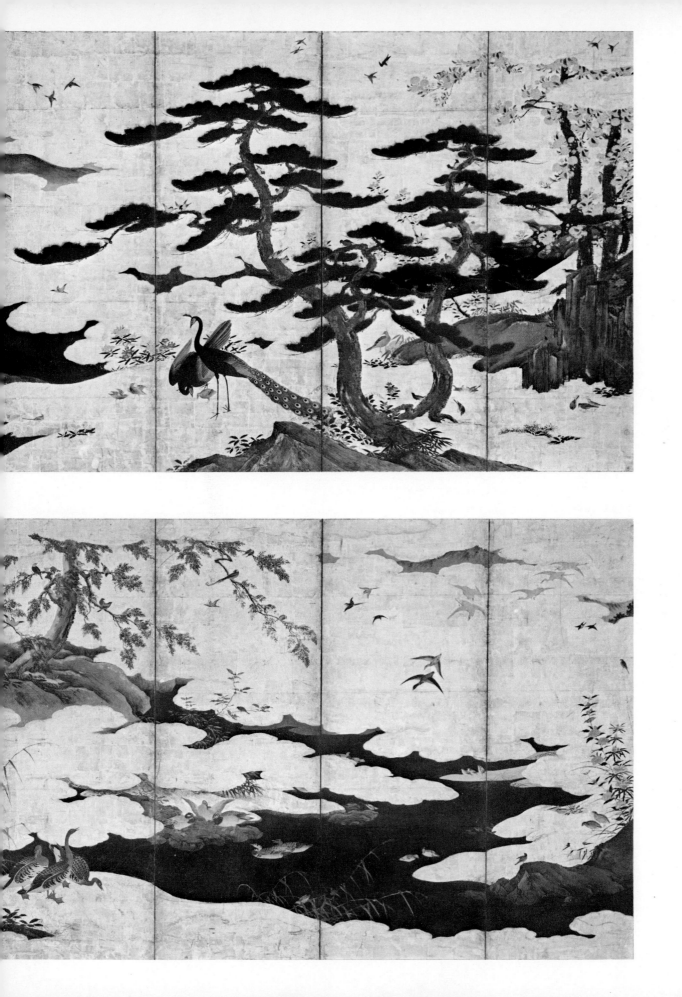

resist the blatancy of the gilding. Here, the pines and cypresses curve gently and birds in flight are swift and spirited while their companions below are relaxed and convivial.

The trumpet call with which Eitoku introduced the Momoyama age was answered by Mitsunobu with the song of flutes. The contrast in their styles points out that although the aggressive spirit of the age was pervasive, a painter's personal inclinations could still find their expression.

Landscape

Kanō Sanraku (1559–1635)
Early seventeenth century
Four sliding doors, ink and light color on paper
H. 6 ft. 1 in. (185.5 cm) x W. 3 ft. ¼ in. (92 cm) each
Shōden-ji, Kyoto

Not far from Shanghai in the area of Hang-chou in China is a place known as the West Lake that has been famous as a scenic attraction from the T'ang dynasty to the present day. After the Sung dynasty, a set of ten views and another of thirty-five—many with such poetic names as "Cloud between two peaks" and "Willow, waves, and the sound of ducks"—became traditionally accepted as particularly fine sights in the area around the lake. Japanese Buddhist monks often studied in the Hang-

chou region in the thirteenth century, and in the Zen-dominated Muromachi period these views became a favorite subject for Japanese artists, who appreciated such thematic landscapes.

Sanraku, who was adopted into the Kanō family at the insistence of Hideyoshi, is known to have illustrated the famous views of the West Lake on several pairs of screens. The subject invariably brings out the best in his ink-painting style. The work here is housed in the abbot's quarters of

Shōden-ji, a Zen temple in the northwestern outskirts of Kyoto. In Sanraku's time, this building was in the Konchi-in, a subtemple of Nanzen-ji, the greatest of the capital's Zen monasteries, but in 1652 it was dismantled and moved to its present location. The entire set from which these panels are taken consists of fifty-eight sliding doors, presumed to have been transferred from the Konchi-in with the main structure.

In this painting our attention is confined by the two dark clusters of rock in the foreground and by the peak in the immediate background to a temple compound at the edge of the lake. Here, everything is unnaturally clean, straight, and lined with mellow gold. A black-robed visitor ascending the stairs with his attendant and a donkey fleeing from its master converge directly in front of the massive temple gate, which swings open to admit the guests. One wonders if Sanraku might have intended us to see this as an ideal world, to visualize ourselves entering the mystery and security of this temple compound with its fragrant pines and spotlessly ordered rooms.

The artist's frank and controlled handling of this scene enhances the sense of serenity and isolation. A straightedge has been used frequently in the architecture and only in the clothing of the figures have the lines been relaxed.

9

Maple / Landscape

Kanō Sanraku (1559–1635)
Around 1619–1620
Four sliding doors with paintings on both sides, color and gold leaf on paper/ink and light color on paper
H. 5 ft. 10 7/8 in. (180 cm) x W. 3 ft. 13/16 in. (93.5 cm) each
Daikaku-ji, Kyoto
REGISTERED IMPORTANT CULTURAL PROPERTY

These panels are taken from the interior of the Shōshinden of Daikaku-ji where they formed a dividing wall between two rooms. The two sides exhibit the extremes of Momoyama screen painting:

one is a conservative ink-wash landscape and the other is a bright and direct painting of a few trees on a gold ground painted in the colorful style introduced only a few decades earlier by Kanō Eitoku.

Although there are obvious differences between the sides, both have been attributed to Kanō Sanraku. That works so dissimilar in appearance could have been painted by the same artist is not implausible; Japanese artists often varied their styles according to their subject matter and inclination, a fact that makes attribution of undocumented works all the more difficult. In the maple painting we recognize as characteristic of Sanraku the silhouettes against a solid curtain of gold and the heavily outlined triangular rocks textured with parallel *ts'un* strokes and crowned with a tiny bird. The maple is subdued, more graceful than the peonies and red plum tree of the main hall (Shinden) of Daikaku-ji, the best-known examples of Sanraku's decorative colored style. From the narrow cleft of a gentle slope, its trunk inclines to the left, a motion echoed by a cluster of chrysanthemum below and reinforced by the swaying leaves of a demurely retiring

willow on the far right. The reiteration of elegant curving lines of the trunks and branches has replaced the dramatic intensity of Eitoku's trees (see No. 4), but the style is not yet as geometrically tense as Sanraku's Plum Tree and Pheasant painted ten years later (No. 11).

The paintings mounted on the reverse of these panels form part of an ink landscape extending around the four walls of the adjoining room, the *jōdan no ma*. Together with the sliding doors of the Shōden-ji (No. 8), they are considered to be Sanraku's most representative landscape paintings. Crisply defined multistoried Chinese pavilions are set around the edges of a hazy ink wash scene of mountains and rivers that opens into the far distance. The softly rounded shapes of the mountain panorama recall the work of Muromachi masters like Sōami (d. 1525), but the brushwork, particularly in the washes outlining the shores of the lake, does not match the subtle, descriptive control of those earlier works. Sanraku seems more interested in the trees and buildings, which he has clustered in the foreground like a Japanese village.

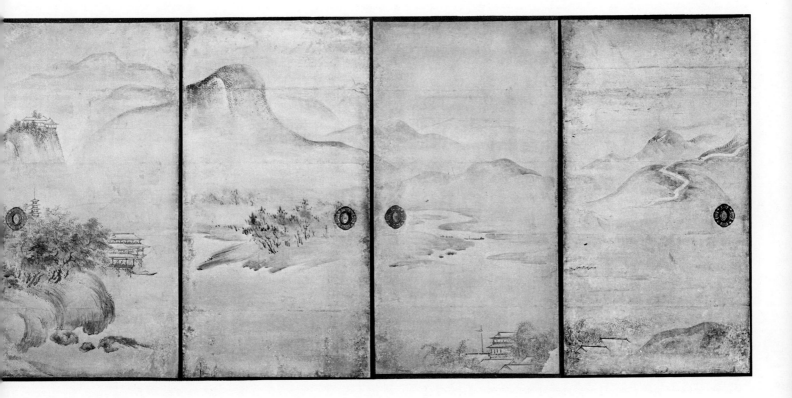

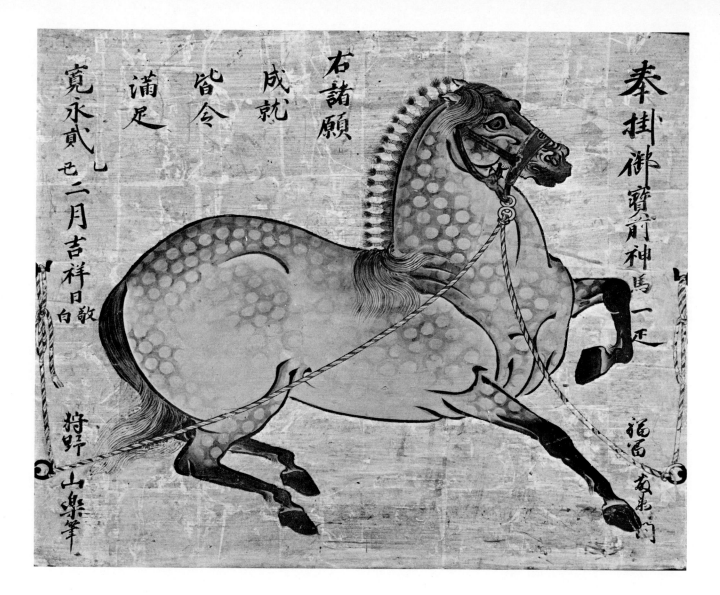

10

Votive pictures of horses (Ema)

Kanō Sanraku (1559–1635)
Dated 1625
Pair of panels, ink and color with gold leaf on wood
H. 2 ft. 1 ⅝ in. (65 cm) x W. 2 ft. 5 ½ in. (75 cm) each
Kaizu Tenjin Shrine, Shiga Prefecture

This pair of panels, painted and signed by Kanō Sanraku, was dedicated to the Shinto shrine Kaizu Tenjin-sha in 1625 by Fukutomi Tōemon. Identical inscriptions record that each is a presentation of one horse to the gods by Tōemon to obtain the fulfillment of all of his requests. The artist's signature appears in the lower outer corners, and the donor's in the inner corners, while the line at the far left of each notes the date of dedication.

The offering of these wooden votive pictures, called *ema* (literally, "painted horse"), to Shinto shrines is a long-established tradition in Japan still practiced today. The choice of a painted horse for a votive tablet recalls the earlier custom of presenting live horses, a donor's most prized possessions, to the gods, either for rain or for relief from over-abundant rains. Generally, a light-colored horse

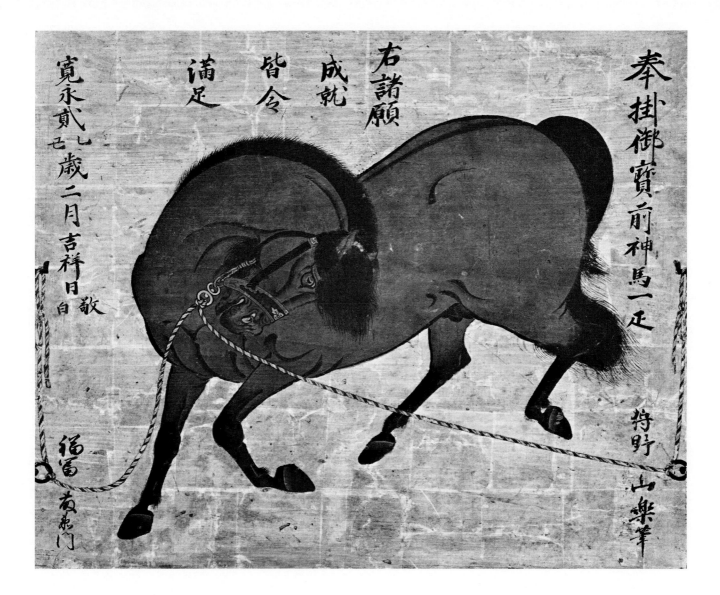

was presented for the former purpose and a dark one for the latter. As the usages of the *ema* broadened and as their popularity resurged in the Momoyama and Edo periods, they were used for thanksgiving as well as supplication, and their subject matter ranged from animals to poetry.

Sanraku's horses are carefully groomed, spirited, and healthy. The ruggedness of their faces and the wide sweeping curves of their bodies convey fierce nobility and great physical strength. Yet their poses diminish this effect; although the dark horse tugs on its fastening, it seems to do so tentatively because of its coyly turned head and mincing steps. The other, while massive and alert, seems frozen in

its stance, unable to find either the balance or the thrust needed to tighten its tether.

Ema by other major Momoyama artists are also known, but this example is particularly important as one of the few works positively ascribed to Sanraku. It appears that Fukutomi Tōemon made a special effort to please the gods by commissioning the leading painter of the Kyoto branch of the Kanō school, paying for a gold leaf background, and having a third person write the inscription. He must have been pleased with the result: although the work is comparatively small, it has the richness and finesse of the bold screens painted for the most powerful patrons.

23

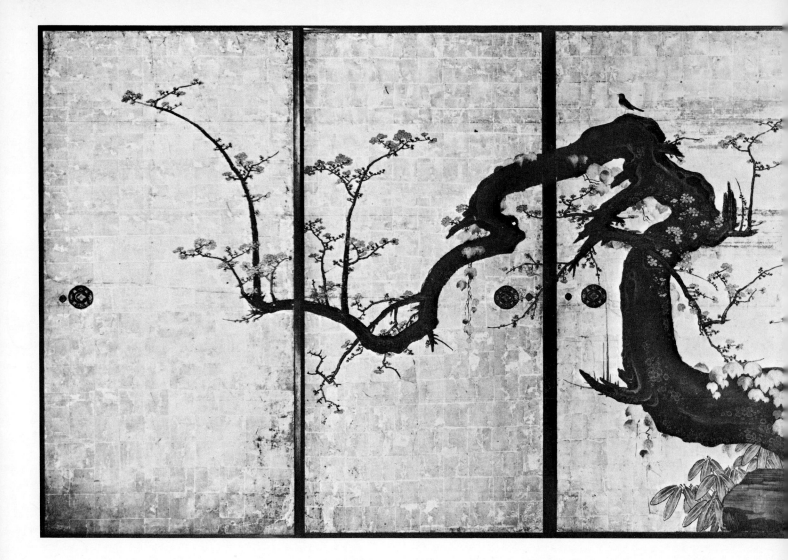

11

Plum tree and pheasant

Attributed to Kanō Sanraku (1559–1635) or his son
 Sansetsu (1590–1651)
1631–1632
Four sliding doors, color and gold leaf on paper
H. 6 ft. ¾ in. (184.8 cm) x W. 3 ft. 1 in. (94 cm) each
Tenkyū-in (Myōshin-ji), Kyoto
REGISTERED IMPORTANT CULTURAL PROPERTY

In 1631 when the Lady Tenkyū-in, younger sister
of the daimyo of Himeji, Ikeda Terumasa (1564–
1613), built this temple within the Myōshin-ji
compound, work on the paintings decorating its
interior, including those from the room in the
southwest corner of the abbot's quarters, was
begun. The identity of the painter presents a com-

plex problem: the doors have been attributed
either to Kanō Sanraku, to his adopted son San-
setsu, or to the two working in collaboration. Al-
though the faceted rocks and the modeled trees
against solid gold are features associated with San-
raku, the composition's stylized mannerism is more
common to the works of his son, who executed the
Morning Glories on a Hedge and Tigers and Bam-
boo in the two adjoining rooms on the south side.
If we grant that the seventy-two-year-old Sanraku
was willing to learn from his son, then a possible
solution may be that Sanraku, appreciating progres-
sive elements in the younger artist's style, incorpo-
rated them into his work.

Plum Tree and Pheasant lines the back, or north,
wall of the southwest room, and its right edge is at
the focal point of a continuous design of snow-
laden willow and flowering white plum. From a
jagged rock outcropping and a pair of vertical ced-

24

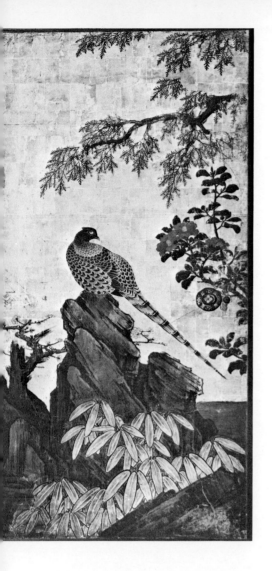

Rounding up horses

Hasegawa Tōhaku (1539–1610)
Around 1570
Pair of six-fold screens, color on paper
H. 5 ft. ⅝ in. (156.5 cm) x W. 11 ft. 2⅝ in. (342 cm) each
Toyko National Museum

This exaggerated, almost comic scene is the artist's interpretation of a hard day's work in the life of a samurai: in a rolling green field beside a winding stream thirteen warriors and ordinary foot soldiers (*ashigaru*) swoop down to capture wild horses. In the center of the right screen two galloping horsemen lasso one of the escaping horses, while a mare and colt in the lower right corner exchange alarmed glances and another horse to the left kicks back in anger at his pursuers.

The panorama continues on the left screen, where the seasonal imagery has advanced from the summer symbols of wisteria-covered pine and willow, seen on the right, to the red maple, chrysanthemums, and bush clover of autumn. Here, the focal point is the rearing stallion in the third panel from the right, heroically restrained by three muscled and grimacing henchmen. In the fourth panel their companion demonstrates his horsemanship by riding a bucking horse bareback. At the far right an already docile horse is washed down by two grooms stripped to their loincloths, while at the left the herd of tamed horses relaxes.

The Shinshun (or Nobuharu) seal, which was removed from these screens by a dealer, was used by Hasegawa Tōhaku at the beginning of his career while he still lived and worked northeast of Kyoto in Noto Province, where he was known as a figure painter. He studied painting in Echizen with the father of Soga Chokuan (Nos. 21, 22) and arrived in Kyoto sometime during the 1570s, but it was not until he was forty that he became known as a major artist in the capital.

In striking contrast to Tōhaku's later work, in the Chinese ink painting style, Rounding Up Horses has the bright colors, rolling hills, and lively narrative figure drawing that stem from the native painting tradition known as *yamato-e* which persisted as an undercurrent in Japanese art since its full devel-

ars in the corner, the trunks of two plum trees (see ill., p. 3), thrust in opposite directions. This compositional device, which makes the best use of the shape of the room, can be traced back to the brilliant early work of Kanō Eitoku.

Despite the hard realism of the tree and the jewellike colors of the plants, the result is more abstract and static than its immediate predecessor at Daikaku-ji (No. 9) or the paintings of Kanō Mitsunobu (No. 7) and the Tōhaku atelier (No. 15) a few decades earlier. In the present example, the rigorous control of design seems almost mechanical, as in the lines of the rock that parallel exactly the pheasant's tail and in the twisted trunk of the plum, which is contrived to display a strikingly eccentric silhouette against an uninterrupted void of gold. Yet it is through such artifice that a detail like the tiny bird posed self-confidently at the apex of the plum is able to command the entire wall.

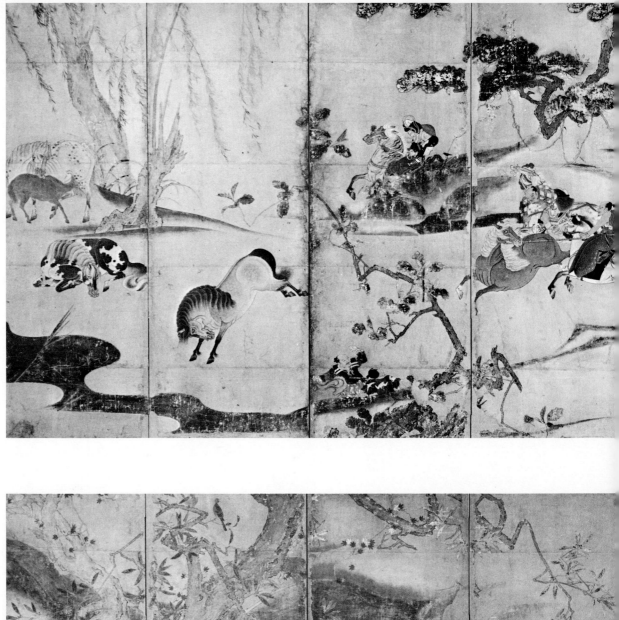

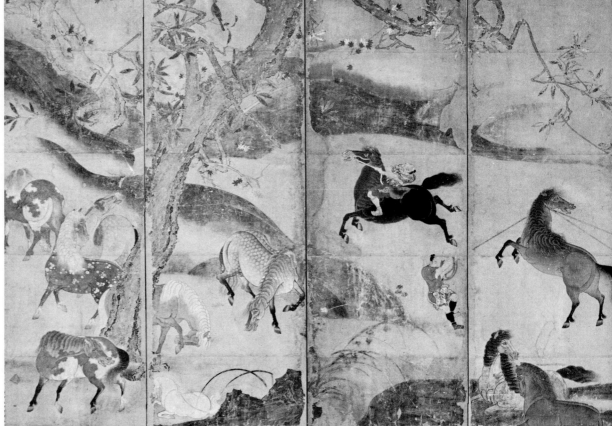

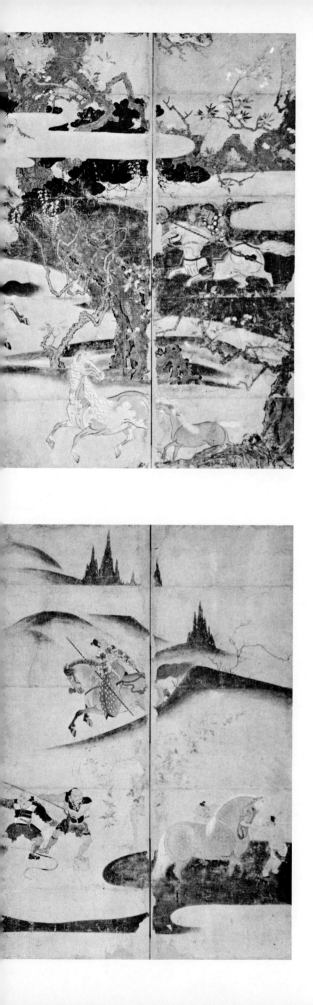

opment in the late Heian and Kamakura periods (twelfth and thirteenth centuries). On the basis of the seal and style the screens have been dated to the third quarter of the sixteenth century and are among the earliest examples of subjects that first became popular in the mid-sixteenth century, treating events in the lives of the increasingly important warrior class.

13

Bamboo and crane

Hasegawa Tōhaku (1539–1610)
Around 1590
Pair of six-fold screens, ink on paper
H. 5 ft. 1⁵⁄₁₆ in. (156.3 cm) x W. 11 ft. 10⅝ in.
 (362.2 cm) each
Private collection: Irie Yūichirō, Kyoto

Arriving in the capital in the 1570s, Tōhaku retained his independence of the prevailing Kanō school and probably saw himself in a position of rivalry with them. Perhaps to legitimize the status of his own school he apparently fabricated an artistic pedigree, claiming descent from the great fifteenth-century master of ink painting, Sesshū Tōyō (1420–1506) and even calling himself "the fifth-generation Sesshū" in his later years. His friendship with Sen no Rikyū, Hideyoshi's tea master, gave him access to the important collections of Chinese paintings of the Southern Sung and Yuan dynasties belonging to the Zen temple Daitoku-ji. His intimate association with this temple is marked by the door and wall paintings he provided for at least six of the subtemples within the Daitoku-ji compound during the last three decades of his life, between 1580 and 1610. Tōhaku was especially impressed by the work of the thirteenth-century Chinese Zen monk Mu Ch'i, and these Bamboo and Crane screens are directly modeled after Mu Ch'i's masterpiece, Kuan-yin, Monkeys, and Crane, a triptych that is still in the Daitoku-ji.

Mu Ch'i's crane emerging from a bamboo grove is a single hanging scroll on silk forming the left portion of the triptych. In the two center panels of the left screen Tōhaku repeats Mu Ch'i's composi-

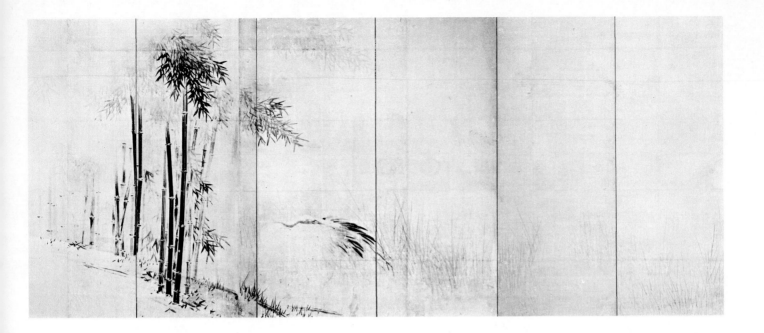

tion but introduces variations reflecting his own personal style. In the fashion of his time, for example, he selects the horizontal format rather than the vertical. Traces of door handles beginning around the middle of the right-hand screen indicate that the paintings were originally mounted as sliding doors, perhaps part of a much larger composition including monkeys or other animals and extending around the walls of a temple room.

The Chinese artist is concerned with the awesome inner spirit of the bird and gives it a warm character of its own. Tōhaku, painting quickly, simplified the shapes of his model, eliminating their delicate shading and delineation in favor of a staccato pattern of flickering dark and light accents. In order to create the illusion of mist, he blurs leaves and stems in a manner that suggests his renowned screen of pine trees in the Tokyo National Museum.

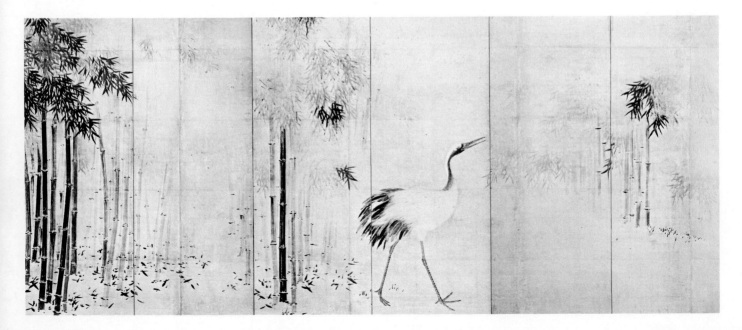

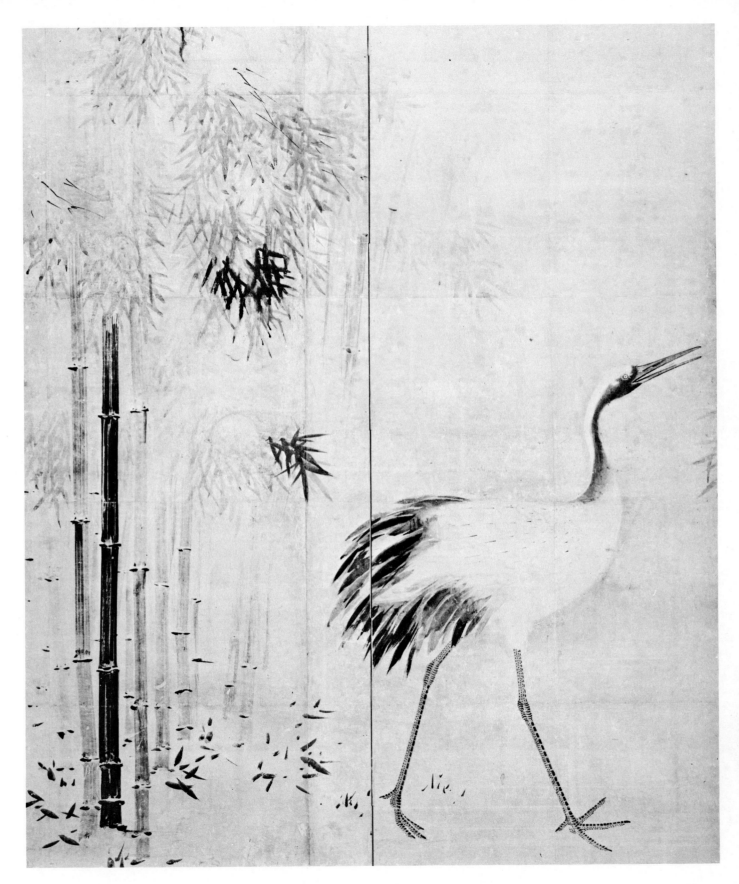

Landscape

14

Hasegawa Tōhaku (1539–1610)
Around 1599
Four sliding doors, ink and gold on paper
H. 6 ft. 5¾ in. (197.5 cm) x W. 2 ft. 10¹⁄₁₆ in.
 (86.5 cm) each
Rinka-in (Myōshin-ji), Kyoto
REGISTERED IMPORTANT CULTURAL PROPERTY

This painting is taken from the center of the north wall of a continuous ink landscape stretching across sixteen sliding door panels in the central room of the abbot's quarters of the Rinka-in at Myōshin-ji. The Rinka-in was founded in 1599 by the influential priest Nange Genkō (1538–1604), who seven years before had commissioned Tōhaku to decorate the interior of the Shōun-ji (see No. 15).

In this painting Tōhaku reinterprets one of the stock themes of late Muromachi (1392–1568) screen and door paintings, a theme that can be traced as far back as the work of the academy painters of the twelfth- and thirteenth-century Southern Sung court: a Chinese scholar sits in a thatched pavilion nestled beside an enormous boulder and jutting pine, contemplating the distant mountains across an open lake. The full eight panels of this wall include a distant temple on the left and a visitor approaching along a winding path on the right.

Tōhaku shows little concern for the equilibrium between man and nature that is present in Muromachi-period landscapes, and emphasizes instead his own virtuoso brush technique and skillful manipulation of continually shifting near and far views. Heavy and sharp-edged modeling strokes create crystalline and faceted boulders that are uniquely his own and easily distinguishable from those of the official Kanō school. While these vigorous brushstrokes bring the massive rocks and boulders of the foreground into outspoken prominence, the far distance is indistinct. The figure of the scholar seems to have lost any symbolic significance, and, like the sharply delineated boat on the opposite shore, he serves chiefly to indicate the relative scale of the landscape. Even his view of the lake is blocked by the tortured limbs of a barren tree projecting in front of his window.

The subtle gold wash in the background of the original was covered with a new layer during the course of restoration in the 1830s.

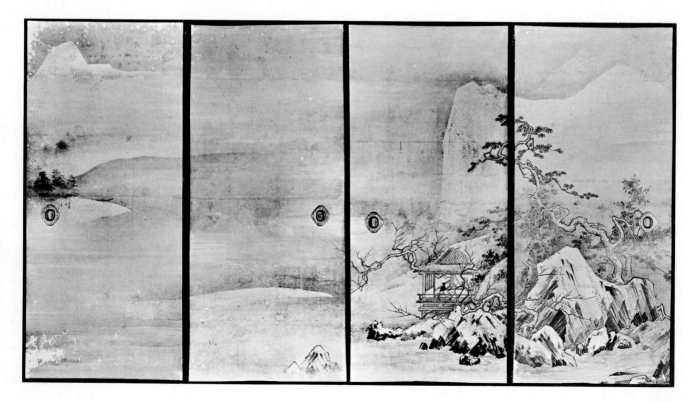

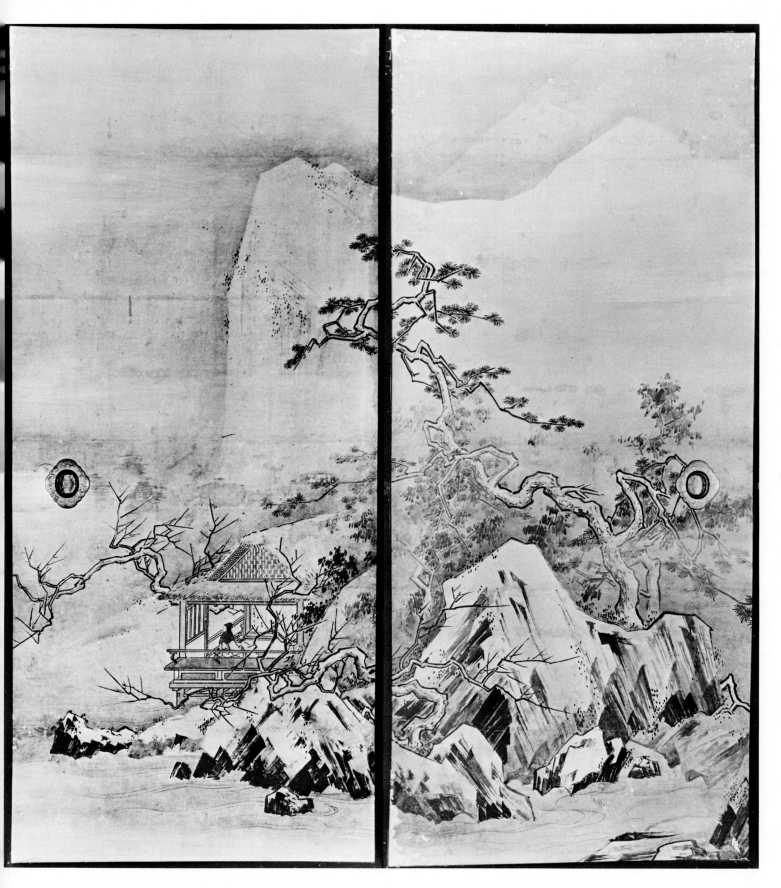

15

Pine and cherry trees / Pine and cherry trees

Hasegawa School
Around 1600
Four sliding doors, color and gold leaf on paper
H. 6 ft. 7/16 in. (184 cm) x W. 4 ft. 8⅛ in. (142.5 cm) each
Myōren-ji, Kyoto
REGISTERED IMPORTANT CULTURAL PROPERTY

Most of the works attributed to Hasegawa Tōhaku are ink paintings (Nos. 13, 14), but, like so many of his versatile contemporaries, he could also work in the popular color and gold technique. No records remain to document the artist or date of these paintings, but recently they have been accepted as the work of the Hasegawa atelier. Tōhaku was ambitious and eager to compete with the Kanō faction for large-scale commissions and enlisted the help of

his sons, particularly Kyūzō (1568–1593), in forming a school of his own.

Four rooms and a vestibule of the Myōren-ji audience hall were embellished with thirty-six sliding doors of pine, cypress, and blossoming cherries set beside a bright blue stream and nearly obscured by a heavy cloud of gold. On the front of these four doors a pine leans precipitously from the left and extends through every panel, its scalloped green

foliage echoing the surrounding clouds. Cropped at the top and bottom, the tree seems cramped and pushes out toward the viewer. These techniques of composition, which were perfected by the Kanō school in the 1590s, were almost always used for works with only a few trees against a luxurious backdrop of gold.

On the reverse a bulky pine pulls back to allow the more pliant cherry tree to lean forward. The composition is closely related to Sanraku's Maple (No. 9), painted several decades later, but shows a less disciplined control of pattern and greater interest in background detail.

The Myōren-ji paintings strive to match the extravagance of Tōhaku's magnificent Maple and Cherry Tree series of 1592, originally painted for Hideyoshi's Shōun-ji, and now housed in the Chishaku-in. Especially similar are the fat cherry blossoms built up in relief technique and scattered in rich abundance to soften the heavy trunks.

16

Landscape

Kaihō Yūshō (1533–1615)
1599
Two hanging scrolls, ink on paper
H. 6 ft. 6⅜ in. (199 cm) x W. 6 ft. 1⅝ in. (187 cm) each
Kennin-ji, Kyoto
REGISTERED IMPORTANT CULTURAL PROPERTY

In the 1590s the priest Ekei (d. 1600), influential abbot of Ankoku-ji, a temple in Aki (now Hiroshima Prefecture) of the Rinzai sect of Zen Buddhism, decided to move his residence to Kennin-ji, a major Zen temple in the capital. Kennin-ji had suffered heavy damage from fires and storms in the late sixteenth century, and Ekei, long supported by Hideyoshi, undertook the restoration of the abbot's quarters of the main building around 1599. The five sets of sliding doors executed for the new rooms are thought to have been painted by his close friend Kaihō Yūshō, an artist with a unique and personal ink style working independently of the Kanō school.

In 1934, when the temple was damaged in a typhoon, these paintings were remounted onto fifty hanging scrolls. This pair comes from a group of eight that once lined two walls of a room in the southwest corner of the building. The other six scrolls, depicting a narrow strip of land in front of vast, empty sea, continue the composition to the left.

In the midst of the sparkle and self-assertiveness of most good Momoyama screen paintings, this landscape comes as a surprise and a respite, reflecting the atmosphere of philosophical quietude that permeated the Muromachi-period landscape paintings. Although he was born into a warrior family, Yūshō was raised in a Zen monastery, the Tōfuku-ji, and is said to have appreciated and studied the styles of Sung and Yuan dynasty Chinese artists. Nevertheless, what we see here can hardly be considered a routine reinterpretation of an older style. The suggested trees and foliage seem reminiscent of

the splashed ink *(haboku)* technique of Muromachi painters, but the composition, as well as the choice and contrast of strokes, is entirely Yūshō's own.

Sharp, dark lines reveal a temple nestled in the mist-covered mountains. Delicate gray washes hint at distant hills, giving the scene scale, and darker gray swaths of ink float boulders and cliffs in mid-air in the foreground, adding a touch of suspense. In comparison to the landscapes of Kanō Sanraku (No. 8) and Unkoku Tōgan (No. 19) Yūshō's style seems spare and fundamental. Whether Yū-shō's landscape is a purification or a dilution, a spiritualization or an empty and unpeopled dream, this is an intriguing work that in a few quickly drawn strokes invites us to recall those moments between perception and memory, consciousness and dream, that are at the same time sharp and vague.

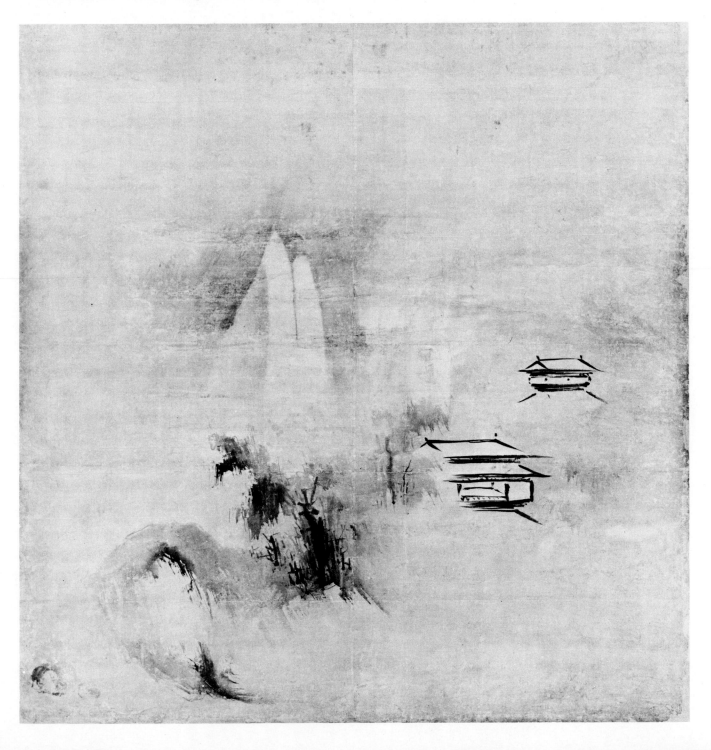

17

Plum and pine

Kaihō Yūshō (1533–1615)
Around 1599
Four sliding doors, ink on paper
H. 5 ft. 8⁵⁄₁₆ in. (173.5 cm) x W. 3 ft. 10¼ in.
 (117.5 cm) each
Zenkyō-an (Kennin-ji), Kyoto
REGISTERED IMPORTANT CULTURAL PROPERTY

Around the time that the abbot's quarters of Kennin-ji were restored (1599), the Zenkyō-an, a subtemple, was also renovated. Here, as in No. 16, the artist is thought to be Kaihō Yūshō. For the Zenkyō-an, he painted a composition of bamboo, plum, and pine in twelve panels that covered three sides of a room: beginning from the far right, a single panel with bamboo, then six panels with an aged plum branching to the right and left, and finally, a magnificent old pine extending across five panels. Sometime later the last four panels with the pine were remounted on the reverse of the preceding four—the final three panels of the plum and the short introductory sprig of the first pine panel.

With characteristic wit, Yūshō creates a dialogue between the two ancient trees: while only the upper part of the pine is shown and its branches spread downward, the lower portion of the plum is dominant and its branches reach upward in response.

Branch tips of both pine and plum stretch into otherwise empty panels as if straining to make contact. Each tree has near its center an intentionally eye-catching feature: in the pine it is the pair of mynah birds, and in the plum, the two swordlike branches that spring from the base of the trunk.

Yūshō is a master of contrast and abbreviation. His orchestration of straight lines and curves, pale washes and intense dark strokes, full evocative forms and tense contractions is closely controlled, but the individual strokes are brilliant and unselfconscious. Although aged and bent, the pine bristles with explosions of needles. The plum's two sharp branches frequently lead commentators to recall Yūshō's military heritage and reputed love of swordsmanship.

Like most of Yūshō's subjects, the choice of bamboo, plum, and pine derives from a theme common in Chinese painting. The literati of the Yuan dynasty found particularly satisfying the combination of the suppleness of the bamboo, the yearly regeneration of the plum, and the age of the pine, each with its own symbolic connotations. Yūshō's work differs widely in intent and scale from its Chinese prototypes, but retains their spontaneous, calligraphic brushwork in lieu of a detailed representation.

As with all fine paintings of the period, gold wash is not permitted to draw attention from the main elements but remains harmoniously subordinate.

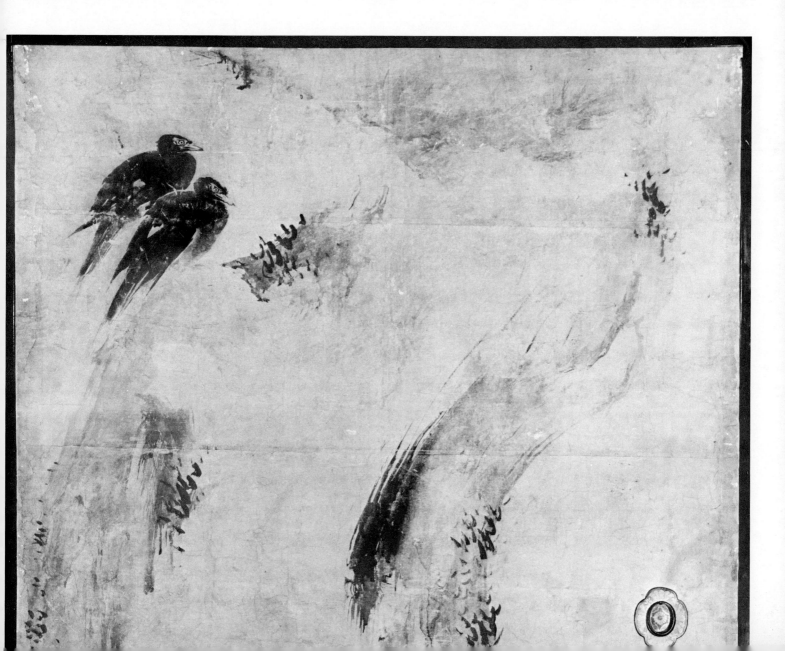

18

The four accomplishments

Kaihō Yūshō (1533–1615)
Late sixteenth century
Pair of six-fold screens, ink and light color on paper
H. 5 ft. 1 7/16 in. (156 cm) x W. 11 ft. 8 13/16 in.
 (357.6 cm) each
Reitō-in (Kennin-ji), Kyoto
REGISTERED IMPORTANT CULTURAL PROPERTY

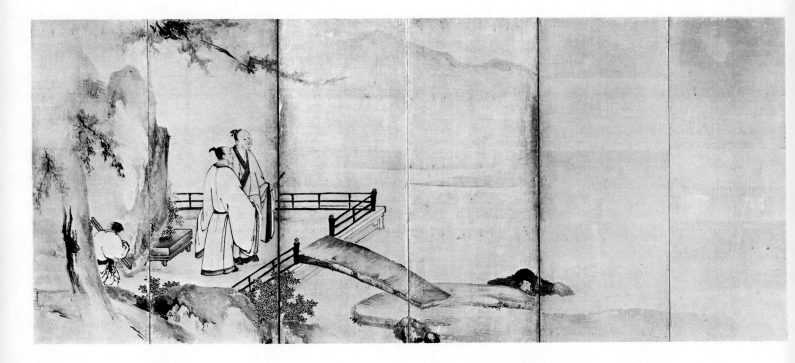

The four accomplishments, the prerequisite abilities and greatest pleasures of a Chinese scholar, are calligraphy, painting, music, and *go,* a game resembling chess. Enamored of things Chinese and scholarly and attracted to the suggestion of retreat from the world, the Zen priests of the early Muromachi period made the four accomplishments one of the standard themes of large-scale Japanese ink painting. The Muromachi artists usually placed four small groups of scholars, each enjoying one of these pastimes, in an extensive landscape setting, but in the Momoyama period the figures were enlarged and the landscape de-emphasized.

Like several other paintings of the four accomplishments by Yūshō this example is a casual varia-

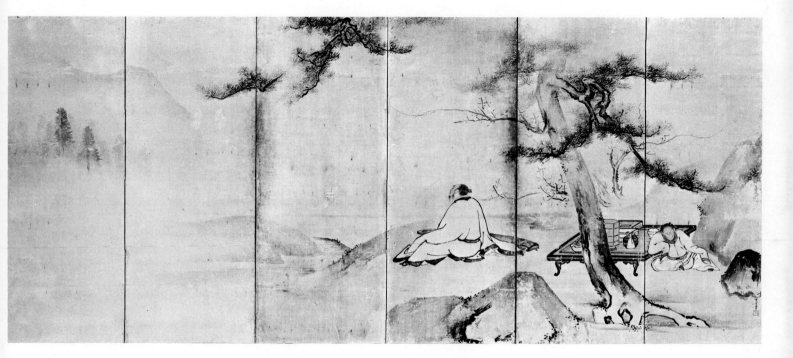

tion on the venerable theme. Instead of pleasurably exercising their skills, the scholars turn from them as if disinterested, preferring lofty conversations and idle dreams. Even the symbols of the accomplishments—the painting scrolls borne by the attendant and the *go* board in the left screen and the zither *(ch'in)* and books in the right screen—are partially obscured. Deviating from the standard treatment, Yūshō alludes to another theme: the countless Chinese paintings of scholar-gentlemen gazing into the distance beneath a bent pine or communing with nature from balustraded platforms (see No. 14). Conspicuous roles are played by the bearer of scrolls in the left screen, who supplies the only movement in the painting, and by the sleeping attendant in the right screen, who provides a humorous comment on the enjoyment of nature and the arts.

Although Yūshō received early training in the Kanō school (it is uncertain whether his teacher was Kanō Motonobu or Motonobu's grandson, Eitoku), the soft and light style of this work indicates how far he deviated from the orthodox Kanō tradition. Technically, this is most obvious in the manner he delineated the rocks, composing them with pale washes as gentle rounded shapes rather than with strong, dark outlines and texture strokes to define angular surfaces.

Both screens bear the artist's signature and seal.

19

Seven sages in the bamboo grove/Landscape

Unkoku Tōgan (1547–1618)
Around 1588
Four sliding doors, ink on paper
H. 5 ft. 10⅞ in. (180 cm) x W. 4 ft. 7¹¹⁄₁₆ in.
 (141.5 cm) each
Ōbai-in (Daitoku-ji), Kyoto
REGISTERED IMPORTANT CULTURAL PROPERTY

During the early years of the Wei-Chin period in China (220–420 A.D.) floods and droughts, continual warfare, and political intrigue drove men of honesty and learning to seek spiritual refuge, most commonly in the revival of Taoism. To avoid talk of the ugly realities, these scholars engaged in "pure conversation" that stimulated imagination and wit. The most well known of these "pure conversation"

groups consisted of seven men who met regularly in the seclusion of the bamboo groves north of Lo-yang, where they ignored tradition and pursued their personal philosophies. Since early in the Muromachi period these seven sages were one of the popular themes for Japanese painters working in the monochrome ink style.

This example consists of four from a set of sixteen panels forming the west wall in the central room of the guest hall (Kyakuden) of the Ōbai-in. As is appropriate for a subject that emphasizes transcendental values, the elements of composition are few: the sages, their attendants, some rocks, and a hint of bamboo and pine. The effect is reminiscent of the ink paintings of Tōgan's close contemporary Kaihō Yūshō (No. 18). Like Yūshō, Tōgan effectively sets strong, clearly defined strokes against pale gray lines and washes. The pair of sages who appear to discuss the poem being written by their eccentric friend on the left are selectively highlighted with quick, dark strokes that bring the

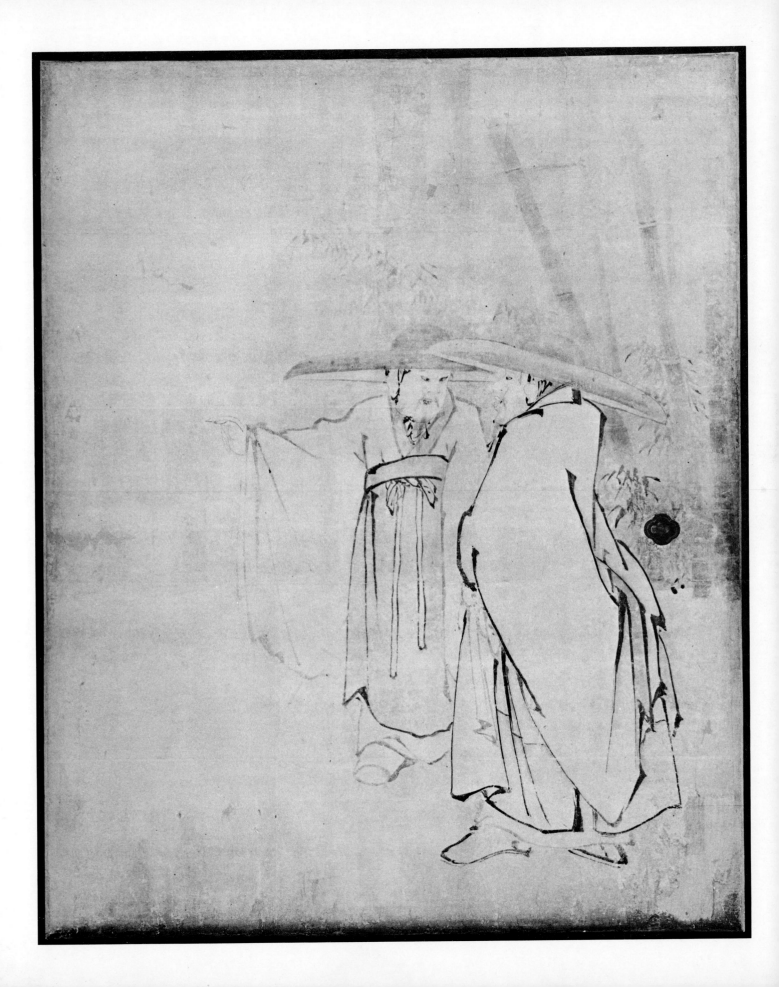

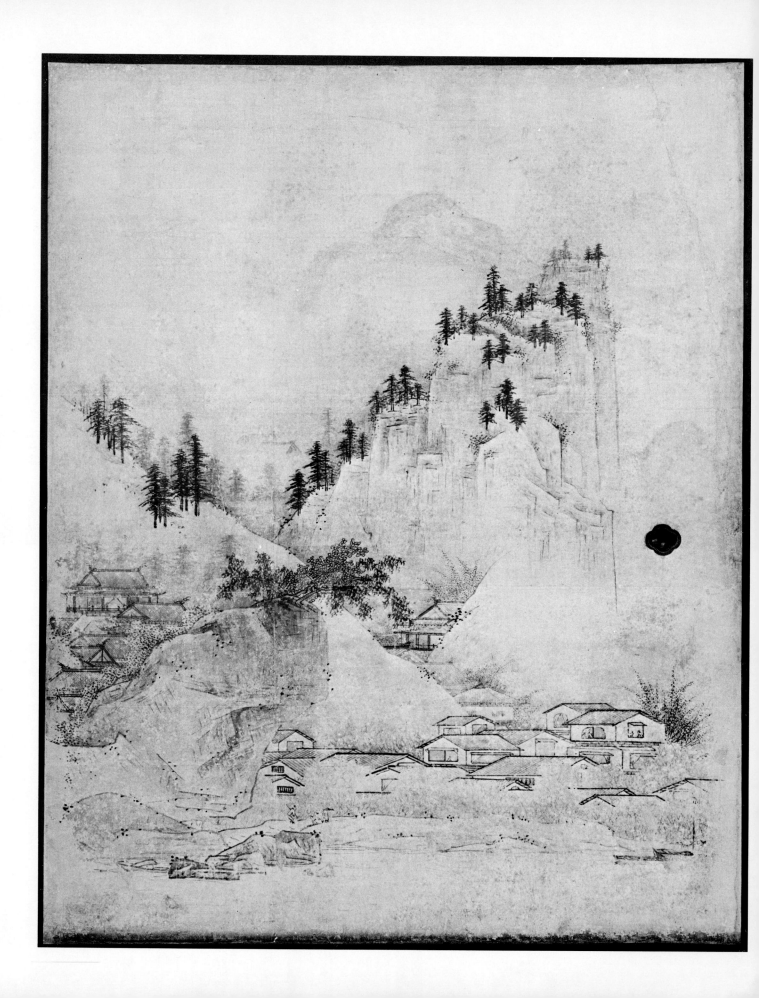

right-hand figure closer, intensify the eyes, mouth, and ears, and delicately reinforce the pointing hand.

The superb ink landscape on the reverse justifies Tōgan's claim to be the third-generation Sesshū. Here his earnest reinterpretation of the fifteenth-century master's sober and deliberate style places him in the more conservative wings of the Momoyama art world, but he was widely admired both in the capital, where he attained the title *Hokkyō* in 1611, and by his daimyo patrons in the western provinces. The Ōbai-in, for example, was built in 1588 by Kobayakawa Takakage (1532–1596) of

Chikuzen, who is said to have "discovered" Tōgan some years earlier.

The composition is painstakingly structured and unified by the rhythmical development from right to left. Out of the sea, in which two boats head for home, a spit of land leads the eye to a cluster of boats moored in the harbor of a quiet fishing village. There the diagonals cross to form the crescendo—a mountain range that then fades to the left in a masterful example of the artist's ability to play on the opposite extremes of mass and emptiness.

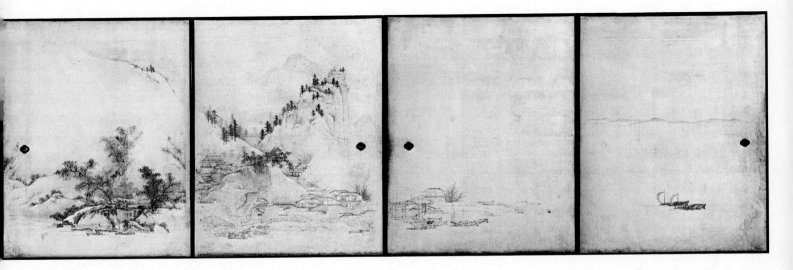

20

Horses in a landscape

Unkoku Tōgan (1547–1618)
Around 1600
Pair of six-fold screens, ink on paper
H. 4 ft. 10 ¹¹⁄₁₆ in. (149 cm) x W. 11 ft. 9 ¹⁵⁄₁₆ in.
 (360.5 cm) each
Kyoto National Museum

A herd of mysteriously pale, almost ethereal wild horses frolics across a mountain meadow. The delicacy of the outlines is unusual among the rough and simplified brushwork of much Momoyama screen painting. The landscape elements are quite characteristic of Tōgan's familiar style, especially

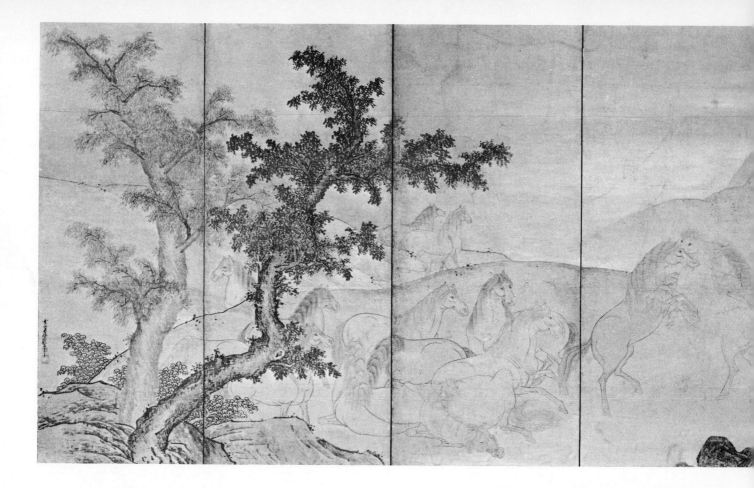

his pairing of light and dark trees and the closely overlapping squared-off ridges that ascend the facades of his mountains (compare No. 19).

The screens must have appealed to the powerful daimyo who commissioned them for the inner chambers of his castle, but Tōgan seems to have been slightly uncomfortable with his subject. The mountain peak in the left screen, though grand, floats unattached to the landscape—an afterthought to fill an awkward gap. The horses seem posed to record every possible attitude and angle from which they might be viewed, from the bony sleeping nag in the left foreground and the handsome "dancers" rearing back on their hind legs to the graceful galloping pair on the right.

The short-legged *yamato-uma,* or "Japanese horse," was smaller and stockier than European breeds and was often criticized by foreign visitors for its stature. A Spanish trader arriving in 1594 insisted that "according to our standards their horses are not at all good and the very best one in all Japan is only fit to carry firewood" (Bernardino

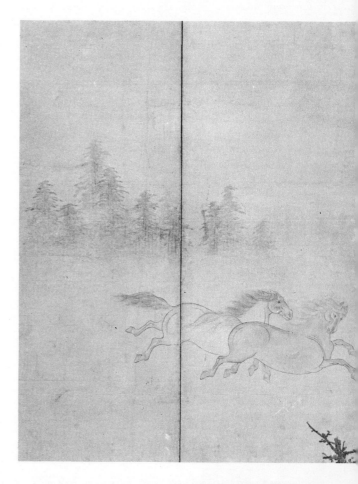

44

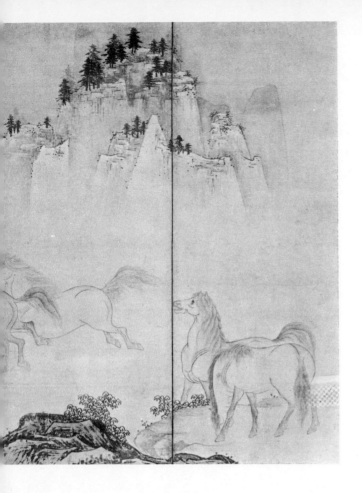

de Avila Girón, "Weapons," in Cooper, *They Came to Japan,* pp. 141–142). On the other hand, an Englishman concluded that "their horses are not tall, but of the size of our midling Nags, short and well trust, small headed and very full of mettle, in my opinion, farre excelling the Spanish Jennet in pride and stomacke" (John Saris, "The Garrison at Fushimi," in Cooper, *They Came to Japan,* pp. 142–144).

Each screen is signed "Tōgan, successor to Sesshū." It was a lineage claimed with equal self-righteousness by his rival Hasegawa Tōhaku (Nos. 12–14), but Tōgan finally won the legal right to the title. In addition each painting bears two seals, one reading "Tōgan" and the other "Unkoku," a further reference to Sesshū, whose studio was called the Unkoku-an. Tōgan adopted the name Unkoku and the character Tō of Sesshū Tōyō after 1593, when his patron Mōri Terumoto (1553–1625) of Aki Castle requested that he copy out one of the Mōri family treasures, the fifteenth-century artist's famous Long Handscroll of 1486.

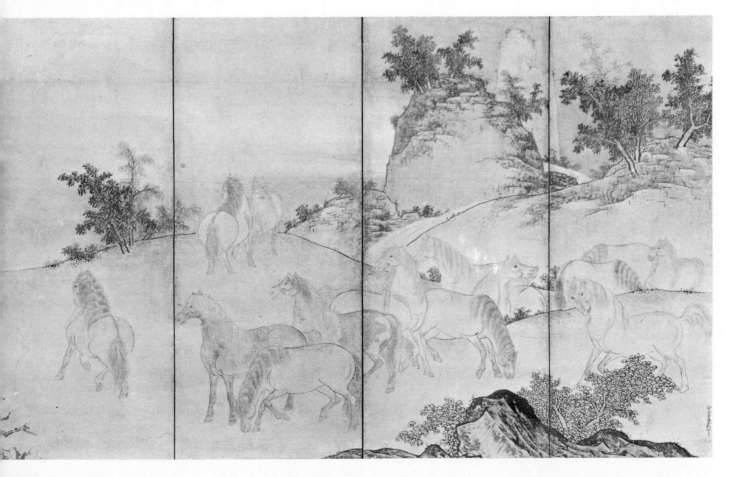

21

Birds and flowers of the four seasons

Soga Chokuan (active around 1570–1610)
Late sixteenth century
Pair of eight-fold screens, ink and color on paper
H. 5 ft. $^{11}/_{16}$ in. (154.2 cm) x W. 11 ft. 10$^{15}/_{16}$ in.
 (363 cm) each
Tokyo National Museum

Scarcely visible behind the gnarled branches of a winter plum, a waterfall cascades through a mountain ravine into a stream that rushes past a barrier of jutting rocks, winds its way around a small peninsula, and flows serenely into the distance on the far right. Dotted with the birds and flowers of the four seasons, these screens, which were once in the Imperial Collection, stand apart from the idyllic golden world of Kanō Mitsunobu's work on the same theme (No. 7) or the dramatic and simplified dignity of Eitoku's Crane and Pine (No. 4). Each bears a square seal reading "Taira Chokuan," an independent artist about whom very little is known. He is said to have worked in Echizen Province (modern Fukui) for the Asakura daimyo family, but sometime after the downfall of their house in 1573 he moved to the thriving port city of Sakai, just south of present-day Osaka, where he founded a school specializing in bird and flower painting.

In a style surprisingly conservative by Momoyama standards, he has painstakingly detailed each plant and bird, contrasting their bright feathers and precise contours with somber ink tones in the landscape. The colorful birds distributed evenly across the surface and the basic organization of the composition—neatly framed at either end by one large tree—are similar to a series of screens dating from the late fifteenth and early sixteenth centuries. The late Muromachi artists, notably Sesshū, were in turn indebted to their Chinese contemporary Lü Chi, a bird and flower painter active at the Ming court around 1500, whose work must have struck the Japanese as refreshingly novel, colorful, and down-to-earth.

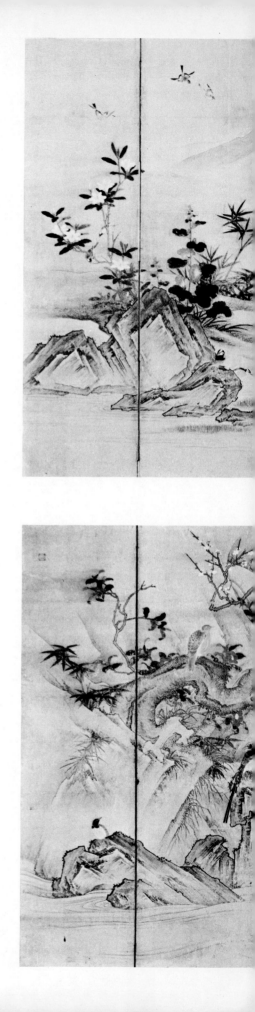

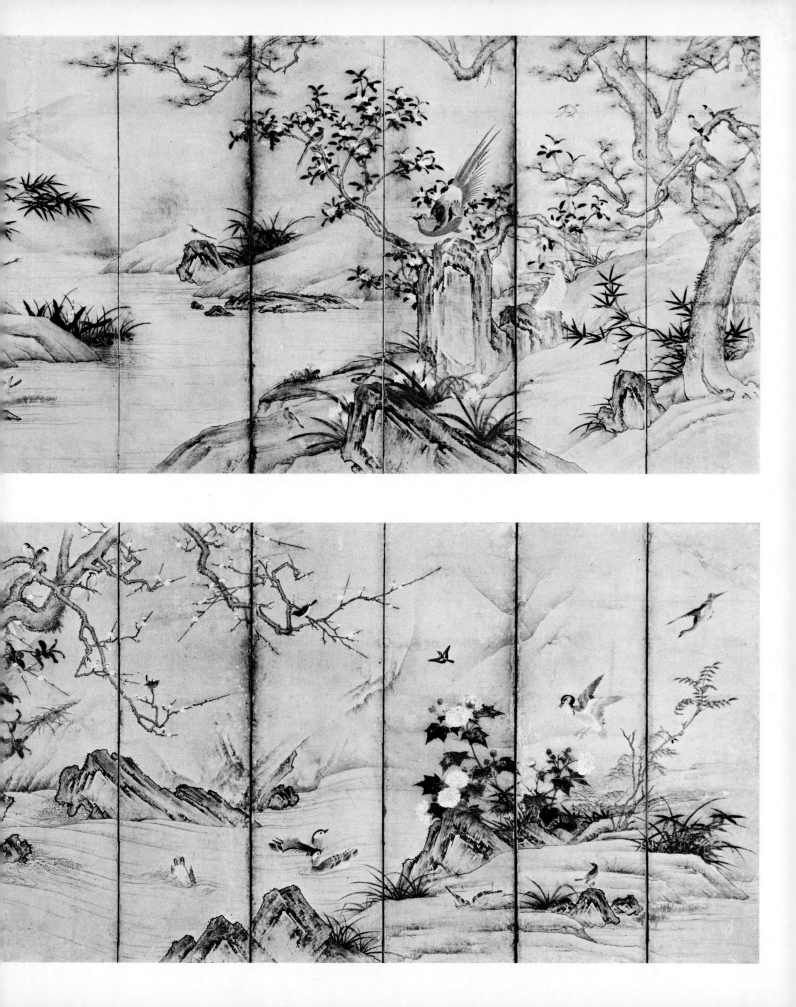

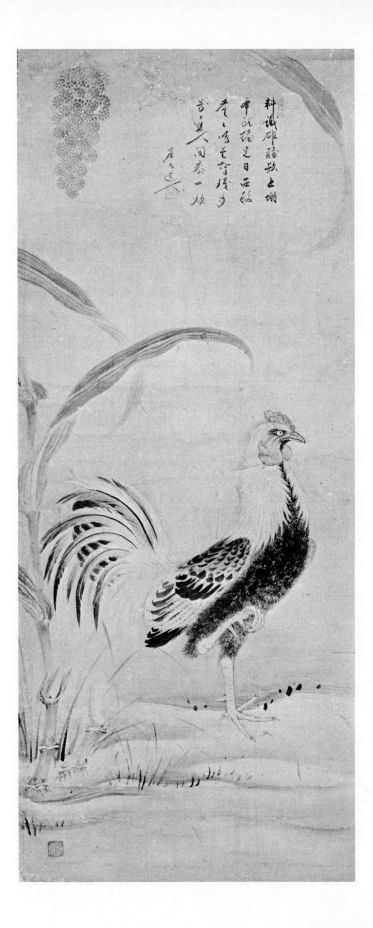

Chickens

Soga Chokuan (active around 1570–1610)
Late sixteenth century
Pair of hanging scrolls, ink on paper
H. 4 ft. 4¼ in. (132.7 cm) x W. 2 ft. 8¹³⁄₁₆ in. (83.3 cm) each
Rinka-in (Myōshin-ji), Kyoto
REGISTERED IMPORTANT ART OBJECT

The artist, whose square seal reading "Taira Cho-kuan" appears on each of these scrolls, is best known for his paintings of hawks. He seems to have enjoyed depicting all birds, however, including such familiar barnyard fowl as the rooster and hen. This diptych is a family portrait, with a suitably arrogant rooster gazing stiffly over the head of his plump hen, who squats protectively over her chicks. Her fierce glare alerts us to an undercurrent of unpleasant tension and possible violence. Two chicks huddle under the ruffled feathers of her breast, but a third turns to inspect the peculiar pastime of his siblings, who amuse themselves by tearing the wings off a butterfly.

The rooster and hen are framed by the sinuous curves of the leaf of a millet stalk and the vine of a grape arbor. Chokuan shows masterful control of ink tones: smooth translucent grapes and fluffy plumage—all are painted with care. The short poems above each bird are also balanced in the careful framework. They were written in Chinese by a Zen priest, Nange Genkō (Kyohaku Dōjin), whom we know as the patron of Tōhaku (No. 14) and the founder of the Rinka-in, where the paintings are still preserved:

> Above hang the crystalline grapes
> Below squats the mother hen, immobile
> Protecting her little brood of five:
> Deeper than a crane's cry is the maternal instinct.
>
> On the way to his coop, a cock looks up expectantly
> And raises his leg toward the westward-moving sun:
> Don't erase my leftover dreams with incessant
> crowing
> For all I have are dull chores and another meal to
> be eaten.

23

Hawks

Attributed to Soga Nichokuan (active first half
 of the seventeenth century)
Early seventeenth century
Pair of six-fold screens, ink on paper
H. 4 ft. 9 11/16 in. (146.5 cm) x W. 9 ft. 8¾ in. (322 cm) each
Tokyo University of Fine Arts

The curious shapes of this landscape have an eerie
and threatening quality not present in Chokuan's
Birds and Flowers of the Four Seasons (No. 21).
The paintings are attributed to Soga Chokuan's
son, Soga Nichokuan (or Chokuan II), who was
active until at least the middle of the seventeenth
century, specializing in paintings of falcons and
hawks.

While a stream surges toward us once again
from the foot of a waterfall, a pine laced with
branches of plum frames the predator and prey at
the center of the right screen. A hawk is poised ag-
gressively with beak open, feet firmly apart, and
wings raised high. The mosaic patterning of his
feathers, the frame of open space to either side, the
rock pedestal, and the canopy of dark pine needles
set him off as the mighty conqueror. The deformed
pine is covered with puffy growths and its needles
seem to wriggle like spider's legs. Trapped in a
cul-de-sac, the fish below sense the hawk looming
above them; the largest twists back as if to protect
the others or make a dash upstream, but the out-
come seems inevitable. To the left a wave breaking
against a peculiar rubbery rock hovers like an open
jaw.

The tense scenario continues onto the left screen.
Here a still autumn afternoon is interrupted by the
sudden cries of a white heron, which is driven
toward his frantic mate by a plummeting black
hawk.

In these screens the militant personalities of the
hawks and the ominous forms of the landscape
clearly take precedence over seasonal imagery.

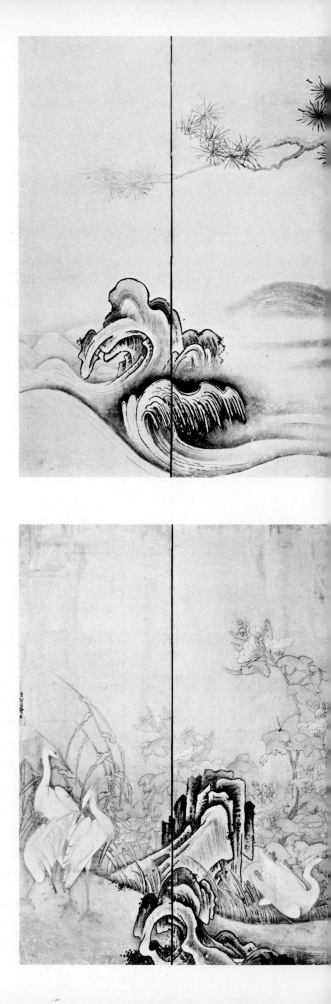

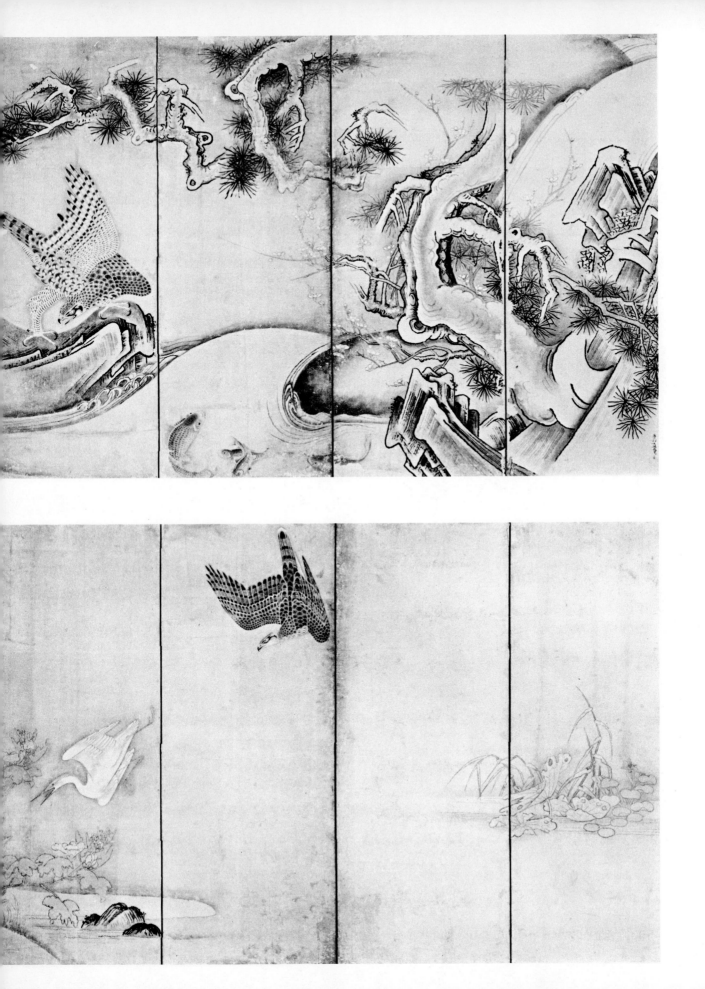

51

24

Scenes from the *Tale of Genji*

Tosa Mitsuyoshi (1539–1613)
Late sixteenth century
Six-fold screen, color and gold leaf on paper
H. 4 ft. 10⅝ in. (149 cm) x W. 11 ft. 9⁹⁄₁₆ in. (359.5 cm)
Private collection: Honde Seiichi, Kyoto

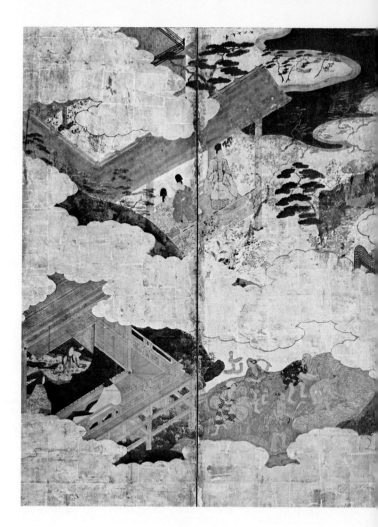

The *Tale of Genji,* one of the world's great books, is a novel of the loves and life of a courtier of the eleventh century, Prince Genji, and the fate of his descendants. Scenes from the novel are recurring and popular themes in Japanese art; here, a random selection of five has been placed in a composition tightly unified by the parallel diagonals of the architecture. Long narrow bands of gold clouds subdivide the screen into an upper and lower register, making it easier to distinguish between the individual episodes.

Chronologically, the first scene is that in the lower left corner showing Genji's future wife, the young Murasaki *(Waka Murasaki),* in a mountain temple on the northern outskirts of town. Genji, suffering from a vague illness, comes here to seek the remedies of a renowned holy man and discovers her living with short-cropped hair in this simple hermitage with her nurse and some nuns. Though he sees her only from a distance, the young prince determines that this "enchanting creature" shall be his. In the novel there is only a casual mention of the "poor villagers of the neighborhood," but perhaps as a concession to the contemporary delight in genre, Mitsuyoshi gives a prominent role to the five peasants hard at work harvesting rice.

At the top center is a scene from the chapter called "The Sacred Tree" *(Sakaki).* In a carriage accompanied by a handful of attendants Genji has made his way through the autumn fields to a country shrine (Nonomiya) in the Saga district of Kyoto in order to visit a former mistress, Lady Rokujō. Having neglected her for some time, he has come to bid her a last sad farewell before she sets out on a long journey to Ise. As mentioned in the text, the buildings of the shrine are surrounded by a flimsy brushwood fence, with a solemn *torii* gateway nearby. Genji sends in a long message disparaging his earlier frivolous way of life and after consider-

able hesitation Lady Rokujō agrees to see him: "An evening moon had risen and as she saw him moving in its gentle light she knew that all this while she had not been wrong; he was indeed more lovely, more enticing than anyone in the world beside." (Murasaki Shikibu, *The Tale of Genji,* trans. Arthur Waley, Houghton Mifflin ed., 1 vol., n.d., p. 193).

At the upper left is the scene of Genji's exile at Suma. His scandalous romances have put him in bad standing at court and he decides to withdraw voluntarily from the capital, lest worse harm should befall him. He chooses to reside on the coast of Suma, a spot deserted except for a few fishermen's huts. Though only a few days' journey from Kyoto, it must have seemed like the end of the world to one whose entire life revolved around the palace. Accompanied by two attendants, the handsome prince stands at the edge of a rustic thatched veran-

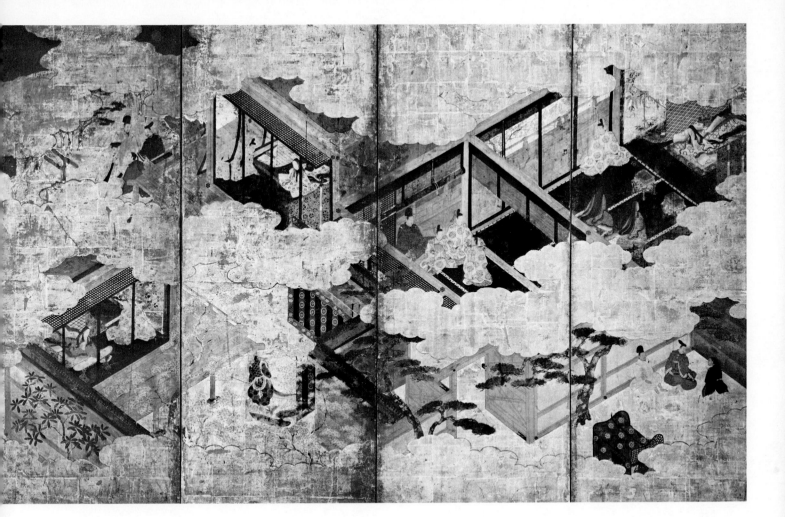

dah and gazes toward the distant sea across an autumnal garden of red maple, bush clover, and pampas grasses. The artist apparently illustrates the following passage:

> The flowers which had been planted in front of the cottage were blooming with a wild profusion of colour. One particularly calm and delightful evening Genji came out on to the verandah which looked towards the bay. He was dressed in a soft coat of fine white silk with breeches of aster-colour. . . . He began in a low voice to read the Scriptures. The sunset, the light from the sea, the towering hills cast so strange a radiance upon him as he stood reading from the book, that to those who watched he seemed like some visitant from another world. Out beyond the bay a line of boats was passing, the fishermen singing as they rowed. So far off were these boats that they looked like a convoy of small birds afloat upon the high seas.

With the sound of oars was subtly blended the crying of wild-geese, each wanderer's lament swiftly matched by the voice of his close-following mate. How different his lot to theirs. And Genji raised his sleeve to brush away the tears that had begun to flow (Waley, *The Tale of Genji*, p. 247).

In marked contrast to the rustic structures at the far left is the spacious interior of the imperial palace at the far right. Here, noblemen and ladies have gathered in anticipation of a Picture Competition (*E-Awase*). Two princesses vye for the child emperor's approval of the paintings they have collected. Genji steps in to take charge of the contest, which is attended by the emperor's mother (and Genji's former lover) the Lady Fujitsubo, who may be the woman seated on the raised dais at the front of the room in Mitsuyoshi's screen.

When the great day came, though there had not been much time for preparation, everything was arranged in the most striking and effective manner. The ladies-in-waiting belonging to the two sides stood drawn up in line on either side of the Imperial Throne; the courtiers, very much on the alert, were ranged up in the verandah of the small back room. Lady Chujo's party (the left) exhibited their pictures in boxes of purple sandalwood mounted on sapanwood stands, over which was thrown a cover of Chinese brocade worked on a mauve ground. . . . Akikonomu's boxes were of aloeswood arranged on a low table of similar wood, but lighter in color. The carpet was of Korean brocade on a blue-green ground. The festoons hanging round the table and the design of the table-legs were carefully thought out and in the best of taste (Waley, *The Tale of Genji,* p. 339).

Victory was assured for Akikonomu's side when they presented as their last entry the sketches Genji had made while in exile at Suma. There were many who could scarcely refrain from tears when they saw the stern and cheerless existence he had been forced to endure during those years.

The scene at the lower center is taken from "The Law" *(Minori).* Genji's wife, the ailing Murasaki, orders a thousand copies of the Lotus Sutra to be made and arranges that the dedication and the accompanying dance and music take place at their palace. As the mist begins to clear at dawn and the colors of the spring flowers come to light, a single dancer performs the rapid steps of the Ranryō-ō dance to the shrill music of flutes.

The artist, Tosa Mitsuyoshi (or Kyūyoku), came from a family that had traditionally worked exclusively for the court and the Kyoto aristocracy, specializing in classical themes presented most often in the intimate album format. Even on a screen he remains a storyteller, focusing on the details of costume and setting. In the narrative style dating back at least to the twelfth century, he omits the roofs, allowing the eye to move freely from the garden, past bamboo blinds and rain shutters into the inner chambers.

Meeting at the frontier: A scene from the *Tale of Genji*

Tawaraya Sōtatsu (active first third of the
 seventeenth century)
1620s
Six-fold screen, color and gold leaf on paper
H. 3 ft. 1⅜ in. (95 cm) x W. 8 ft. 11½ in. (273 cm)
Private collection: Hinohara Sen, Tokyo
REGISTERED IMPORTANT ART OBJECT

A group of attendants in informal court robes and tall black hats are clustered around an unhitched carriage where they gossip, nap, and wait for an order to take to the road again. Isolated on a panel to the left, a bearded gentleman kneels respectfully to deliver a message to the young page boy walking toward him. One attendant points toward the carriage as if to indicate the person for whom the message is intended, though the occupant remains

discreetly shielded from public view behind bamboo blinds. Although three small rocks are the only hint of a landscape setting on this expanse of gold leaf, the figures seem firmly planted on the ground.

This screen is among the few paintings widely accepted as the work of the enigmatic Tawaraya Sōtatsu. Very little is known about his life, although in 1620 he was granted the honorific Buddhist title of *Hokkyō* reserved for particularly talented painters. Like Hon'ami Kōetsu (Nos. 33–35, 65), Sōtatsu worked for the cultured elite of Kyoto. The Kanō school's bold forms and vigorous, Chinese-inspired brushwork may have appealed to the new military leaders, but Kyoto's courtiers and wealthy merchants preferred native Japanese styles and themes. No subject could have suited these patrons better than the *Tale of Genji* (see No. 24).

Sōtatsu has taken as his theme the chapter "Meeting at the Frontier" *(Sekiya)*, in which Utsusemi, one of Genji's former mistresses, is returning to the capital with her husband after several years in the provinces. Near the Osaka barrier they inadvertently encounter Genji, who is setting out on a pilgrimage with a large crowd of retainers. Pulling off

the road, the members of Utsusemi's party draw their carriages into the shade, unhitch the oxen, and wait for Genji's magnificent procession to pass. The sight of her brother recalls Utsusemi to Genji's mind, and he sends her a tender message.

Sōtatsu has presented the episode in a dramatically abbreviated form, but his patrons would have appreciated the romantic overtones of the moment depicted here, when the invisible Utsusemi waits anxiously for a message from her former lover. The carefully structured composition reinforces the emotional implications of the scene. The pattern of black hats and the circle of attendants form a protective shield around the carriage, while the messenger at the far left is set apart as if an intruder.

The courtier and noted calligrapher Karasumaru Mitsuhiro (1579–1638) (No. 37), a friend and patron of Sōtatsu, collaborated by writing a passage from this chapter across the left half of the screen. The inscription forms an integral part of the painting, dancing lightly above the heads of the figures and then cascading in a rough curve through the empty left-hand panel toward Sōtatsu's signature and "Taisei-ken" seal near the bottom corner.

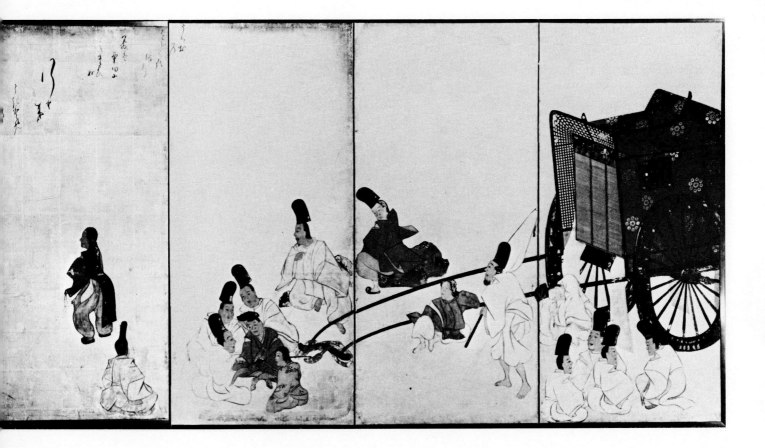

26

Moon and autumn grasses

Attributed to Tawaraya Sōtatsu (active first third
 of the seventeenth century)
Early seventeenth century
Pair of six-fold screens, color and gold leaf on paper
H. 5 ft. 7/16 in. (153.5 cm) x W. 12 ft. 3 in. (373 cm) each
Private collection: Yamaoka Seibei, Tokyo

A silver half-moon hangs low in an autumn evening
sky and illuminates a gold-leaf field of wheat-
colored pampas grass, delicate white bush clover,
and blue and white bell flowers. In Japan this is a
classical theme with poetic allusions that evokes a
sense of melancholy and a poignant regret for the
passing of time. The fragility of the small and finely
painted flowers is emphasized by their isolation
against the abstract gold ground and by the vivid,
lively tones of shell white and bright green with a
scattering of azurite.

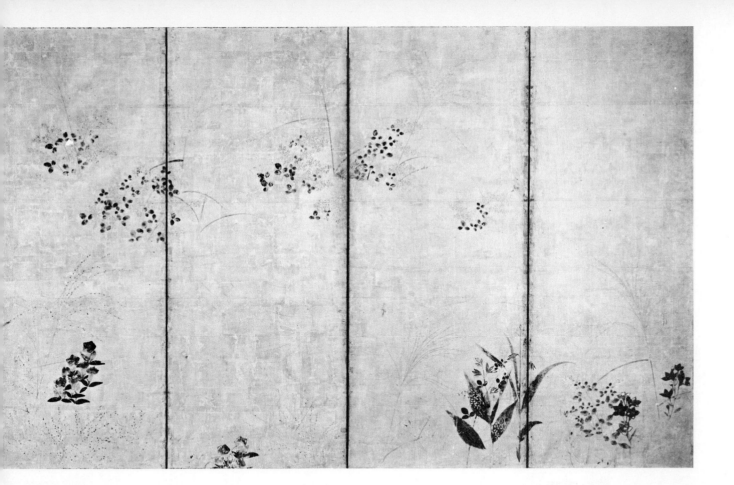

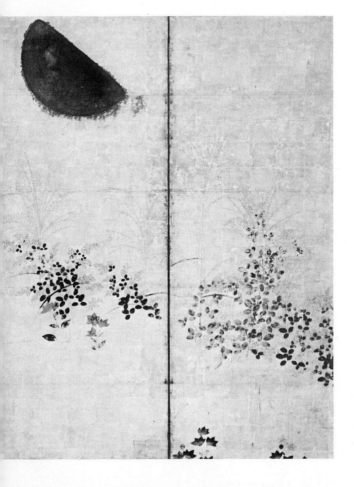

Although unsigned, each screen has a circular red seal reading "Inen." Seals and signatures are normally placed at the outer edge of screens, but if we were to arrange this pair according to the position of the seals, putting the moon on the right side, the left half would seem a random scattering of plants with little role in the composition as a whole, and both halves would seem cut off at their outside edges. For this reason, it has been suggested that they were meant to stand on opposite sides of a small room. One may also speculate, however, that the Inen seal, which appears with suspicious frequency on paintings attributed to both Sōtatsu and some of his followers, was added later at the wrong ends of the screens. If they are arranged with the moon at the center, the clusters of plants and grasses seem to dance lightly across the surface in a deliberate pattern. A feathery tassel at the far right signals the movement toward the left, and a row of white clover raised to the upper half of the screen draws the eye to a dense line of color charging upward to the climactic orb of the tarnished moon. There is a pause, a single panel without flowers,

and then the pattern descends again toward the lower left corner.

Although restrained and understated, it is a painting that may well have come from the hand of a great master like Sōtatsu. He decorated many of the calligraphy scrolls of his friend Hon'ami Kōetsu (1558–1637) with gold and silver underpaintings of flowering plants (see No. 34), and he may well have experimented with this same subject on a larger scale.

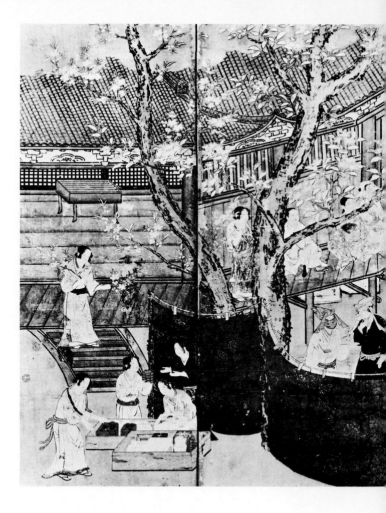

27

Merrymaking under the cherry blossoms

Kanō Naganobu (1577–1654)
Early seventeenth century
One of a pair of six-fold screens, color, ink, and gold on paper
H. 4 ft. 10¹¹⁄₁₆ in. (149 cm) x W. 11 ft. 5 in. (348 cm)
Tokyo National Museum
REGISTERED NATIONAL TREASURE

Swaying to the beat of a hand drum, their head-ribbons streaming and their feet thumping, a circle of young boys dance in the shade of a flowering cherry tree on a picnic outing. The most outstanding genre painting to emerge from the Kanō tradition, this screen represents better than any other the exuberance of the age and the pleasures of its ruling class. Their costly garments, many depicted with gold leaf decoration in the *nuihaku* technique (see Nos. 51–54), and their aristocratic features make it clear that these are sword-bearing sons of the feudal lords who rose to power with Hideyoshi. The boy who leans on his sword and looks to the right links this screen to a now-damaged right-hand screen (not included here) which depicts a noble-woman entertained by her ladies-in-waiting. It is often suggested that this woman may represent Hideyoshi's beautiful consort Yodogimi on a cherry blossom outing with their only son Hideyori (1593–1615). The young man in a red tie-dyed robe seated on the verandah of an octagonal Buddhist hall in this screen would then be Hideyori, who, as host, contents himself by tapping along with his hands and feet while his friends cast occa-

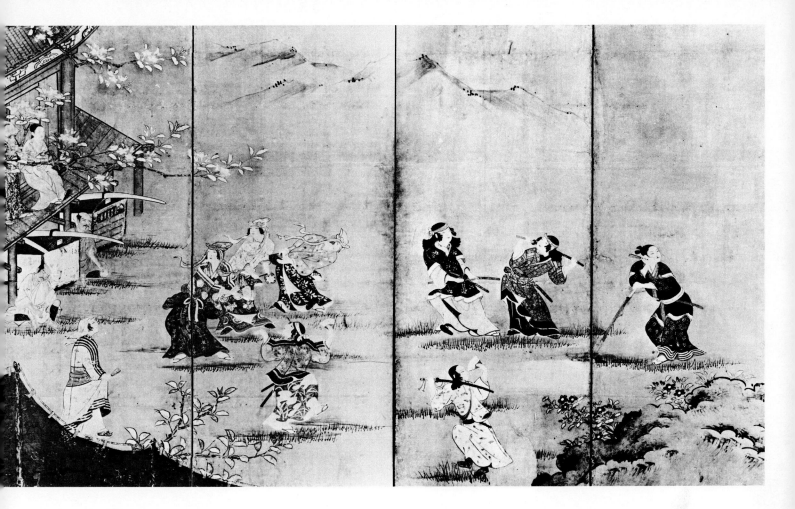

sional glances at him over their shoulders. If it is indeed Hideyori's handsome face that is framed by two branches of the cherry tree, then this screen commemorates one of the few happy moments of his life, cut short when Ieyasu liquidated the last members of the Toyotomi family.

The group arrived in palanquins, which are now parked in the shade beneath the verandah where bored bearers wait and nap. A sheer silk curtain is intended to shield their private party from the world of vulgar passersby. To the far left, just outside the curtain, female servants are unpacking two large boxes filled with an assortment of picnic lunches: we see stacks of red lacquer trays, black lacquer food bowls, and a hexagonal red lacquer food box.

Indicative of the urbane humanism of an emerg-ing genre tradition the artist focuses on the figures and their colorful costumes and shows little interest in the encompassing landscape elements. Distant hills are sketched in the most cursory manner and in the rock that frames the scene at the right edge the usual harsh modeling strokes are replaced by a lively scalloped contour that blends with the over-all mood. Even the quick, sharp strokes of the grass suggest in their regularity the steady beat of the dance.

This is the only surviving work of Kanō Naga-nobu, whose seal appears at the left edge of the screen. Naganobu, a generation younger than his brother Eitoku, was summoned to Edo by Ieyasu in the early years of the seventeenth century. There he established a branch of the Kanō school, attain-ing the honorific title of *Hokkyō* by 1625.

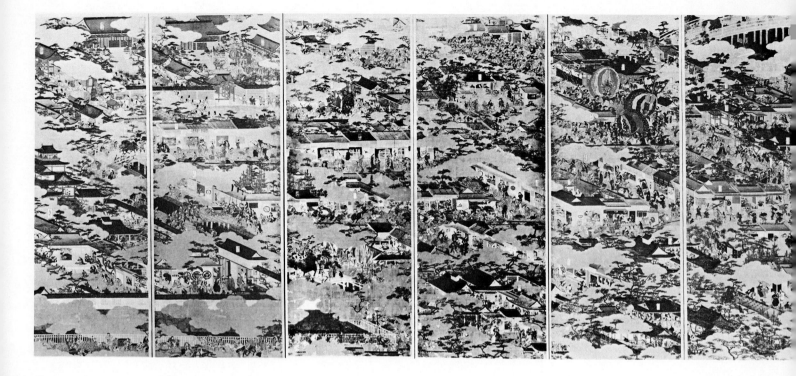

28

Activities in the capital

Around 1614
Pair of six-fold screens, color and gold leaf on paper
H. 5 ft. 4 in. (162.5 cm) x W. 11 ft. 2⅞ in. (342.5 cm) each
Tokyo National Museum
REGISTERED IMPORTANT CULTURAL PROPERTY

Painted screens called *Rakuchū-Rakugai Zu* presenting a birds-eye view of the capital and its surrounding suburbs first appeared in the early sixteenth century, when Kyoto was being rebuilt after the devastation of the Ōnin War (1467–1477). Some scholars argue that the screens reflect the wealthy merchants' pride in their city; others point out that the screens almost invariably emphasize

buildings erected by high-ranking military figures (the shogun's palace or the residence of the governor-general) and may symbolize the efforts of the military class to gain firm control of Kyoto. Whatever their purpose, screens of this type depicted famous scenic spots, important buildings, seasonal festivals, and daily business with an abundance of realistic detail that must have appealed to patrons of all classes.

The two halves of a pair of screens usually divided the city into two sectors, either north and south or east and west, and were displayed facing one another on either side of the viewer. This pair of screens, formerly in the Funaki collection, is extremely unusual because it shows the southern part of Kyoto and the eastern suburbs, extending from the Hōkoku Mausoleum to the Gion Shrine, in a continuous panorama. By dividing the scene into a series of vignettes, bands of gold clouds focus the viewer's attention on individual areas, while

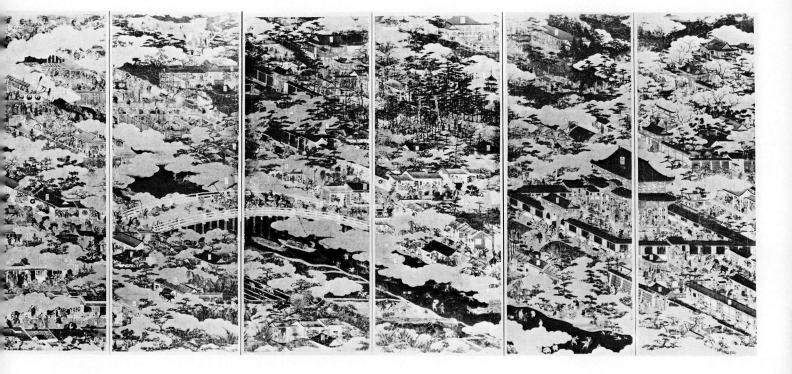

the Kamo River, running obliquely across the two screens, unifies the composition and makes it clear that the two screens were designed to be placed side by side. The artist confined the view to much narrower limits than was customary and enlarged the scale of the buildings and figures, emphasizing the daily activities of the city dwellers. Shops for fans, lacquerware, fabrics, *go* boards, house fittings, and a seemingly endless number of other commodities are included. Other scenes portrayed are the sword sharpener at work, a procession of mendicant priests soliciting funds for a new temple bell, a Portuguese merchant dressed in pointed black hat, black cloak, and brilliant red pantaloons, and an unwilling prostitute caught in the clutches of a would-be customer. On the two left panels of the right screen the artist gives special attention to the new entertainment district of the old capital. Women's Kabuki, puppet theater, and Nō drama are performed on stages in the dry riverbed at Shijō

(Fourth Avenue) above, and the "houses of pleasure" line Rokujō (Sixth Avenue) below. Hundreds of people crowd the streets, yet each is characterized with a fluid, expressive line that accurately conveys energetic movement. The style is close to that of the idiosyncratic Iwasa Matabei (1578–1650), a well-known painter of genre subjects.

Although earlier screens of this type focused on such sights as the Gion Festival and Kitano Shrine, here the Hōkoku Mausoleum dedicated to the deified Hideyoshi and the Great Buddha Hall of the Toyotomi family's Hōkō-ji appear prominently in the lower right corner of the right-hand screen, while the Nijō castle of the Tokugawa family fills the lower left corner of the left-hand screen, symbolic of the rivalry that existed between these two military clans in the early years of the seventeenth century. The screens have been dated on the basis of these and other architectural and topographical details.

29

Craftsmen

First half of the seventeenth century
Twelve panels, color on paper
H. 23 ⅝ in. (60 cm) x W. 19 ¹¹⁄₁₆ in. (50 cm) each
Private collection: Okazoe Tetsuo, Tokyo

Craftsmen were increasingly important in the expanding urban centers of sixteenth-century Japan. The artisans whose products are sold in the fancy shops along the streets of Kyoto in Activities in the Capital (No. 28) are seen here in their workshops. With assistants that often include the entire family, they ply their trades surrounded by the tools of their profession. This type of genre painting, known as *shokunin-zukushi* ("all the professions") was probably a product of the Momoyama patron's interest in the "quaint" activities of the urban lower classes.

Once invented, these popular scenes were soon simplified and stereotyped. Sets generally consisted of twenty-four small paintings mounted two per panel on a pair of six-panel folding screens. The twelve paintings surviving in this set appear to have been painted by an anonymous town painter *(machi-eshi)* in imitation of the more carefully painted group by Kanō Yoshinobu (1552–1640) now in the Kita-in in Saitama Prefecture.

Figure 1 illustrates a clothing shop for samurai. From a pole in front hang a short-sleeved jacket, perhaps a *jimbaori* (see No. 48), leggings, gloves, kerchiefs, and *hakama,* the wide, divided skirt worn by men. Below a woman adds the final touches to another pair of *hakama* while the master puts together the soles and ankle covering of the white cotton split-toed socks called *tabi.* A Western-style hat is a sign of the Momoyama craze for Portuguese clothing.

In Figure 2 a furrier supplies other accessories for the warrior or hunter. Hanging on the wall is an imported tiger skin, a garment that Nobunaga liked to throw around his shoulders, as well as fur quivers and scabbards like those sported by samurai on festive occasions (see No. 72, color ill.). Deerskin was made into saddle blankets, fashioned into long chaps, or slung from the back of a rider's waist as a kind of cushion (see No. 12).

An elegantly attired gentleman accompanied by his retainer watches a specialist appraise the quality of a long bow in the bow-and-arrow-maker's shop (Figure 3).

In Figure 4 blades and scabbards rest against the back wall of a swordsmith's atelier.

There are two looms visible in the weaver's establishment (Figure 5). One is a tall draw loom for pattern weaving used to produce *karaori* robes (see No. 55). The draw boy manipulates cords to raise special combinations of warps for the weaver who works with as many as six harnesses. In the foreground a woman uses the beater and shuttle on a much simpler loom, while her assistant fixes a broken warp. Others wind skeins of yarn onto spools.

In a dyer's shop (Figure 6) we can observe several different fabric dyeing techniques. At the far left a man paints a pattern by hand, while beside him another applies a thick paste of rice-starch resist through a paper stencil. Both men wear the peaked hat of the artisan class. To the side a woman dips a bolt of fabric into one of three sunken vats of indigo dye, and, in the foreground, another stretches the newly dyed material its full length to attach it to the pole behind her. After each step in the dyeing process a young boy with a long forked pole drapes the kimono-length fabric from a trellis for drying. Sample clothing patterns are pasted on the wall.

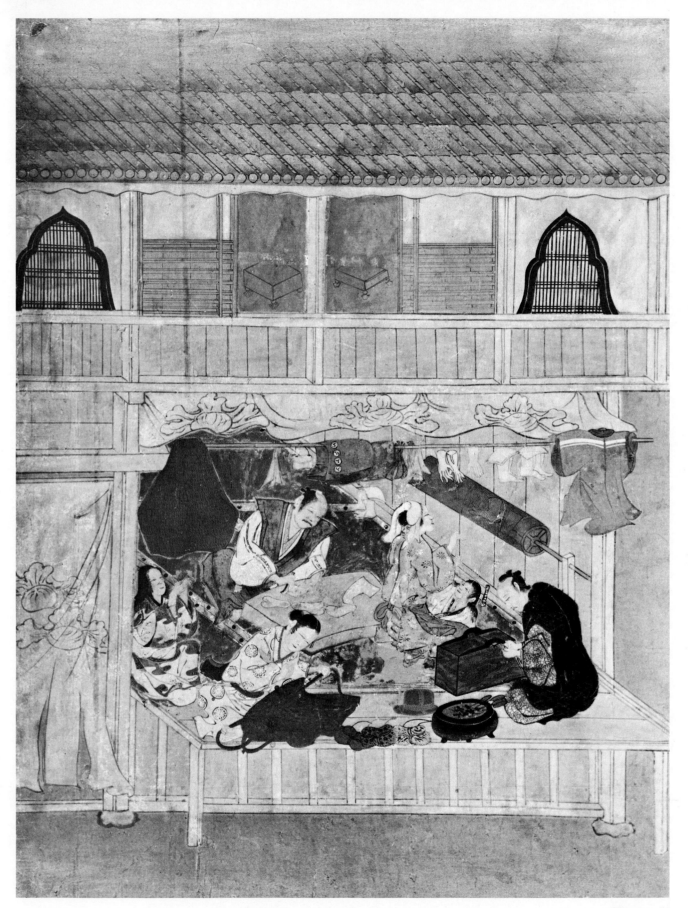

Figure 1

Figure 2

Fans were used by everyone from Nō actors on the stage to samurai in the "pleasure quarters" (No. 28). In the fan shop (Figure 7) an assistant uses a suspended weight to pound and soften stacks of thick and heavy paper, and the master at the left applies paste with a large brush. In the corner a woman inserts bamboo ribs into the pleats of a folding fan.

In Figure 8, a bookbinding and handscroll studio, one man brushes paste onto paper, while another prepares to cut a stack of sheets along a straightedge. There is also a shop (Figure 9) where cypress wood is shaved into thin pliant sheets that are formed into various containers and trays fastened together with dark strips of cherry bark. In Figure 10 a *tatami* mat maker works indoors while

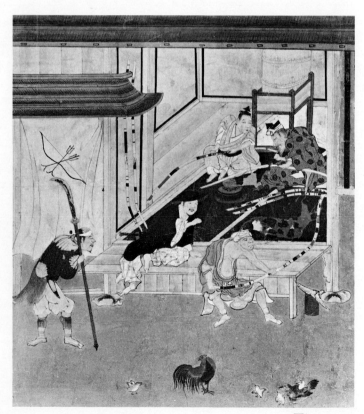

Figure 3

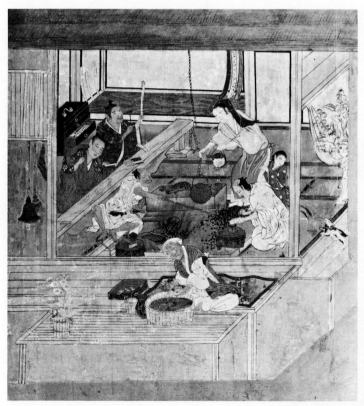

Figure 4

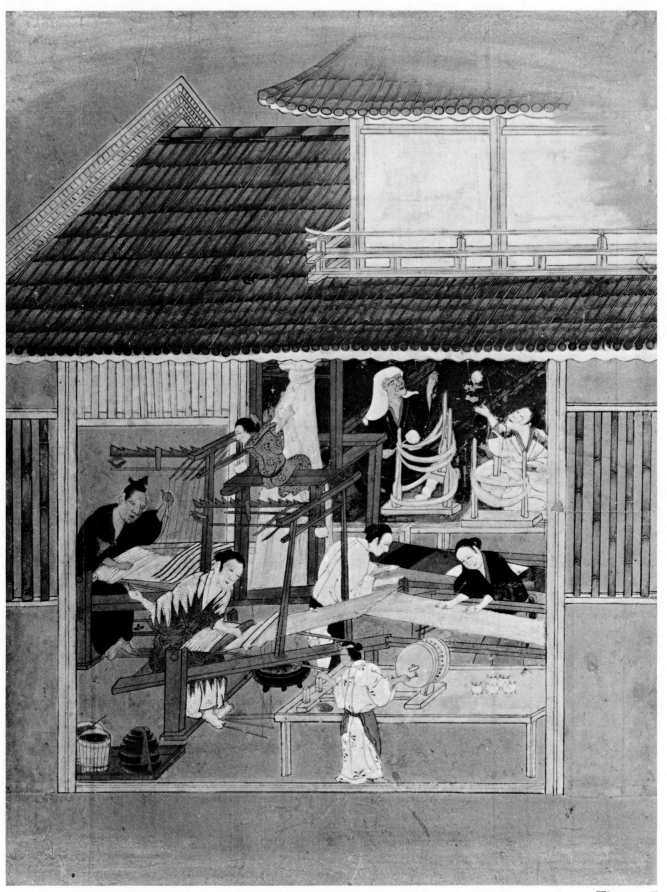

Figure 5

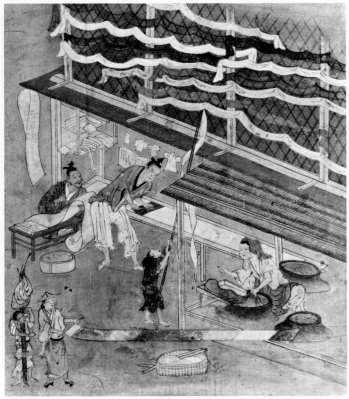

Figure 6

Figure 7

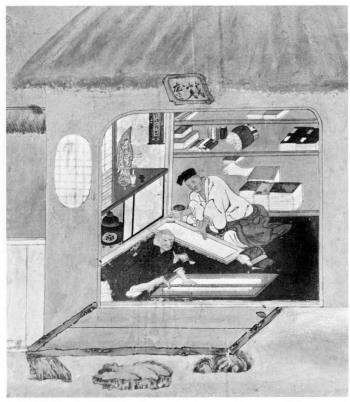

Figure 8

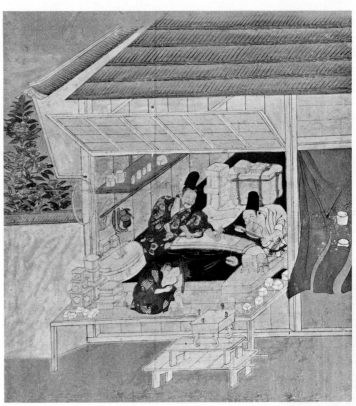

Figure 9

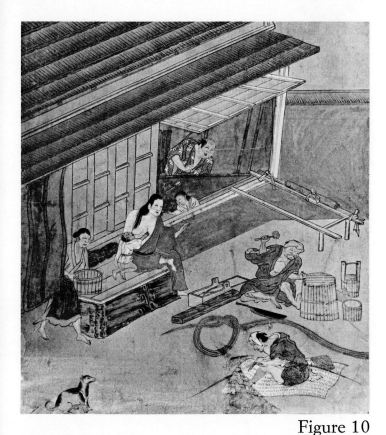

Figure 10

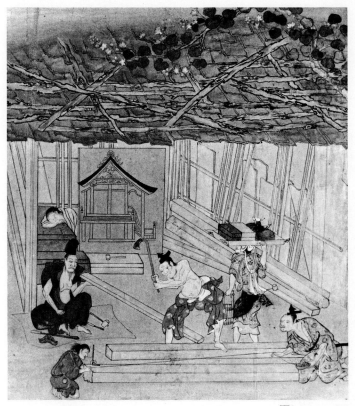

Figure 11

Figure 12

the less fortunate cooper sits outside fashioning his wooden barrels.

In the back of a carpenter's shop (Figure 11) is a picture of the master's specialty, Shinto shrines. In the foreground beams are marked with an inked thread. Finally, a smithy forges simple household tools in Figure 12.

Differences in social status between members of this artisan class are at once apparent. The weavers and the owners of the clothing shop, for example, dress well and live in prosperous-looking two-storied structures with tile roofs. The bookmaker's studio has the refined look of a tea house complete with brazier for boiling water for tea, while the toolmaker lives in the simplest kind of hut. Curtains hanging in the doorways carry a family crest or sign to identify the specialty of the house.

30

Horses in a stable

Late sixteenth century
Pair of two-fold screens, color on paper
H. 5 ft. 1 in. (155 cm) x W. 5 ft. 6¾ in. (169.5 cm) each
Honkoku-ji, Kyoto

These two screens show a long, low stable whose interior is divided into eight horse stalls fronted by a narrow area carpeted with *tatami* mats. Handsome horses with glossy coats and braided manes move restlessly in their stalls, pawing the plank floors and kicking at the partitions. In addition to the tethering ropes three horses are restrained and partially suspended by heavy ropes hung from the rafters and passing under their bellies. In the foreground stable attendants amuse themselves with games, conversation, and a monkey. As is common in genre paintings, a range of social levels is represented: the men with black *eboshi* on their heads and court robes probably have ceremonial duties, the *go* player whose kimono hangs open has the shaved head of a priest, those with their hair tied in back are low-ranking samurai *(ashigaru),* and the men with small pointed caps are probably the actual stable hands.

Surprisingly enough, the immaculate cleanliness of the stalls was not simply an artistic convention.

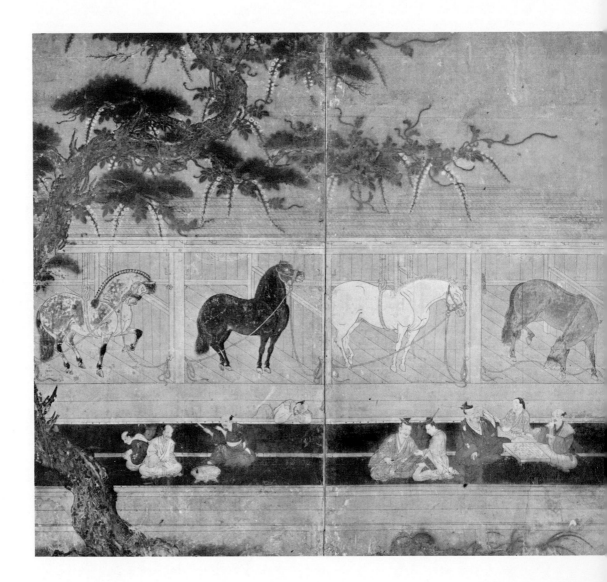

According to a Jesuit missionary's account of the stable at Oda Nobunaga's Azuchi Castle, "it was a stable only in name because it was so clean and well kept that it seemed rather to be a fine chamber for the diversion of youths than a place to lodge horses. The four or five youths who looked after it went about dressed in silk and carrying daggers in gilt sheaths" (Luis Frois, "Azuchi Castle," in Cooper, *They Came to Japan,* p. 134–135). Apparently such a stable was meant to be a formal show place; the only equipment in evidence here is the elaborate saddle hung on a rack near the center.

Because the newly affluent warrior class had few possessions they valued more than their horses, screens of stables, horses in pastures, and horse training were extremely popular during the Momo-yama period. An earlier version of this subject in the Tokyo National Museum shows the entire stable and includes landscapes with the birds and foliage of different seasons on the right and left. The present screens repeat with only slight variation the standard horse poses and figure groupings of the earlier work, but the scope of the composition has been reduced and only the flowering cherry, a symbol for spring, and the pine covered with wisteria, an image for summer, have been retained.

It is likely that the screens are the work of *machi-eshi* painters. These anonymous urban workshop artists produced competent, though sometimes unoriginal, works on a limited number of favorite themes for patrons who could not afford the fees of the prestigious artists.

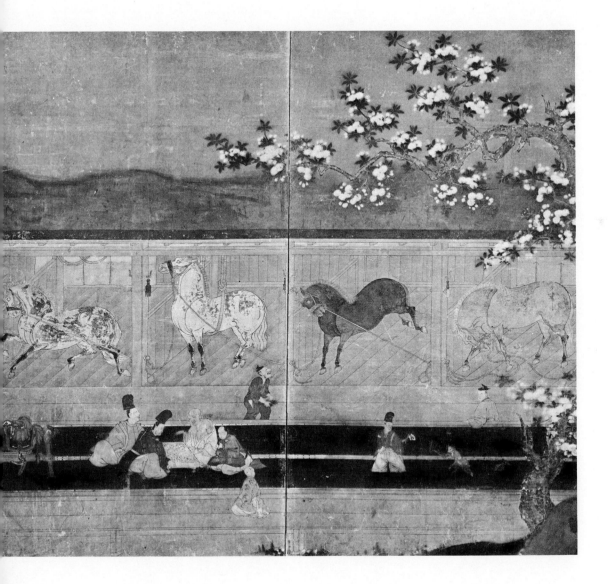

Calligraphy

The five Momoyama calligraphers represented here were members of the cultured elite, and they draw their subject matter, the classical poetry of China and Japan, from a tradition reaching back many centuries. Three of them, the nobleman Konoe Nobutada (1565–1614), the wealthy artist-craftsman Hon'ami Kōetsu (1558–1637), and the monk Shōkadō Shōjō (1584–1639) are regarded as the finest calligraphers of their period. The term "Kan'ei no Sampitsu" ("Three Brushes of the Kan'ei Era" [1624–1644]) was coined for them in the late nineteenth century, although the label is actually anachronistic in the case of Nobutada, who died in 1614.

Kōetsu is quite properly given special emphasis here with three pieces that he designed or wrote. The eldest son of a sword connoisseur, Kōetsu no doubt owed much of his aesthetic sensitivity and disciplined eye to his family profession. His father, Hon'ami Kōji, evaluated sword blades for both Nobunaga and Ieyasu and trained his son in this demanding art. After his father's death in 1603 Kōetsu experimented with a wide range of crafts, including lacquer inlay, pottery for the tea ceremony (No. 65), and calligraphy (Nos. 33–35). His innovative writing style led his own contemporaries to consider him a genius, and he was honored even by the shogunate: in 1615 Ieyasu presented him with a tract of land at Takagamine in the hills on the northwestern edge of Kyoto. Here Kōetsu presided over a village of like-minded, free-spirited craftsmen.

Perhaps as a deliberate reaction against the ever-present authority and values of the military class, Kōetsu and his friends revived an ideal of refined beauty associated with the imperial court of the classical Heian period (794–1185). He reportedly owned samples of the writing of famous late-Heian calligraphers, whose works are characterized by a fluid, elegant style and experimental—even playful—composition. His perception of Heian calligraphy was naturally filtered through his own experience and was also influenced by the "tea taste" of men like Sen no Rikyū, who admired individuality, warmth, intimacy, and an almost artful carelessness.

Although knowledge of Japanese is essential to a full understanding of the art of calligraphy, the range of expression conveyed by the simple brush line can be appreciated even by the novice. It is here, beyond the barriers of legibility and subject matter, that the writer speaks to us directly of his learning, humor, imagination, and feeling. The brush and ink are so sensitive that the slightest hesitation, the least hint of excitement, leaves its indelible mark on the paper.

In the first few centuries A.D., the Japanese, who had no writing system, adopted the highly developed Chinese system of ideographs, written from top to bottom and from right to left. The three styles of Chinese calligraphy that became widely known and used in Japan are called, in Japanese, *kaisho* ("regular," or "clerical," script), *gyōsho* ("running" script), and *sōsho* ("draft" script). They are distinguished by their degree of cursiveness. In Shōkadō's rendering of a Chinese poem, "Home Again" (No. 36), all three scripts appear side by side. The title line

Detail of No. 36,
"Home Again" by Shōkadō Shōjō

on the far right and the three characters in the next column, the name of the author, (T'ao Yüan-ming), are written with the distinct and clearly separated strokes of the *kaisho* style (see ill. above). In *gyōsho* the characters are more quickly written and many sequential strokes are joined or run together to produce a slightly simplified, less static shape. This distinction between *kaisho* and *gyōsho* is clear in a comparison of the identical third character of Shōkadō's title and in the first line of the text. The contrast in style between *kaisho* and *sōsho* is more extreme, as we see in a comparison of the first two characters of the title to their *sōsho* equivalents in the first two characters of the text. In the *sōsho* script the brush is in almost continuous contact with the paper, creating highly abbreviated, fluid forms. Moreover, calligraphers of Shōkadō's status invented their own personal *sōsho* variations. All three scripts might be freely mixed, and it is often particularly difficult to distinguish between *gyōsho* and *sōsho*.

In the first systematic application of Chinese writing to the totally unrelated Japanese spoken language, characters were used for their sound as well as their semantic value. In the eighth century *Man'yōshū ("Collection of Ten Thousand Leaves")*, the earliest anthology of Japanese poetry, Japanese words are expressed with so-called *man'yōgana*, Chinese characters used phonetically. This cumbersome method was soon abandoned and reappears in the works of later calligraphers like Kōetsu (No. 34) only for its artistic effect.

Two phonetic syllabaries of symbols called *kana* (literally, "borrowed names") were evolved in the early Heian period to reproduce the spoken language. *Katakana*, or "square *kana*" derive from the rectilinear *kaisho* forms of Chinese characters and were used primarily for textual

glosses. Kōetsu uses small *katakana* notations in the Sagabon Nō texts (No. 33). *Hiragana* or "smooth *kana*" are abbreviations of *sōsho* forms. Particularly graceful and elegant in appearance, *hiragana* were favored from the time of their invention for the writing of Japanese verse and prose literature. Chinese characters continued to be used in conjunction with the native syllabaries, resulting in a writing system that is both flexible and rich in visual appeal. In the final *waka* (thirty-one syllable Japanese poem) of Kōetsu's printed poems from the *Shinkokinwakashū* anthology (No. 34), for example, the third line from the left is composed of a single Chinese character (*tsuki,* or "moon") followed by six *hiragana* reading *"mo tsuyu nagara."*

Ambitious scale characterizes the calligraphy as well as the painting of this period. Nobutada, for example, dares to fill a pair of screens with only a few lines of large *kana* (No. 32). There is also an increasing awareness of the pictorial possibilities of both composition and paper decoration. Like the classical Heian period four hundred years earlier, the Momoyama era was a great age for calligraphy. The major artists shunned established styles and sought instead to expand the expressive vocabulary of written forms. Whether in Nobutada's bold *kana,* in Shōkadō's self-conscious shapes (No. 36), or in Mitsuhiro's jagged lines (No. 37), Momoyama calligraphy displays pride and the thrill of discovery.

that ordered the printing of the classics by movable type. The emperor's personal attachment to Zen Buddhism is reflected in this painting of Bodhidharma (*Daruma*, in Japanese), the semilegendary founder of the Zen sect in China. Bodhidharma had always been a favorite subject among Zen adepts, who attempted to communicate his fierce inner strength and spiritual force in only a few deft strokes. As in this example, the half-length figure of the Indian patriarch, his head and hands covered with a loose mantle, is generally drawn with uncouth "foreign" features, such as a conspicuously bulging nose.

By drawing the outlines of the figure with the split fibers of a bamboo stem, Go-Yōzei imitates a brushwork technique called "flying white," in which spaces within the strokes give the impression that a powerful brush has flown across the paper.

The poem the emperor inscribed on the painting is said to be one that a beggar once offered to Shotoku Taishi (574–662), Japan's first statesman and benevolent patron of the Buddhist faith. According to the legend, the beggar, to whom Shotoku had shown compassion, was an incarnation of Bodhidharma.

In six carefully staggered lines Go-Yōzei demonstrates his virtuoso control of limpid, flowing *kana*. His fondness for ornamental curls is also reflected in the ribbonlike contours of the painted figure. Go-Yōzei writes with the confidence of a monarch reigning in a period that accorded the imperial family a renewed sense of self-esteem.

31

Bodhidharma

Emperor Go-Yōzei (b. 1571; reigned 1586–1611; d. 1617)
Around 1600
Hanging scroll, ink on paper
H. 21 3/16 in. (53.8 cm) x W. 13 15/16 in. (35.4 cm)
Jishō-in, Kyoto

Go-Yōzei, the one-hundred-seventh emperor of Japan, reigned for the twenty-five years spanning the rise and fall of the Toyotomi family and the inauguration of the Tokugawa dynasty. Lacking military resources of his own, Go-Yōzei was little more than a figurehead, but his aura of divine ancestry led Hideyoshi to actively seek his favor, once going so far as to entertain the entire imperial retinue at his Kyoto mansion, the Jūraku-dai. In the best tradition of imperial patronage, Go-Yōzei actively participated in the arts: he studied painting with Kaihō Yūshō and encouraged scholarship by issuing a decree during the Keichō era (1596–1615)

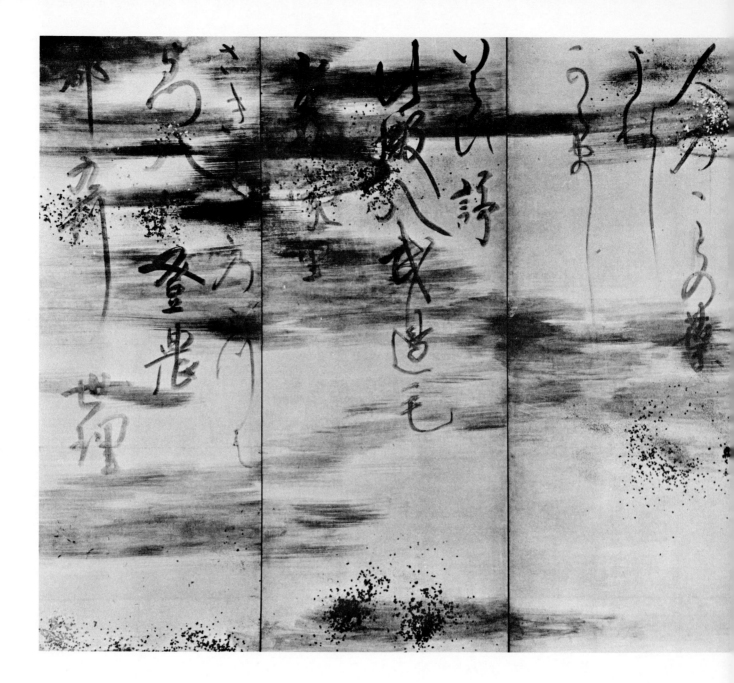

32

Six principles for the composition of poems

Konoe Nobutada (1565–1614)
Late sixteenth century
Pair of six-fold screens, ink and gold on paper
H. 5 ft. 4 9/16 in. (164 cm) x W. 11 ft. 10 1/8 in.
 (361 cm) each
Yōmei Bunko, Kyoto

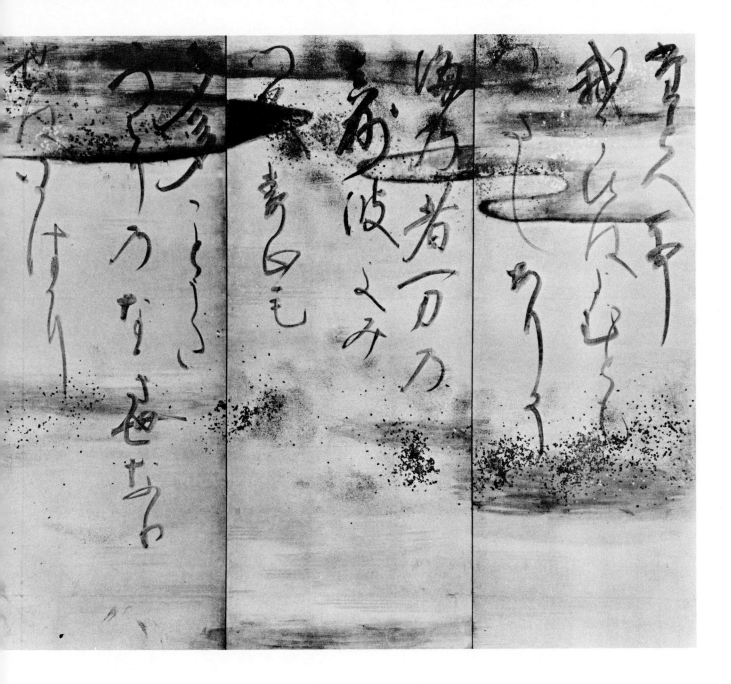

The calligraphy of these six poems captures the ebullient spirit of the Momoyama age. The verses are taken from Ki no Tsurayuki's (884–946) preface to the first imperial poetry anthology, the *Kokinwakashū* (*"Collection of Ancient and Modern* Waka") of 905. In that preface, one of the foremost pieces of poetry criticism in Japanese literature, Tsurayuki offered these *waka* as examples of the six categories (*rikugi*) of Japanese poetry, alluding to the six types of poems mentioned in the preface to the ancient Chinese classic the *Shih Ching* (*"Book of Songs"*). Each of the five-line *waka* boldly written across two panels on these screens was prefaced by a one-line heading, the name of the category.

This choice of subject matter was a natural one for Konoe Nobutada, who was not only one of the master calligraphers of his time but also a prolific writer of *waka* and *renga* (linked verse) as well as a painter. Nobutada (also known as Sammyaku-in) was born into one of the most prominent families of the hereditary nobility and rose by the age of forty-one to the highest rank in the civil government, that of chief minister *(Kampaku)*. His tempestuous nature is reflected in these screens: Chinese characters and Japanese *kana* cascade exuberantly over a ground of loosely brushed gold and silver clouds sprinkled with particles of foil. His forms, although they reflect the Heian style, are

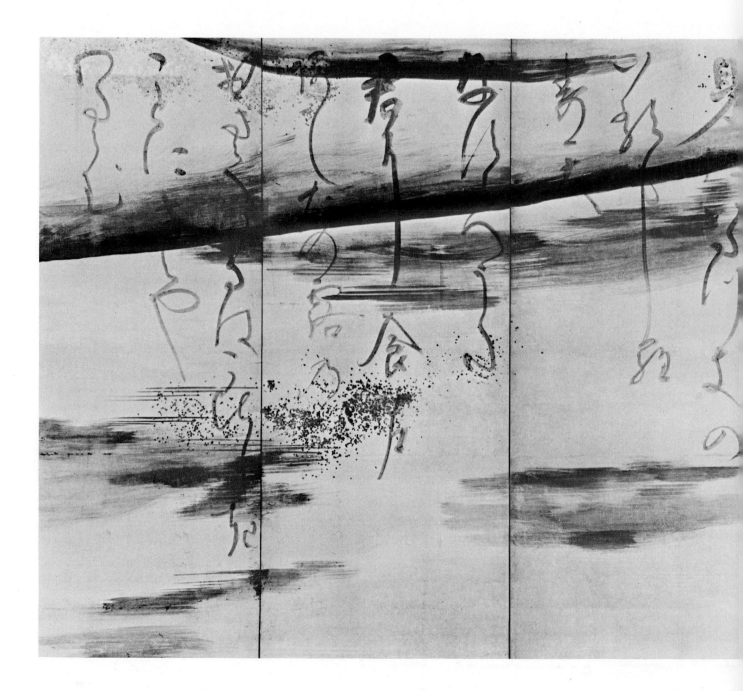

76

neither as delicate and precise as classical examples nor as restrained as the work of his contemporary Hon'ami Kōetsu (Nos. 33–35).

On the other hand, Nobutada is not careless. His Chinese characters (for example, that which appears at the top of the second line from the right on the left screen) are active but controlled and balanced. To feel the steady yet swift rhythm one has only to follow a continuous line (such as the eighth from the right on the right-hand screen) to note how much dance is possible within a relatively narrow column. It is no wonder that the impression conveyed by this writing has been compared to the rapids of a mountain stream.

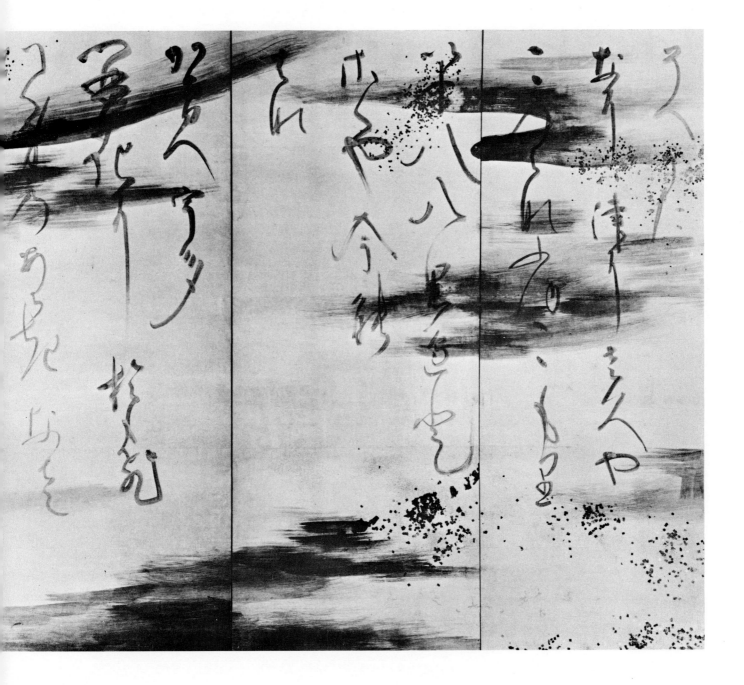

33

Printed Nō texts

Designed by Hon'ami Kōetsu (1558–1637);
 published by Suminokura Soan (1571–1632)
Around 1606
Five volumes bound in book form, ink on lightly
 colored paper with mica-printed designs
H. 9 7/16 in. (24 cm) x W. 7 1/16 in. (18 cm) each
Tokyo National Museum

These books introduce us to one of the three wealthiest men in early seventeenth-century Kyoto, Suminokura Soan, who epitomized the new upperclass merchant (*machishū*) culture. One of the most powerful families in the capital, the Suminokura were licensed by the government to send trading ships as far as Hanoi, until travel to foreign countries was banned in 1635. All of Soan's *machishū* friends were culture enthusiasts, but he was distinguished among them by his scholarly interests. The books that Soan began to publish around

1606 on his private press in the Saga district, west of Kyoto, reflect a combination of his literary taste and financial resources, as well as the classical aesthetic of his friend Hon'ami Kōetsu.

These volumes are from a set of one hundred texts of the Kanze school of Nō drama, which were published at Saga in eight different editions between 1606 and 1615. As is usual with the limited written repertory of the Nō theater, the texts include only the chants *(utai)* of each drama, the bare outline of the play. The rest was transmitted orally. The relative pitch (up, down, or even) of these sung portions is indicated by the short lines at the right of the text columns.

Both Soan and Kanze Kokusetsu (1566–1626), the seventh head of the prestigious Kanze school of Nō, studied calligraphy under Kōetsu, who was responsible for the writing and design of early luxury editions of the *Sagabon,* of which this is an example. The *hiragana* text is printed from movable type, a technique newly introduced to Japan in the 1590s either from Korea or from the Portuguese Jesuits who had brought their own press for printing missionary tracts in Japanese. Such printed books, which mark Kōetsu's debut as a major artist-calligrapher at the relatively advanced age of forty-eight, surely did much to spread the personal interpretation of the classical aesthetic he espoused.

Both the covers and inside pages glisten with a coating of lightly tinted *gofun* (powdered shell) and are embellished with woodblock printed patterns in powdered mica paste. A printed title cartouche is affixed to the corner of each cover, and the volumes are bound with silk thread. Many of the small-scale floral and geometric designs in the *Sagabon* were directly inspired by eleventh- and twelfth-century anthologies treasured for their perfect harmony of poetry, calligraphy, and exquisite printed paper decoration. Other patterns like those illustrated here reflect the more modern designs of Kōetsu's contemporary Tawaraya Sōtatsu (No. 25). In any case, the *Sagabon* marks the beginning of Kōetsu's acute sensitivity to the quality and design of paper.

Printed poems on the subject of the moon from the *New Collection of Ancient and Modern Waka (Shinkokinwakashū)*

Designed by Hon'ami Kōetsu (1558–1637)
1610s
Handscroll, ink on lightly colored paper with mica-printed designs
H. 13 ¾ in. (35 cm) x L. 16 ft. ¹⁵⁄₁₆ in. (490 cm)
Daitōkyū Kinen Bunko, Tokyo

As a devotee of the classical courtly tradition, Kōetsu transcribed many early *waka* and preferred above all the melancholy autumn poems from the eighth imperial *waka* anthology, the *Shinkokinwakashū,* sponsored by the then-retired emperor Go-Toba (1180–1239) in the thirteenth century. From among the nearly two thousand intricately interwoven poems of this anthology, Kōetsu has here selected nine consecutive *waka* (numbers 416–424) that mention the autumn moon.

Like the Sagabon Nō texts (No. 33), these poems are printed in movable type on a paper luxuriously coated with a sizing of powdered *gofun* and decorated both front and back with a series of woodblock designs in mica. These designs, some of which are repeated at intervals, include an ivy vine, plum branches and other flowers, as well as a group of deer and a bridge; all are in the soft, rich style that Kōetsu generally favored on the writing surfaces of his early works. Although Kōetsu occasionally contributed some of his own paintings or designs, several of his most famous poem scrolls with gold and silver underpaintings bear the Inen seal associated with Sōtatsu. The style of the paintings in those examples also tends to confirm their attribution to Sōtatsu, who must have worked in close collaboration with the calligrapher.

With deceptive simplicity, *kana* and *kanji* are scattered across the paper in an interplay of dark, heavy accents (usually the larger, more complex Chinese characters) and smaller, lighter, more fluid elements, including exaggerated vertical elongations of *kana*. An especially fine example is the fifth

poem (not illustrated), which begins with the name and title of the poet, Teika no Ason (or Fujiwara Teika [1162–1241]) written over the deer that stands erect at the center of the first "deer" sheet and continuing through the middle of the next sheet:

> On that lonely mat—
> As the autumn wind deepens
> In the waiting night
> She spreads the moon as her cover
> The Lady of Uji Bridge

The first three syllables of *"samushiro"* ("narrow reed mat") are written in large, assertive *kana*, evenly spaced in the center of the paper, while the last syllable, "ro," and the exclamatory "ya" drop down to form a short line of their own. This is characteristic of a style called "scattered writing" *(chirashigaki),* which Kōetsu adopted from the writers of the late Heian period (794–1185). True to his times, however, Kōetsu disregarded the subtle nuances of Heian calligraphy. The character for "moon" on the adjoining sheet is conspicuously

80

emphasized at the top of the short second line; it seems to float like a half-moon above the printed Uji Bridge design. The following particle "o" is tiny and unobtrusive. It is an exceptional example of a *waka* that is directly coordinated with a specially selected underdecoration.

With the eighth poem, on the second to last sheet (opposite, below), Kōetsu dramatically switches to archaic *man'yōgana:* the entire *waka* is written in Chinese characters meant to be read in Japanese and is arranged in a solemn "Chinese" style. By Kunaikyō, a poetess who died around 1204, it reads:

> Could they still be waiting
> To see this moon
> Those villagers on the far side
> Of the sudden shower's lifting clouds

The four lines of the last poem are also straight and evenly spaced, but the effect is quite different because Kōetsu reverts here to the lighter Japanese *kana,* limiting himself to only five *kanji.*

Collection of Japanese and Chinese poems for recitation *(Wakan Rōeishū)*

Hon'ami Kōetsu (1558–1637)
Handscroll, ink and gold on silk
Dated 1626
H. 13 ½ in. (34.4 cm) x L. 44 ft. 7 ⅜ in. (1360 cm)
Nezu Art Museum, Tokyo

In his late sixties and seventies Kōetsu turned increasingly from *waka* to Chinese poems from the early eleventh-century anthology of mixed Chinese and Japanese verse called the *Wakan Rōeishū,* or the *"Collection of Japanese and Chinese Poems for Recitation." Rōei* are vocal pieces sung at court by the cultivated nobility, but by Kōetsu's time the anthology was used more as a pattern book for calligraphy than for song. The original version, compiled and written by Fujiwara Kintō (966–1041) and still preserved in the imperial archives is in two books: the first contains poems on the four seasons, and the second on miscellaneous topics. Kōetsu has here selected poems from the first book, choosing from the spring section topics like "early spring" and "spring evening," from the summer section those on "enjoying the cool of the evening," "late summer," "lotus," "cuckoo," and "fireflies," and from the winter section poems on "the year end." Although in the *Wakan Rōeishū* each topic is represented by poems in Chinese and in Japanese,

Kōetsu eliminated many intervening *waka,* as well as the headings and the names of poets. He is equally interested in the visual and the literary content of the verses, arranging them as though they made one continuous verse.

The scroll begins with poems on the various aspects of "early spring." The first (ill., p. 81) is a couplet by the T'ang dynasty poet Yuan Chen (779–831):

> Ice melts in the fields and the tips of the new water
> reeds are short;
> Spring enters the willow branches and the eye-shaped
> buds are closed.

Both seven-character verse lines are written in two sentences, each with a four-character phrase followed by a shorter one of three characters. Kōetsu preserved this rhythm and internal punctuation.

The next two excerpts are by Po Chü-i (772–846), one of the most famous of the T'ang poets and a great favorite in Heian Japan. Po and Yuan were good friends and frequently exchanged poems. Po's couplet is also in seven-character meter:

> First order the warm breeze to bring the news of spring,
> Then ask the singing birds to tell us the reason.

In two lines of parallel prose, each written in two sentences—a six-character phrase followed by one of four characters—Kōetsu again preserves the rhythm of the Chinese by his careful spacing and composition:

> The willow buds on the east and west banks do not
> sprout at the same time;
> The plum blossoms on the north and south branches
> differ in their flowering and falling.

The last two poems of this long scroll (below) are on the winter "year-end" theme. The next to last, like those discussed above, is a Chinese couplet in seven-character meter, but here Kōetsu varied the rhythm by using a combination of five and two characters for the first verse line. As in his earlier *Shinkokinwakashū* transcription (No. 34), the last poem, a *waka* written entirely in *hiragana,* contrasts strongly with the Chinese script of the preceding poem.

This scroll is among a large number that have survived from Kōetsu's late period, and the final inscription, which is precisely dated to the tenth month of 1626, notes that it was written at the Taikyo-an at Takagamine when he was sixty-nine years of age (sixty-eight by Western count). His square seal reading "Kōetsu" is affixed at the end.

The underdrawing is a continuous sequence of autumn grasses painted on a silk ground in two shades of gold. By the 1620s Sōtatsu had achieved a reputation as a painter and apparently no longer collaborated with Kōetsu in the designs for poetry scrolls. Instead, it was probably one of Sōtatsu's pupils who painted these autumn grasses.

Because of the trembling visible in some of his strokes, it is thought that Kōetsu may have developed palsy, and even Ieyasu is said to have been worried about the artist's health. Oddly enough, many of Kōetsu's followers picked up and exaggerated this tremulous line of his late style. The arrangement of the lines of poetry into orderly columns of evenly spaced couplets, as well as the prominence of dry, thin, angular strokes, reflect a more serious mood than is found in his earlier works.

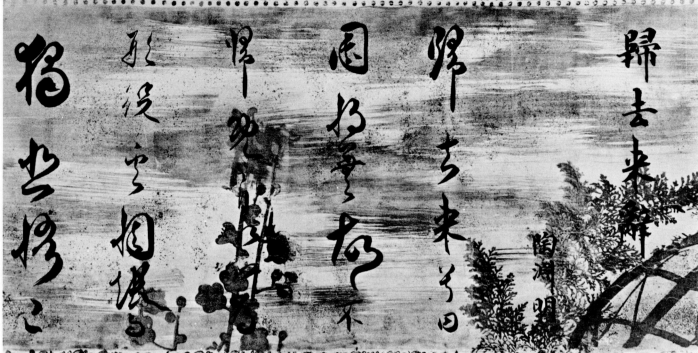

36

"Home Again"

Shōkadō Shōjō (1584–1639)
Early seventeenth century
Handscroll, ink and gold on paper
H. 12 1/16 in. (30.7 cm) x L. 19 ft. 8 9/16 in. (600.8 cm)
Fujita Museum, Osaka

This richly ornamented handscroll is inscribed by the monk Shōkadō Shōjō with the famous prose poem "Home Again" (K'uei-ch'ü lai-tz'u) by the Chin dynasty Chinese scholar T'ao Ch'ien (or T'ao Yüan-ming [365–427]). The poem, composed when T'ao Ch'ien resigned his official government post and returned to his native home, extols the merits of rural felicity and expresses the author's relief at abandoning all craving for material riches.

Like T'ao Ch'ien, Shōkadō was an independent spirit: he declined an administrative position at Otokoyama, the monks' quarters beside the Iwashimizu Hachiman-gu, chief shrine of the war god Hachiman, and chose instead to live quietly in a nearby temple residence. Here, he practiced calligraphy, ink painting in the style of Chinese Zen monks, poetry, and the tea ceremony. One of the three leading Kyoto calligraphers of the first decades of the seventeenth century, he developed a conservative style based upon the kana script of the classical late Heian period (794–1185). In strong contrast to Nobutada (No. 32), Shōkadō is interested in the shapes of the characters rather than their flow. Each form is an independent composition with its own unique and self-contained design. A thick brush and dark ink are used to model characters whose shapes, composed of broad, curling strokes, are often pleasantly original.

The seven sheets of paper are lavishly printed with gold ink designs of plum blossoms, chrysanthemums, camellia, pine, ivy, bellflowers, hydrangea, and, in the margins, tiny scrolling vines. Even the back of the scroll is embellished with gold butterflies.

Record of the author's trip to the eastern capital

Karasumaru Mitsuhiro (1579–1638)
Early seventeenth century
Handscroll, ink on paper with color and gold
H. 11 7/16 in. (29 cm) x L. 29 ft. 11 1/4 in. (912.3 cm)
Tokyo National Museum

Karasumaru Mitsuhiro was born into a distinguished court family and rose to a position of high rank. Talented as a poet and calligrapher, he was also a trusted and skilled diplomat who often traveled as an emissary of the Kyoto imperial court to the military government of the Tokugawa shoguns in Edo, the eastern capital.

This scroll is a travel diary for just such a journey; the inscription at the end states that Mitsuhiro arrived in Edo on the eleventh day of the third month. It is not clear what year is meant, but the mature style of his *sōsho* suggests that it was late in his life.

The author probably copied his record of the castles and famous beauty spots onto this carefully prepared paper after the trip. The text is interspersed with poems composed at almost every stop and soft, simplified ink sketches. Like most travelers to Edo, Mitsuhiro looked forward to the sight of Mount Fuji as he set out in the early hours of the morning across the plains at its foot.

In the section illustrated below he has transcribed three poems inspired on this occasion. Beginning high at the upper right with three relatively straight, long columns he writes of the dawn sky in spring with its mist that obscures the view of Fuji's peak. Incredibly, mist seems to affect even the characters he is writing.

Then he drops down to a new line accentuated by darker ink. The eight lines of this verse descend in two short steps, with the character for mountain (*yama*) at the top of its sixth line somewhat enlarged and isolated. Though Mitsuhiro still turns his eyes toward Fuji, he can see only the shifting clouds suspended from the crest of Mount Ashitaka, an inactive volcano on the southern slope.

His third poem, beginning just below the summit of the mountain in the sketch, is written in diagonally descending lines that reiterate the contour of the mountainside. The last few lines of the verse are squeezed into the only remaining space at the bottom. The strip of land that intersects this verse represents the subject of the poem—a long, narrow coastal plain at the base of Mount Fuji called Ukishima.

In keeping with the early seventeenth-century revival of beautifully decorated papers, Mitsuhiro wrote across eight long sheets of paper first dyed in shades of pale indigo, yellow, and red, and then block-printed with a scattering of small floral designs including chrysanthemums and paulownia in gold, silver, and blue. The colored papers are generally alternated in the sedate manner of eleventh- and twelfth-century models, but occasionally Mitsuhiro incorporates one of the favorite decorative motifs of his own time, the bold diagonal zigzag (see No. 67).

Mitsuhiro studied various schools of calligraphy, including that of Kōetsu, but ultimately developed a self-confident and aggressively unconventional style of his own. His eccentric and abrasive characters bear little relationship to the elegant and precise styles of most of his contemporaries.

Nō Masks

Nō, meaning "talent" or "the exhibition of talent," is the name given to a slow-moving ritualistic form of drama unique to Japan. The origins of Nō reach back to at least the eleventh century, when itinerant players performed acrobatics, magic tricks, and mime for temple and shrine festivals. Called *sarugaku,* or "monkey music," these popular entertainments were refined into a sophisticated dramatic form largely through the efforts of two *sarugaku* actors, Kan'ami (1333–1384) and his son Zeami (about 1363–1443), who attracted the attention of the third Ashikaga shogun, Yoshimitsu (1335-1408), in 1374. Under Yoshimitsu's patronage, Kan'ami and Zeami shaped *sarugaku* into plays designed to appeal to the literary tastes of both the aristocracy and the new military leaders who could now afford the luxury of supporting the arts.

Zeami, the author of most of the Nō plays still performed, defined this drama as a highly stylized and symbolic combination of song, dance, and mime. To describe the most important attribute of Nō he used the word *yūgen.* In the Heian period (794–1185) the word meant "dark" or "clouded," with a suggestion of mystery—beauty that is veiled rather than obvious. By Zeami's day *yūgen* had come to mean "charming" or "graceful," but still retained the implication of latent power and mystical beauty. An actor's performance, a play, or even a mask can be said to reveal *yūgen.* Zeami wrote, for example, "if the characterization calls for a display of anger or for the representation of a devil, the actions may be somewhat forceful, but as long as the actor never loses sight of the beauty of the effect and bears in mind always the correct balance between his mental and physical actions and between the movements of his body and feet, his appearance will be so beautiful that it may be called the '*yūgen* of a devil'" (Zeami, "On Attaining the Stage of Yūgen," in *Anthology of Japanese Literature,* ed. and trans. Donald Keene, New York, 1955, p. 260).

Colored by Buddhist thought and interwoven with classical allusions, the Nō plays deal with themes taken from history, legend, fiction, and poetry and are almost always tragic. In a typical play the ghost of some well-known historical or legendary personality relates a moving episode in his life to a secondary character, often a priest. A play has no more than four or five actors including the principal dancer and his assistant. They enter the theater on a raised passageway that leads to a small, square, wooden stage. Against this stark setting the color and gold of their embroidered and brocaded costumes (Nos. 51–55) and the dramatic effect of their masks are all the more impressive. The text is short, consisting of prose for quiet scenes and lyrical poetry for the more emotional, sung portions. The chants *(utai)* of the chorus, which is seated to one side of the stage, form the written repertory of the Nō theater (see No. 33). Several drummers and a flute player sit at the back of the stage, heightening the tension of important moments in the play with their music. Nō performances, which may last nearly six hours, always include several plays, a custom that may have its origins in the variety shows offered by the *sarugaku* players.

In the century after Zeami's death the breakdown of the central government and the civil wars raging across Japan forced Nō actors to seek new sources of support outside the capital. Catering to the taste of provincial audiences, they emphasized plays filled with dramatic action rather than the quiet, lyrical dramas preferred by Zeami. At the same time Kyōgen, or comic sketches, which also grew out of *sarugaku,* were incorporated into Nō performances. Acting as an interlude between the emotionally intense Nō plays, Kyōgen relies heavily on slapstick humor and the absurd confusions that arise when a character does not behave according to his station in life. The crafty servant who outwits his master is a particularly popular figure.

With the gradual unification of the country in the early Momoyama period, feudal lords turned once again to Nō. No one launched himself into the study of Nō with greater enthusiasm, or less humility, than Toyotomi Hideyoshi. A dedicated actor who even traveled with a folding stage in order to practice while he was on a campaign in Kyūshū, Hideyoshi commissioned ten plays detailing his own exploits. In 1594 he performed five of them, along with several of the most difficult plays in the repertoire, for the emperor Go-Yōzei at the Imperial Palace. Although he particularly encouraged the Komparu school of Nō actors, Hideyoshi also supported the other three professional troupes in existence at the time—Kanze, Hōshō, and Kongō. Because lesser military lords were persuaded to follow his example, Nō underwent a great revival in the Momoyama period: new plays were written, costume design developed into an elaborate art, and the kinds of masks and wigs proliferated.

Under the Tokugawa regime, Nō was gradually transformed into a solemn ritual believed to contribute to the prosperity of the state. Already archaic by the late sixteenth century, the language of the texts became even more incomprehensible. Mime was largely eliminated and the dances were prolonged into a slow and stately ceremony.

Wooden masks are worn for almost all roles except those of ordinary middle-aged men and range from the ferocious visage of a jealous female ghost (No. 45) to the cheerful countenance of a youthful demigod (No. 42). Because many of the masks, particularly those for female roles, have subtle, even ambiguous, expressions, the actor's ability to suggest a variety of emotions depends on his skill in manipulating the mask so that light and shade play over its surface. Although the mask may not completely cover his face, he must convince the audience that it is part of his flesh.

Carved from well-seasoned Japanese cypress *(hinoki),* the masks are covered with several layers of paint to produce a smooth, almost luminous surface. In a few cases real hair is set into the mask, but generally these details are painted on. If the mask is to be used for the role of a supernatural being, the eyes, and sometimes the teeth, are inlaid with gilt bronze to catch the light (Nos. 40, 41, 45). Wigs are invariably worn with the masks, and headdresses often complete the effect.

The early masks expressed clearly recognizable, uncomplicated states of emotion, but like the plays themselves, the masks became increasingly stylized. By the end of the Muromachi period (1392–1568) a group of specific mask types had been defined, and, for the most part, modern masks follow styles created in the fifteenth and early sixteenth centuries. In spite of their apparent similarity, examples of the same mask type have slightly different nuances of expression, so that an actor's choice of a particular mask will alter his interpretation of the role.

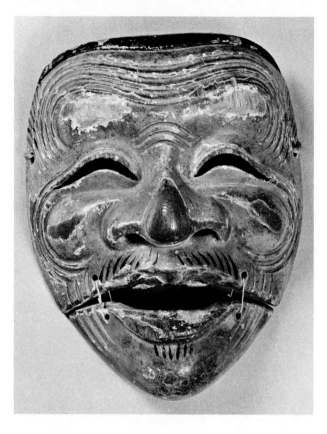

Kyōgen mask: grandfather *(ōji)* **39**

Late sixteenth century
Polychromed wood
H. 7½ in. (19 cm) x W. 5¹¹⁄₁₆ in. (14.5 cm)
Tenkawa Benzaiten Shrine, Nara Prefecture

In Kyōgen plays, masks are used for animals, demons, gods, and some comically ugly male and female roles. Strongly modeled and often worn simply with a towel or headcloth instead of a wig, the Kyōgen masks rely on blatant overstatement for their effect. Their ludicrously exaggerated features intensify the burlesque humor of the sketches. Kyōgen masks are far fewer in number than those for Nō.

With its drooping eyes, rotting teeth, and slack jaw covered with stubble, the brown *ōji* mask presents a view of old age entirely different from that of *okina* (No. 38). Translated literally, *ōji* means "grandfather," a deceptive title for a mask that is commonly used for roles of lecherous old men in Kyōgen.

Undeniably grotesque, the features of this particular example are actually much less exaggerated

Nō mask: old man *(okina)* **38**

Dated 1574
Polychromed wood
H. 7¹⁄₁₆ in. (18 cm) x W. 6 in. (15.2 cm)
Tenkawa Benzaiten Shrine, Nara Prefecture

Growing out of an ancient benediction ritual that can be traced back to at least the ninth century, the *Okina* play was developed by *sarugaku* players during the Kamakura period (1185–1333) and then carried over into the Nō repertoire sometime in the fourteenth century. Today, *Okina,* which is essentially a prayer invoking peace, fertility, and longevity, opens special Nō performances. Used only in this play, the *okina* mask, with its hinged jaw, unkempt cotton eyebrows, and beard of stiff hair, has the features of a benevolent old man. It is the oldest type of Nō mask still worn.

The present example is inscribed on the back with the date Tenshō 2 (1574) and what appears to be the name of the artist. Although the eyebrows and beard are missing, the mask still radiates the serene good humor typical of *okina* masks.

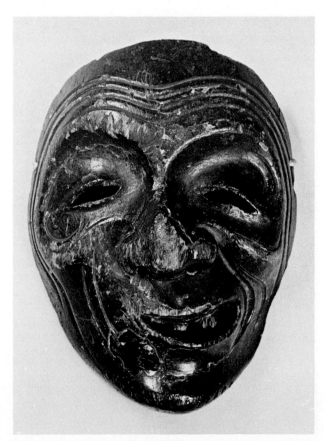

than those of later versions. Although the mask has a simple, artless quality, suggesting that it might have been made before 1550, pieces like this were also used in provincial Kyōgen during the Momoyama period.

Nō mask: deity *(tenjin)* **40**

Dated 1571
Polychromed wood
H. 8⅜ in. (21.3 cm) x W. 6⅜ in. (16.2 cm)
Suwa-asugi Shrine, Fukui Prefecture
REGISTERED IMPORTANT ART OBJECT

Tenjin was the posthumous name given to Sugawara no Michizane, the great ninth-century statesman and poet who was deified in an effort to placate his angry ghost after he died in exile. The *tenjin* mask, which is worn for the roles of various deities, is supposed to express Michizane's rage when his enemies successfully maneuvered to have him sent from the capital.

According to the inscription on the back, this example was presented to the Suwa-asugi Shrine by Nojiri Chiyokumamaru in 1571. The mustached deity bares his teeth in an expression of fury typical of this mask type, and deep hollows in the forehead accentuate the sharp ridges of the upturned brows. The eyes were once inlaid with gilt bronze rings, now lost, that indicated a supernatural character.

Nō mask: male ghost *(yase-otoko)* **41**

Late sixteenth century
Polychromed wood with gilt bronze inlay
H. 8½ in. (21.6 cm) x W. 6⁵⁄₁₆ in. (16 cm)
Private collection: Mitsui Hachiroemon, Tokyo
REGISTERED IMPORTANT ART OBJECT

The *yase-otoko* ("thin man") mask is used for the roles of ghosts of hunters and fishermen who are suffering the torments of hell for violating the Buddhist law against killing living things. The features are those of an emaciated middle-aged man. Like those of the *tenjin* (No. 40) and the *ja* (No. 45), the eyes of this mask are inlaid with gilt bronze

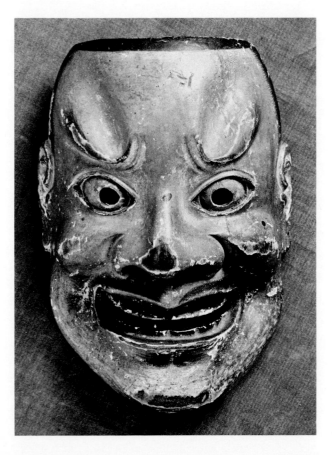

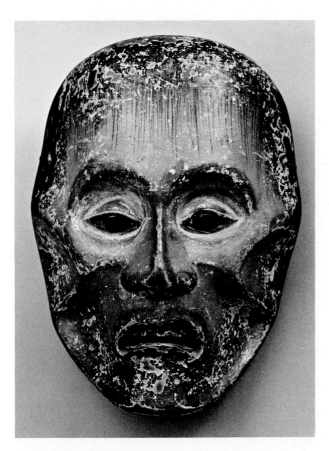

rings to suggest a supernatural status. The mask is usually worn with a shaggy black wig that hangs over the forehead and reaches to the actor's knees in back.

The *yase-otoko* would be worn in a play like Zeami's *Utō* ("Birds of Sorrow") in which a ferocious hunter, who killed young birds in their nests and was in turn slain by tears of blood shed by the parent bird circling in the sky, returns from hell in a vain effort to visit his wife and child. The hunter recalls for the audience his evil past, and, as the chorus describes his tortures in hell, he dances slowly, using a large white fan painted with a bird in flight to suggest the scene:

> In the earthly world I thought it only an easy prey, this bird, only an easy prey. But now here in Hell it has become a gruesome phantom-bird, pursuing the sinner, honking from its beak of iron, beating its mighty wings, sharpening its claws of copper. It tears at my eyeballs, it rends my flesh. I would cry out, but choking amid the shrieking flames and smoke, can make no sound (Zeami, "Birds of Sorrow," in *Anthology of Japanese Literature,* ed. and trans. Donald Keene, New York, 1955, p. 284).

Like the more than forty other masks in the Mitsui collection, this example originally belonged to the Kongō school, one of the four professional troupes of Nō actors that emerged in the late fifteenth and early sixteenth centuries. Although the mask has been traditionally attributed to Himi, a carver of Nō masks active in the Muromachi period (1392–1568), it is probably a late sixteenth-century work in his style. With its sunken eyes, harsh angles, and jaundiced complexion, the mask is a particularly effective representation of a man worn down by pain.

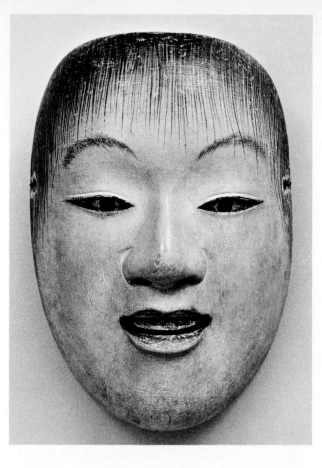

ghosts or gods. The long curves of the cheeks, short, fleshy nose, full lips, and pale skin give the *dōji* an affluent, rather sensual appearance. Although they do not appear here, dimples are usually added to emphasize his tender age.

An inscription by the Edo-period connoisseur Mitsushige Deme Genkyū attributes this example from the Mitsui collection to Chigusa, an artist active in the late fourteenth and early fifteenth centuries, but it was more likely made over a hundred years later during the Momoyama period.

The painting of the tendrils of fine hair and the feathery eyebrows is especially well executed.

Nō mask: boy *(dōji)* 42

Sixteenth century
Polychromed wood
H. 8 1/16 in. (20.5 cm) x W. 5 1/2 in. (13.9 cm)
Private collection: Mitsui Hachiroemon, Tokyo
REGISTERED IMPORTANT ART OBJECT

The youthful, elfin *dōji* mask is ordinarily used for the roles of boys who are eventually revealed to be

Nō mask: young woman *(ko-omote)* 43

Around 1578
Polychromed wood
H. 8 1/16 in. (20.5 cm) x W. 5 1/4 in. (13.3 cm)
Danzan Shrine, Nara Prefecture

Full cheeks, a broad forehead, and a softly rounded chin give the *ko-omote* mask an expression of ten-

der youthfulness that makes it especially suitable for roles of aristocratic young women. The mask illustrates prevailing fashions of the Muromachi and Momoyama periods, when women of the nobility shaved their eyebrows, repainting them higher on their foreheads, wore their hair hanging straight from a center part, and blackened their teeth with a paste of iron filings. Like most masks for female roles, the *ko-omote* has a subdued, almost enigmatic expression.

Preserved by the Jottsugyō Hall of the Danzan Shrine, which has a long history of staging Nō performances, this mask has been stored in a box inscribed with the date Tenshō 6 (1578). The inscription as well as the style of the mask indicate that it probably dates from the early years of the Momoyama period. With its wide-set, heavy-lidded eyes and faint smile, the mask conveys the sense of mystery and otherworldliness implied by the term *yūgen*.

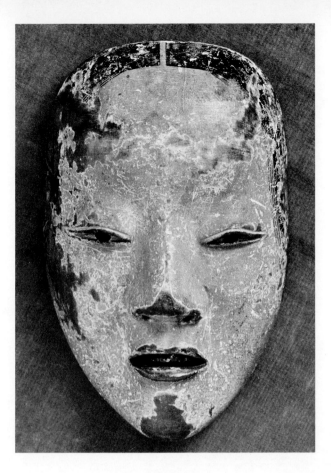

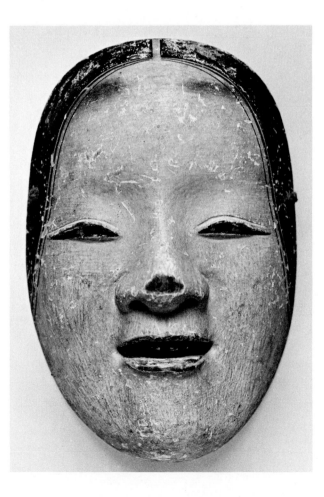

Nō mask: woman (*onna*) **44**

Second half of the sixteenth century
Polychromed wood
H. 8 ⅛ in. (20.6 cm) x W. 5 ½ in. (13.9 cm)
Suwa-asugi Shrine, Fukui Prefecture

In contrast with the plump curves of the *ko-omote*'s youthful countenance (No. 43), this woman's clear-cut features suggest maturity. Her high forehead, narrow, tilted eyes, thin cheeks, and pointed chin create an effect of fragility; her lips are parted, not by a smile, but by an effort to conceal emotion.

Although it appears to date to the Momoyama period, when round-faced beauties like the *ko-omote* were standard, this mask was carved with considerable freedom and does not conform to a specific type. Instead it is identified simply as *onna*, or "woman." With its haunting beauty tinged by ineffable sadness, the face reminds one of the innumerable court ladies in early Japanese verse whose sleeves were damp with tears wept for absent or faithless lovers.

45

Nō mask: demon *(ja)*

Late sixteenth century
Polychromed wood with gilt bronze inlay
H. 8 in. (20.4 cm) x W. 6 1/16 in. (15.4 cm)
Private collection: Mitsui Hachiroemon, Tokyo
REGISTERED IMPORTANT ART OBJECT

Demon masks with horns, called *han'nya,* are used in Nō for ghosts of jealous women. The *ja* mask belongs to this group, but is said to express the fury of a vengeful female ghost with even greater intensity than the other *han'nya* masks. The metal-covered eyes and teeth, prominent horns, scarlet face with white forehead, and a voracious mouth establish the supernatural and terrifying character of the *ja.* Only the high-set eyebrows and the hair indicate that the mask represents a woman.

Like the *yase-otoko* (No. 41) and the *dōji* (No. 42), this mask was also used by the Kongō school of Nō actors. With its dazzling forehead and gleaming fangs, it projects a violence of emotion that is in striking contrast to the self-contained refinement of the *onna* (No. 44).

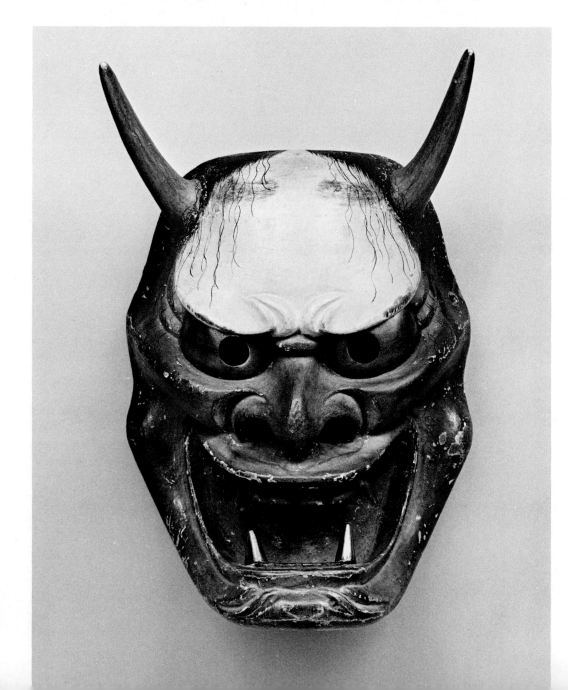

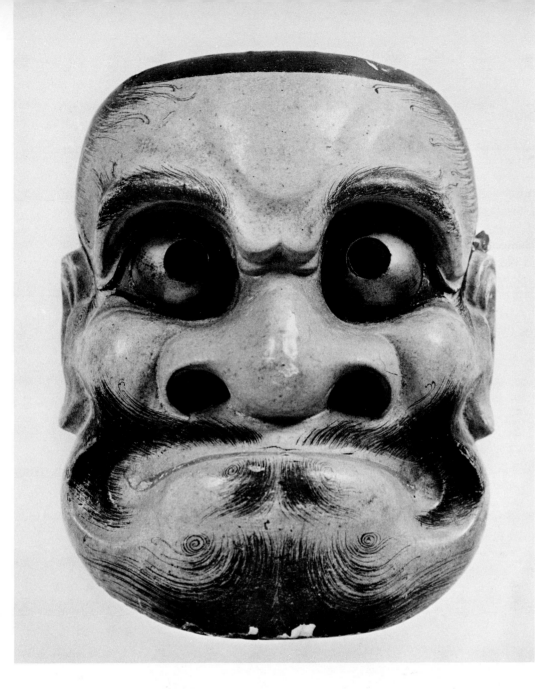

46

Nō mask: demon *(chōrei beshimi)*

Second half of sixteenth century
Polychromed wood with gilt bronze inlay
H. 8 ⅛ in. (20.7 cm) x W. 6 ½ in. (16.4 cm)
Tokyo National Museum

The *chōrei beshimi* belongs to a group of frowning demon masks called *beshimi,* distinguished by their tightly clamped jaws, large ears, flaring nostrils, and bulging metal eyes. Designed by an otherwise unknown artist named Chōrei, this particular type of *beshimi* mask is used for a variety of evil apparitions in the Nō plays. It is usually worn with a long, unkempt red wig, which intensifies its expression of fury.

This example originally belonged to the Komparu school of Nō actors. On the back is the signature "Kihi no Kensei," probably the name of the carver. Although the mask may have been repainted at a later date, the style and carving technique suggest that it was made in the Momoyama period.

Kyōgen mask: whistler *(usobuki)*

Sixteenth century
Polychromed wood
H. 7 5⁄16 in. (18.6 cm) x W. 5 ¼ in. (13.3 cm)
Tokyo National Museum

The *usobuki* mask is used in Kyōgen plays for roles such as the spirit of a mosquito, a cicada, or even a mushroom. Originally *usobuki* seems to have meant "whistler," a reference to the puckered mouth and taut cheeks.

Although later *usobuki* masks are distinctly non-human in appearance, this one resembles a coarse-featured, middle-aged man with tanned, leathery skin. His bushy eyebrows are knotted and his eyes are rolled up in an exaggerated expression of concentration very much in keeping with the burlesque humor of the Kyōgen plays.

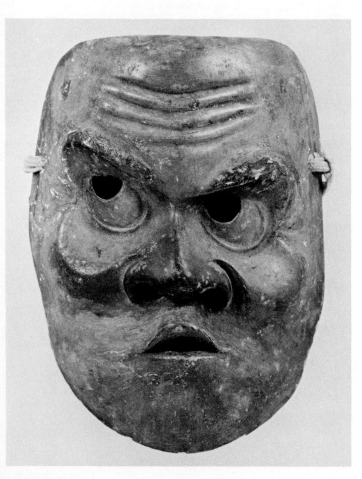

Textiles

Traditionally conservative, the design of clothing worn by Japanese military elite, actors, and even ordinary townsmen changed radically in the late sixteenth century in response to enthusiastic demands for innovations in weaving and dyeing. The extravagant new fashions were worn by anyone who could afford them, regardless of social background. Under Hideyoshi's vigorous patronage the domestic textile industry was revived, and the high-quality products of dyers, embroiderers, and the renowned Nishijin weavers of northwestern Kyoto (where more than five thousand looms were on register) eliminated the dependence on imports from China.

Imported materials, such as woolen fabric, were introduced in the exotic costumes of Westerners who were then arriving on Japanese shores (No. 48). In addition, a painstakingly elaborate style of embroidery in brilliantly colored silks—little used during medieval times—came into its own in the Momoyama period, largely replacing the more restrained woven patterns of Chinese brocades. The rich glittering effect of this technique, called *nuihaku* (literally, "embroidery and metallic leaf") (Nos. 50–54), is produced by embroidering over gold and silver leaf. Around 1600 a technique for a particularly sumptuous brocade called *karaori* was invented for use primarily in Nō costumes (No. 55). The most uniquely Japanese and the most treasured of Momoyama fabric decorations, however, is the tie-dyeing process called *tsujigahana* (No. 49).

Because the Nō robes of the period were intended for formal, almost ritual use on the stage, they are the most striking examples of Momoyama textile art. Against the severe backdrop of the Nō stage, these brightly colored voluminous costumes served to raise the roles of both humble fisherman and proud nobleman from the mundane to the sublime. The robe designs were enhanced by effective patterning devices such as sectioning, in which decorated panels were restricted to the shoulders and hems or to squares of alternating colors. Later, by the mid-seventeenth century, design elements were reduced in size and increased in number to form less dramatic, allover patterns.

Most of these robes shown here are *kosode* (literally, "small sleeves"), whose simple shape provided an open surface ideal for free decoration. Originally a plain garment worn under the many layers of a ceremonial court robe, the *kosode* evolved into a decorated formal outer robe during the Muromachi period (1392–1568). The Momoyama *kosode,* with its wide body, rounded, narrow-cuffed hanging sleeves, and narrow sash, eventually became the tightly fitting robe called *kimono* during the more authoritarian period of the Tokugawa shoguns.

The designs of Momoyama robes and the way they were worn by both commoners and aristocrats can be studied in popular genre paintings of the period such as Merrymaking under the Cherry Blossoms (No. 27) and Activities in the Capital (No. 28), as well as in the portrait of Takatora's wife (No. 3).

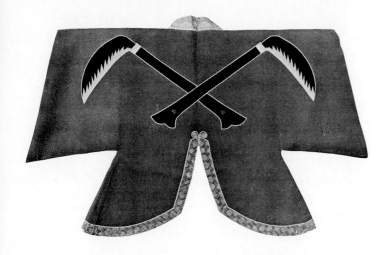

48

stripe design outlined in gold thread, and buttons up the front.

The strong pattern and dramatic color of this *jimbaori* must have reflected the temperament as well as the rank of its owner, Kobayakawa Hideaki (1577–1602), who at the age of twenty in 1597 had already been awarded a high court rank and was commander-in-chief of his uncle Hideyoshi's forces invading Korea. Although this campaign was not a successful one, he fought victoriously on the side of Ieyasu only three years later in the decisive Battle of Sekigahara. He died at the age of twenty-five, before he could enjoy the rich provinces he was awarded as fiefs. Ironically, the ivory silk twill damask lining of his jacket is embroidered in dark blue and yellow green silk with the single word "eternity."

Campaign jacket *(jimbaori)* with design of crossed sickles

Around 1600
Appliqué on woolen fabric
H. 2 ft. 6⅛ in. (76.6 cm) x W. 3 ft. 5¾ in. (106 cm)
Tokyo National Museum

Wool was not widely used in Japan other than for horse trappings or floor coverings until various kinds of woolen fabric (called *"rasha"* from the Portuguese word *"raxa"*) and Western clothing were introduced by Europeans in the late sixteenth century. Soon after that, the wealthy daimyo were purchasing imported woolen fabrics from the Dutch and Portuguese at Nagasaki.

This short jacket is of a type called *jimbaori* that was worn over armor like a tabard, both in camp and on ceremonial occasions, by the generals who fought in the great battles of the sixteenth century. Bulky armor and shoulder guards easily passed through its wide sleeves, and a slit in the back was intended to accommodate the long sword suspended at a warrior's waist and was also convenient for horseback riding.

The coarse but tightly woven *"Grofgrein"* wool, dyed scarlet, was imported from Europe and appliquéd on the back with an unconventional insignia of crossed sickles in black and white wool. Other decoration includes the peony-patterned brocade collar, a hemline trim of chrysanthemum and

49

Short coat *(dōbuku)* with design of cloves

Around 1603
Plain-weave silk with *tsujigahana* dyeing
H. 3 ft. 4³⁄₁₀ in. (120.5 cm) x W. 4 ft. 1⅝ in. (126 cm)
Seisui-ji, Shimane Prefecture
REGISTERED IMPORTANT CULTURAL PROPERTY

During the Muromachi period the *dōbuku,* a short, wide-sleeved coat, was developed to be worn over the *kosode.* This *dōbuku* is a particularly splendid example of the vibrant coloring and large-scale pattern that characterize the finest textiles of the Momoyama period. It was a gift from the first of the Tokugawa shoguns, Ieyasu, to Ōkubo Nagayasu (1545–1613), who, though the son of a popular entertainer, rose as a samurai under the powerful daimyo Takeda Shingen to become by 1610 Ieyasu's chief adviser on agrarian policy and mining. After his death it was discovered that he had embezzled public funds on a vast scale and that his duplicity had been successfully covered up by his closest associates. Ieyasu, an upright man of miserly temperament, ordered a halt to the funeral ceremony, in which Nagayasu was to be buried in a gold coffin, and initiated a full investigation.

In a simple and common form of tie-dyeing used before the Momoyama period, sections of fabric

were bunched together and wrapped with a strong thread to create random sunburst splashes. During the Momoyama period an allover pattern of tiny, precise tie-resist squares became fashionable (Nos. 3, 27). The present example, however, illustrates a unique and much more demanding form of the tie-dyeing process with the poetic name *tsujigahana* ("crossed flowers"). The technique appeared suddenly in the sixteenth century, only to be abandoned after the early seventeenth.

In *tsujigahana* dyeing, the design outlines were first meticulously basted in with very fine stitches that were drawn up tightly. Sections not to be dyed were then wrapped in a water-resistant material,

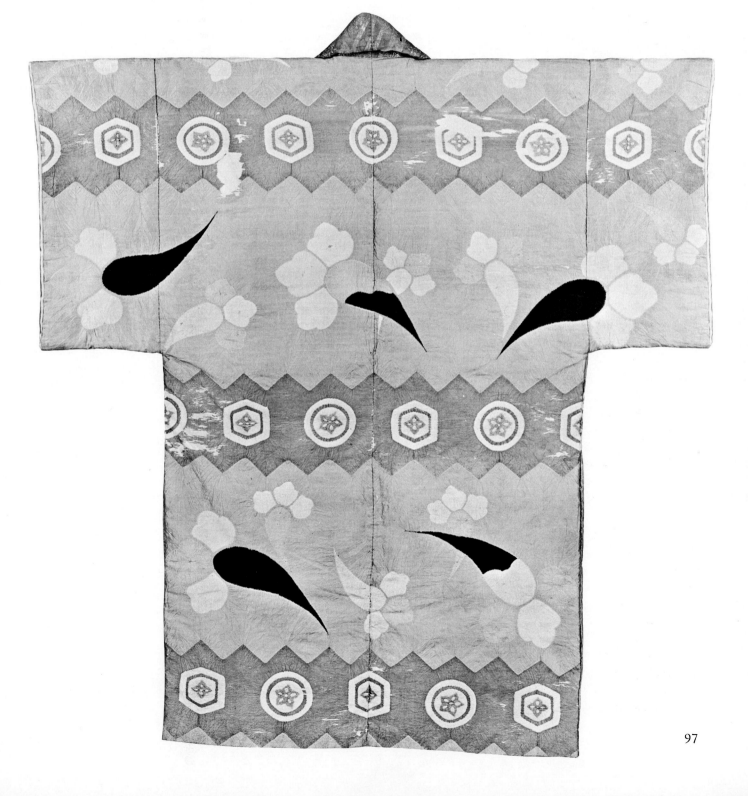

such as bamboo sheath, to protect them from the dye bath. The process had to be repeated for each color. When the fabric is examined closely, the tiny needle holes are visible, testifying to the time-consuming and complex nature of this method. The shirred effect of the drawn-up threads gives a special, much admired texture to the soft silk.

Here, a design of large and small cloves floats playfully across a yellow background, and although only a few colors are used—dark purple, ivory, pale green, and pale blue—they appear in continually varied combinations. The shoulders, waist, and hem of the coat are accentuated by three evenly spaced sawtooth bands of red, in which ivory tie-resist hexagons enclosing four-petal green flowers alternate with circles containing five-petal flowers. The collar is brown brocade with a fret pattern and paulownia crests.

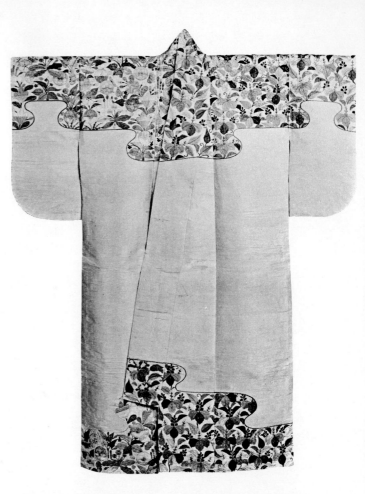

50

Kosode with design of paulownia, cherry blossoms, horsetails, and violets

Late sixteenth century
Embroidery and gold leaf on plain-weave silk
H. 3 ft. 10 ⅞ in. (119 cm) x W. 3 ft. 10 ⅞ in. (119 cm)
Ura Shrine, Kyoto
REGISTERED IMPORTANT CULTURAL PROPERTY

In the last years of the sixteenth century, the entire nation began to wear silk robes, and even lowly peasants had silk sashes.

This *kosode* is datable to the early Momoyama period on the basis of the *kata-suso* ("shoulders-and-hem") style. Its horizontal pattern sections are restricted to the shoulders and hem and are circumscribed by an undulating line likened to stylized sandbars or bands of clouds. Strikingly silhouetted against the plain body of the garment, these panels are elaborately embroidered with paulownia crests on one half and cherry blossoms, horsetails, and violets on the other. As is typical for the period, these designs have been reversed on the back of the garment. An additional note of elegance was originally conveyed by thin sheets of gold leaf once affixed with adhesive to the back-

ground of the *nuihaku* embroidery, but now almost entirely worn away.

Tradition associates this robe with the legendary one presented to the compassionate fisherman Urashima Tarō by his lover, the daughter of the Dragon King of the Sea.

51

Nō costume with design of flowering plants of the four seasons

Late sixteenth century
Embroidery and gold leaf and silver leaf on plain-weave silk
H. 3 ft. 3 ¾ in. (101 cm) x W. 3 ft. 4 ⁹⁄₁₆ in. (103 cm)
Tokyo National Museum
REGISTERED IMPORTANT CULTURAL PROPERTY

Like the previous robe (No. 50), this is a *kosode* with *kata-suso* ("shoulders-and-hem") patterning, but the example here was intended as a costume

for the Nō drama. Somewhat shorter than most Nō robes, it was worn by an actor taking the role of a child and conveys a sense of youthful charm and liveliness similar to that of the *dōji* mask (No. 42).

The body of the robe is an open expanse of lustrous plain-weave white silk that contrasts sharply with the gaily colored and densely crowded flowers of the four seasons embroidered in the panels. Winter is represented by plum blossoms and snow-covered willow branches, spring by double-petal cherry blossoms, summer by dandelions, and autumn by reeds and maple leaves.

Long, loose stitches made with threads of untwisted silk floss are couched down with short stitches that form the leaf vein and flower petal outlines. The color of a flower or its leaves may change arbitrarily partway through the design.

Embellished with gold leaf and silver leaf, this robe is an excellent example of the *nuihaku* embroidery technique.

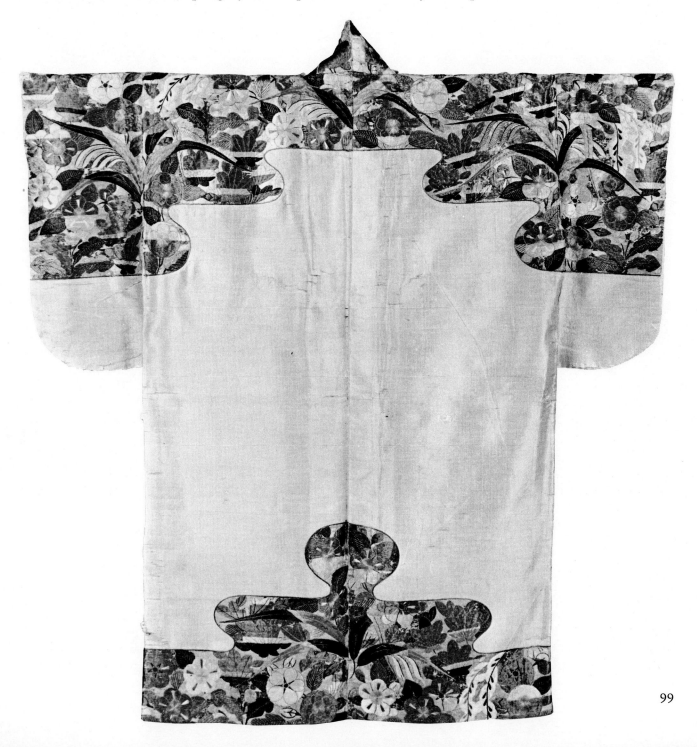

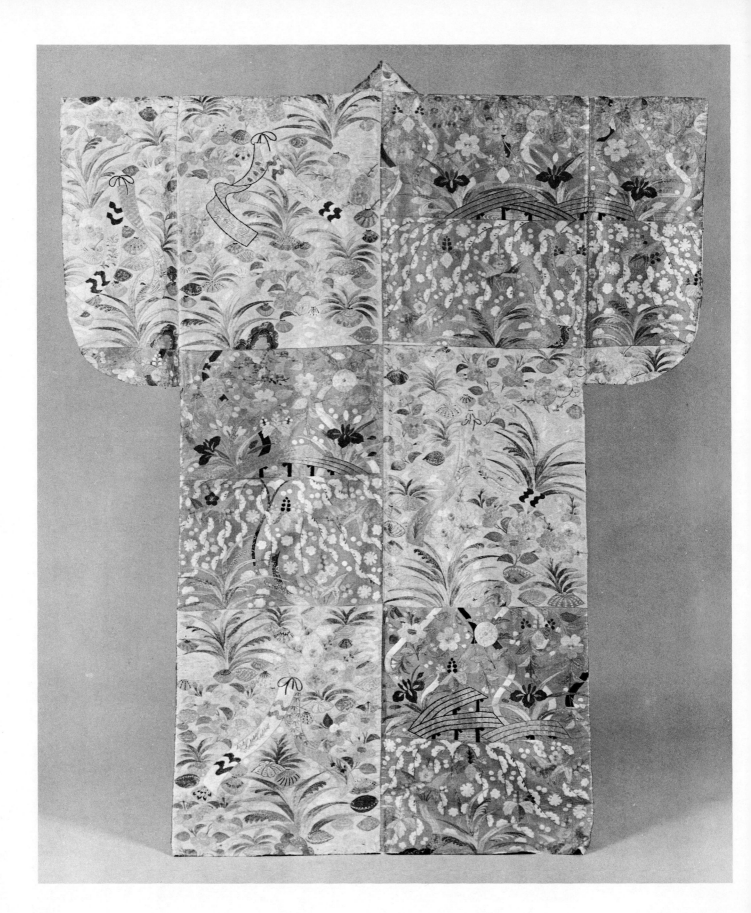

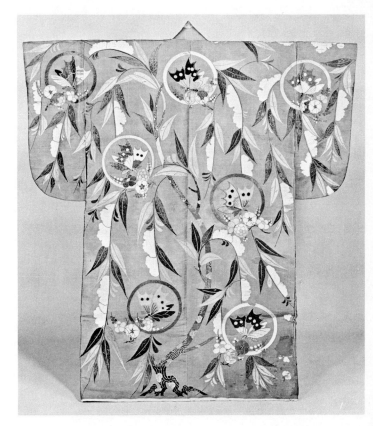

52

Nō costume with design of flowers, poem cards, and plank bridges

Late sixteenth century
Embroidery and gold leaf on silk
H. 4 ft. 6⅛ in. (137.5 cm) x W. 3 ft. 10 ⁷⁄₁₆ in. (118 cm)
Tokyo National Museum
REGISTERED IMPORTANT CULTURAL PROPERTY

This Nō costume was an heirloom of the Mōri family of western Honshū, whose ancestor, Mōri Terumoto, was one of the most wealthy and independent of the great daimyo leaders of the late sixteenth century (see No. 20). The background colors of red and white are woven with section-dyed warps in a distinctive Momoyama pattern of alternating squares called *dan-gawari*. Over this a design is intricately embroidered in polychrome silks and enhanced with applied gold leaf in the *nuihaku* technique.

It may appear at first glance that each red or white area repeats the same pattern, but close inspection reveals that, while reusing the same basic motifs, the artist has taken great care to vary both design and color. Against the white ground are embroidered fluttering narrow strips of paper for writing poems as well as cherry blossoms, grasses, and shells among waves. The red areas are further subdivided horizontally; the upper zone carries a pattern of vertically undulating parallel lines, the familiar Momoyama chrysanthemum and paulownia, branches of a weeping cherry tree, and a bridge of zigzagging wooden planks crossing a stream with iris. The famous eight-plank bridge *(yatsuhashi)* celebrated in a tenth-century poem-tale, the *Tales of Ise,* was revived as a favorite decorative motif in the Momoyama and Edo periods. The lower red zone includes a snow-covered willow tree (see No. 53), autumnal grasses, and, again, the paulownia-leaf crest.

53

Nō costume with design of snow-covered willows and swallowtail butterflies

Late sixteenth century
Embroidery on plain-weave silk
H. 4 ft. 2 in. (127 cm) x W. 3 ft. 9¼ in. (115 cm)
Kasuga Shrine, Gifu Prefecture
REGISTERED IMPORTANT CULTURAL PROPERTY

The innovation in Momoyama textile design that probably had the most impact on the following period is the use of a single motif that extends across seams to cover the entire costume. In this *kosode*-style Nō costume a bold embroidered pattern of large multicolored swallowtail butterflies within roundels fringed with plum sprays is arranged among the drooping branches of a single willow tree against a solid brownish red silk ground. The S-curve of the willow's trunk undulates up the center of the back to intersect with the circle directly below the collar. The rhythmically alternat-

101

ing curves of the leafy branches, weighted with puffs of white snow, are supremely graceful.

The Kasuga Shrine in Gifu also owns a very similar robe with butterflies in roundels among pine and wisteria, but set against a white ground. This Shinto shrine is thought to have been founded during the fourteenth century, the late Kamakura period, by swordsmiths living in this area, as an offshoot of the famous Kasuga Shrine in Nara, which houses the tutelary deities of the Fujiwara family. Because Shinto ceremonial Nō plays were performed there, many Nō costumes of the late-Muromachi and Momoyama periods are still preserved in the shrine.

54

Nō costume with design of cherry blossoms and bamboo fence

Late sixteenth century
Embroidery and gold leaf on silk
H. 4 ft. 5 ⅛ in. (135 cm) x W. 3 ft. 11 ¼ in. (120 cm)
Okayama Art Museum, Okayama Prefecture

Like the previous example this is a *kosode*-style Nō costume with a single motif executed in the *nui-haku* technique across the entire robe. Here, a single branch of a weeping cherry tree rises from the back of the left sleeve and falls in a regular series of slow curves down the center of the back. The thick clusters of blossoms are evenly dispersed, filling the available space in perfect balance without appearing either crowded or rigidly symmetrical. The meandering rhythm of the pliant branch suggests the pattern of a vine, an element particularly favored in Momoyama designs (see No. 70). For variety the blossoms are shown from both the front and the back, interspersed with dainty buds, and the leaves are embroidered in several shades of green. Gold leaf cross-hatching suggesting a bamboo fence is scattered across the background of warm reddish brown to temper the boldness of the large rounded white clusters. Cheerful and carefree, the profusion of blossoms recalls such contemporary works as the Hasegawa school Pine and Cherry Trees (No. 15).

55

Nō costume with design of paulownia and phoenix

Early seventeenth century
Silk twill patterned in weft floats *(karaori)*
H. 4 ft. 9 ½ in. (146 cm) x W. 4 ft. 9 ½ in. (146 cm)
Private collection: Sano Masahide, Ishikawa Prefecture
REGISTERED IMPORTANT CULTURAL PROPERTY

In the first decades of the seventeenth century, toward the end of the Momoyama period, a weaver named Tawaraya of Kyoto invented a richly colored brocade called *karaori* (literally, "Chinese weaving," despite its Japanese origin). The stiff, heavy *karaori* was intended specifically for Nō robes used in female roles, but was occasionally used for the costumes of the roles of aristocratic young men. The red in this superb example further marks it as the costume of a beautiful younger woman.

On a twill-woven dark green silk ground the design is brocaded with brilliant red, yellow, light and dark blue, light green, and white silk pattern-wefts that are raised above the surface so that they appear to float on it. These long and glossy pattern-weft threads are clearly meant to imitate the effect of embroidery, but because of the mechanical limitations of the loom, the outlines of each design element are slightly staggered—not as curvilinear as embroidered contours.

Although it is a repeat weave, some variation is possible in the *karaori* technique, giving the designs an exciting liveliness and strength. Pattern units of two mythical phoenix birds regally paired with four auspicious sprays of paulownia leaves are alternately reversed for variety, and the weaver has outdone himself in attempting to make every possible combination of colors without duplication.

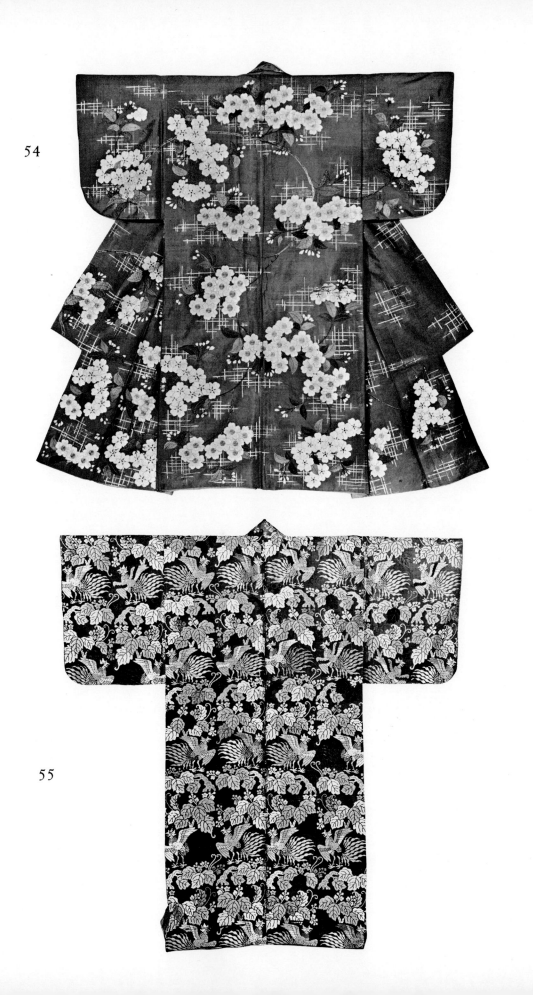

54

55

Ceramics

Before the Momoyama period, most Japanese ceramics were somber-hued, unglazed stone-wares intended primarily for storage, rarely for decoration or ritual. These ceramics were of little interest to patrons of art until the new aesthetics of the ritual tea ceremony made them desirable. Tea drinking, which had been introduced to Japan several centuries earlier by Zen monks returning from Chinese monasteries, was incorporated by the Japanese aristocracy into elaborate social gatherings that included the display of their Chinese ceramic collections. In the late fifteenth century a group of monks reformed this ritual, basing it on the Zen Buddhist view of a humble and frugal life.

For the tea ceremony, the host would invite a few of his friends to join him in the intimate setting of a specially designed tea room. While he laid the fire in a sunken hearth or brazier (see No. 29, Fig. 8) and put the kettle on to boil, they moved silently through the small adjacent garden. In the tea room the guests took their places in a row opposite the hearth, where they watched the careful preparations of the tea master, who passed to each guest in turn his bowl of tea. After drinking his tea the guest would appreciate the unique qualities of the implements. Originally these utensils were Chinese wares, but were supplemented in the sixteenth century by the less pretentious products of Korean kilns and, eventually, by Japanese household wares.

Momoyama ceramics represent not only the creative exuberance of potters with new and advanced techniques at their disposal, but also the cultural aspirations of their patrons. Both prominent military men and merchants participated in the tea ceremony as a social and artistic activity. Under the guidance of the son of a Sakai merchant, Sen no Rikyū (1521–1591) (No. 57), who formulated the Momoyama tea style, they patronized the native kilns for tea utensils and encouraged the potters to experiment.

Many handsome wares came from the established kilns, which expanded their production to include tea utensils as well as storage wares. The water jars and vases from Shigaraki (No. 57) and Iga, which were thought to show restraint and strength, continued the long tradition of unglazed stoneware. Another traditional stoneware kiln, Bizen responded to the Momoyama

market with unglazed pieces of refined form whose effect depended on the natural color changes produced during firing (No. 56).

This period marks the first widespread use in Japan of glazes and painted designs. The numerous kilns in the Mino region in central Honshū were the first to innovate, producing the wares known as Shino, Oribe, Yellow Seto, and Black Seto. Shino ware (Nos. 59, 60) is characterized by its rich feldspathic glaze complimented by designs rendered with iron-bearing pigment in tones of rust and gray. Oribe ceramics (Nos. 61, 62) are said to have captured the eclectic, showy aspect of Momoyama taste, and tradition holds that they were inspired by Rikyū's chief student, the daimyo Furuta Oribe (1543–1615). In contrast to Shino's gentleness, Oribe wares combine areas of brilliant copper-green glaze with playful designs in iron wash on a variety of thrown and molded shapes. The ash-and-iron-glaze traditions were developed in the Muromachi period and were applied to new shapes in the Yellow and Black Seto wares (No. 58) of the Mino kilns, which supplied the tea-ceremony enthusiasts of Kyoto, Osaka, and Sakai.

In northern Kyūshū, kilns developed strong ties to Korean style and technique following Hideyoshi's invasion of the peninsula and the relocation of Korean potters. The standard for wares from the area was set by the chastely decorated, softly glazed products from Karatsu, in Hizen Province (Nos. 63, 64). Kyūshū potters found an appreciative audience among the merchants of Hakata and other port cities of western Japan.

In contrast to the anonymity of these rural wares, Raku ware heralded a new phenomenon in Japanese ceramics: the urban studio potter who signed his work. Raku tea bowls, low-temperature red and black wares, were produced according to Rikyū's taste by the Kyoto tilemaker Chōjirō and his descendants. Even today, the Raku bowls seem to exemplify the special attitude of the Japanese toward ceramics inspired by the aesthetics of the tea ceremony: each bowl is treated as a unique sculptural entity, with a personality, a history of ownership, even a name. Among the most memorable of all Japanese ceramics are the tea bowls fired in the Raku manner by the influential designer, calligrapher, and ceramist Hon'ami Kōetsu (1558–1637) (No. 65).

perfect foil for a single camellia or a branch of early flowering plum.

The tubular vase form seems to have derived initially from Chinese bronze vases, which had been fashionable for tea ceremony use earlier in the sixteenth century, but it was freely interpreted by Japanese potters. In this piece, a short neck finished with a thin folded-over rim balances a heavy, well-defined base. Thus framed, the body has been sculpted further with a blunt bamboo stylus. Two meandering lines softly mold the shoulder, and calligraphic arcs and slashes add variety and interest to the flat walls. Brusquely drawn hatching girdles the base. Part of the body is coated with a dull yellow ash-film and the rest is burnt to a warm rust tone tinged with purple. Momoyama Bizen potters hoped for, but seldom achieved, such rich coloration. In making tea ceremony wares, they continued the Bizen tradition of using no glaze, relying instead on prolonged firing to produce a watertight body with the velvety surface that distinguishes the ware. Experimental yet subdued in their approach, Bizen potters produced a large group of handsome vases and fresh-water jars that were perfectly adapted to the taste of the tea men.

56

Bizen vase

Around 1600
H. 10 in. (25.3 cm)
Private collection: Kitamura Kinjirō, Kyoto

Diamond-shaped in cross-section from the rim to the base, this piece is unique among Bizen flower vases, most of which are simple cylinders. It illustrates the Momoyama potters' preference for treating pieces as sculptural forms rather than merely functional containers. As tea ceremony records show, such a vase would have been selected as the

57

Shigaraki fresh-water jar

Named *"Shiba no Iori"* ("Purple Pavilion")
Late sixteenth century
H. 5¾ in. (14.7 cm)
Tokyo National Museum

Said to have been in the personal collection of Hideyoshi's tea master, Sen no Rikyū, this typical early Momoyama jar was considered to be one of the "three best" Shigaraki jars in tea collections.

The fresh-water jar, or *mizusashi,* contains the cold water for replenishing the kettle and for rinsing the tea bowl. The prototype for its simple form was the small all-purpose container that Shigaraki potters had been making for their farmer clients. When such farm wares came to be adopted as tea utensils, potters applied some conscious design—such as the short, everted rim of this jar—but they

relied mainly on natural effects for ornamentation. On one side this jar has been toasted to a warm reddish brown flecked with the silica granules that occur naturally in Shigaraki clay, while on the opposite face, which was directly exposed to the flames, a crack developed and a thick mantle of glaze formed when gusts of hot air deposited pine ash on the molten surface.

The cumulative effect of such fortuitous firing accidents was termed "scenery" *(keshiki)* by the tea men, and they read the surface of a pot with the same attention they gave to an ink landscape. The visible record of the pot's survival of fire, the rugged beauty of its scarred surface, seemed appropriate for a ceremony that, in its philosophical basis, was intended to serve as a model for disciplined behavior.

Rikyū's choice of this water jar indicates the conservative direction of his taste in the last years of his life. Along with Bizen, Shigaraki wares enjoyed their greatest popularity in the third quarter of the sixteenth century; in the Momoyama period they were being supplanted in most tea circles by the livelier, less introspective glazed wares from Mino and the other new kilns.

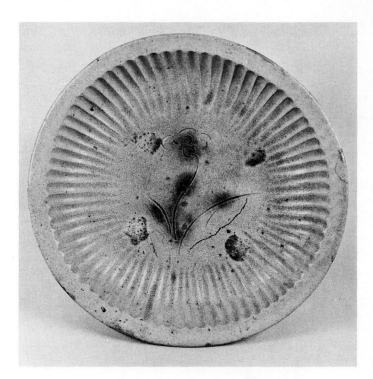

58

Yellow Seto *(ki-seto)* bowl with design of flowering plants

Mino ware
Late sixteenth century
H. 1 ⅞ in. (4.7 cm) x D. 11 ½ in. (29.1 cm)
Tokyo National Museum

With a long history of glazed wares, the kilns of the Mino region (now Gifu Prefecture), were the natural site for the development of glazed tea ceremony ceramics. In appearance as well as name, early Mino Yellow Seto pieces are closely related to the yellow-toned ash-glazed bowls produced at the nearby Seto kilns in Owari Province (and also known, confusingly, as Yellow Seto) throughout the Muromachi period. The Momoyama Yellow Seto *(ki-seto)* developed into a distinctive ware with a butter yellow matte-surface glaze.

Mino Yellow Seto ware seems to have been favored especially for use in the formal meal *(kaiseki)* that precedes the two services of thick and thin tea. Momoyama tea masters replaced the customary black or dark red lacquer table wares with festive pottery bowls and plates. At the same time,

the *kaiseki* meal itself, which had begun as a frugal token repast, developed into an elaborately specialized dinner carefully designed by the host to present the best possible succession of tastes.

The generous dimensions of this basin are unusual for Yellow Seto wares, most of which are small plates or sets of side dishes. Designed as a serving bowl, it has a soft-toned, grainy glaze intended to provide an appealing background for the painstakingly prepared food. The basin is a classic example of the true Mino Yellow Seto style, known both as *aburage-de* ("fried bean-curd type"), in reference to the glaze texture, and *ayame-de* ("iris type") for its typical decoration. A blooming iris, emblem of early summer, is incised onto the plate and lightly splashed with green copper sulfate. The everted rim, which circles the iris like a frame, is sketchily carved with whorls that suggest full-face chrysanthemum blossoms. The method of stacking the piece in the small, shelfless tunnel kiln used at Mino has left traces of a ring-shaped support on the base and four stilt marks on the face.

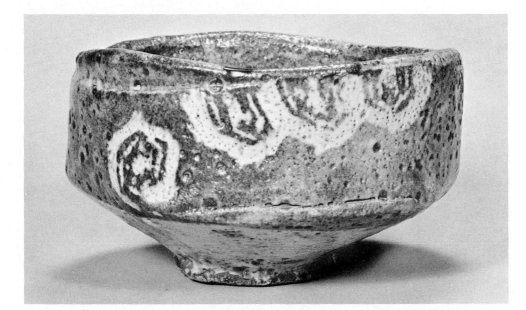

Gray Shino tea bowl **59**

Named *"Mine no momiji"* ("Summit Maples")
Mino ware
Late sixteenth century
H. 3 ⅞ in. (8.6 cm)
Gotō Museum, Tokyo

The vivid design of this bowl, although highly contrived, is one of the most skillful among Gray Shino bowls. Unlike the squat cylindrical "sagger" shape with wide flat base that is typical of most Shino ware, the white lower walls of this piece flare abruptly from a shallow carved foot and meet the nearly vertical gray sides at a sharp angle. The narrow foot gives the bowl a sense of lightness seldom found in Shino pieces.

The potter worked the lip into a gentle, undulating curve, echoing it with bamboo-knife cuts just below the rim and around the lower edge of the sides. The motifs of "tortoise-shell" hexagons and "cypress-fence" cross-hatching, typical Shino designs, stand out sharply on the gray ground. The unique Gray Shino slip, made from iron ore found in the mountains of the Mino region, was applied to the inside and outside walls of the piece; the designs were scratched into the slip before the whole piece was covered with milky glaze, letting the lower walls and designs show white. Where thinly applied, the glaze on the sides fired to black and reddish tones, the red striations perhaps giving rise to the name by which the bowl is known, "Summit Maples."

The bowl is thought to be a product of the Kamashita kiln at Ōkaya, one of the foremost Shino kilns, active in the 1580s and 1590s.

Marbleized Shino fresh-water jar **60**

Mino ware
Last quarter of the sixteenth century
H. 7⅜ in. (18.7 cm)
Private collection: Kimura Yasuyuki, Kanagawa Prefecture

Production of tea bowls did not completely account for the sudden rise in ceramic production in the late sixteenth century. Other utensils for the tea ceremony, including Shino fresh-water containers, were also made in large numbers at the Mino kilns. The two typical Momoyama water jar styles were the "notched rim" style with its inward-folding rim and the plain cylinder, of which this piece is an example.

The marbleizing technique used here combines two clays of similar properties, one the standard white and one tinted with iron. When thrown, glazed, and fired, this combination of clays produced a gray stripe revolving up the white body. The potter had to throw the piece with extreme care so that the bands would spin evenly up the walls and end in a ring of gray around the lip. After throwing, the potter used his bamboo knife to incise a groove around the neck and to encircle the walls with rough cuts. The container was then sliced from the wheel with a cord, leaving a whorl pattern on the base.

Marbleized Shino pieces are rare; this jar is further distinguished by two inscriptions in Chinese characters brushed on the outside with iron pigment: "autumn wind" and "a winter that pierces the heart." A design of cross-hatching was drawn on one side.

It appears that this piece was fired at the Yuemon kiln in Ohira, a small village near Ōkaya, in the last quarter of the sixteenth century.

61

Oribe square plate with design of nested boxes

Mino ware
Early seventeenth century
H. 2 ¼ in. (5.7 cm) x W. 8 ⁷⁄₁₆ in. (21.5 cm)
Tokyo National Museum

Oribe ware appeared at the beginning of the seventeenth century in Mino, the same region that produced Shino ware. Although Oribe ware is said to be named for the tea master Furuta Oribe (1544–1615), the actual relationship between the man and the kilns is unclear. It is certain, however, that Oribe delighted in the imaginative designs and bright colors of the ware and used it frequently at his tea ceremonies.

This piece is in the technically elaborate Narumi Oribe style in which sections of red clay are combined with the usual white clay. Most Narumi Oribe was molded rather than thrown on the wheel to facilitate the combining of two different clays. The white stripes were applied on the portion made of red clay and highlighted with black along their edges. The green glaze was then poured only over the half of the body made of white clay, since this part would not interfere with the copper content of the glaze and would allow the rich green color to shine more clearly. The deep tone and fluid contours of the green glaze made a striking contrast with the more geometric red and white design. The striped motif is known as the "measuring-box" design because the series of rectangles resemble the set of nested boxes used for measuring grain.

Because the piece was formed in a mold, the potter was able to add variation to the walls by giving them a stepped profile. Four legs support the base.

62

Oribe candlestick in the *Namban* style

Mino ware
Early seventeenth century
H. 14 in. (30.6 cm)
Private collection: Setsu Iwao, Tokyo

The arrival of Western culture in Japan in the mid-sixteenth century was soon reflected in the arts. So-called *"Namban"* (Southern barbarian) designs, including Christian crosses and Western costume, were quickly adopted as motifs on native Japanese crafts, particularly lacquer and ceramics. The fashionable and witty Oribe ware was no exception, and the idea of using a human form as a candlestick is consonant with the originality for which it is known.

The hair and features of this "barbarian" Portuguese merchant are realistically finished in a matte iron wash, but the potter stamped quite un-Portuguese chrysanthemums on the collar of the blouse. Although his pantaloons were left white, his blouse and the basket he carries were glazed in characteristic Oribe green.

Much Oribe ware was sculpted: there is a group of these figurine candlesticks, along with numerous pipes, water droppers, and inkstones. This freedom of design on the part of the potters reflects the eclectic tea ceremony taste of Furuta Oribe, who used pieces of imported Delft ware with those of native and Chinese kilns. A stylist with a love of glamorous effects, Oribe is said to have decorated the tea room with rainbow colored paper and to have fashioned small cloths for wiping tea utensils (*fukusa*) from a patchwork of valuable old damasks. His political indiscretion put him in disfavor with his Tokugawa patrons, and, like Rikyū, he was ordered to commit ritual suicide.

The Oribe potters injected new vigor into tea ceramics, breaking with the classical tea style and pointing the direction for the development of seventeenth-century ceramics.

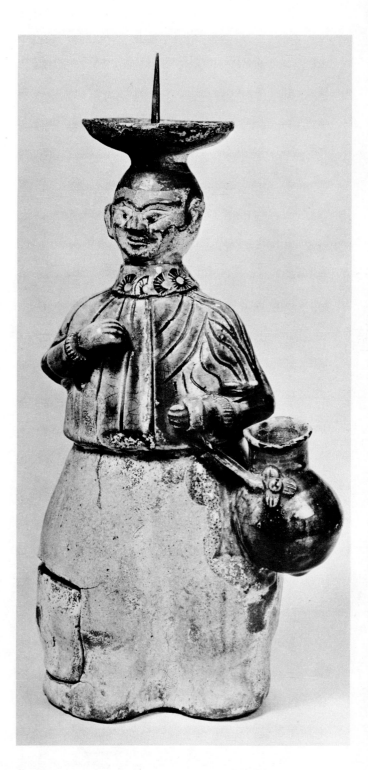

63

Karatsu tea-leaf jar with design of persimmons

Late sixteenth century
H. 6⅝ in. (17.1 cm)
Idemitsu Gallery, Tokyo

Lying near the port of Karatsu on the north coast of Kyūshū, the Karatsu kiln region was geographically close to Korea, and most sixteenth-century Karatsu ceramics strongly resemble utilitarian wares from Korean kilns. In its refinement and careful detail, this jar is no ordinary kitchen storage vessel but a container for tea leaves perhaps made on special order from a tea master. The green tea, used only for the tea ceremony, is made from the smallest, flowery upper leaves of carefully protected tea trees grown on special plantations. The tea leaves were picked in spring and often placed in jars like this for storage in a cool place, either a mountain temple or specially dug pit, to protect them during the hot, damp summer.

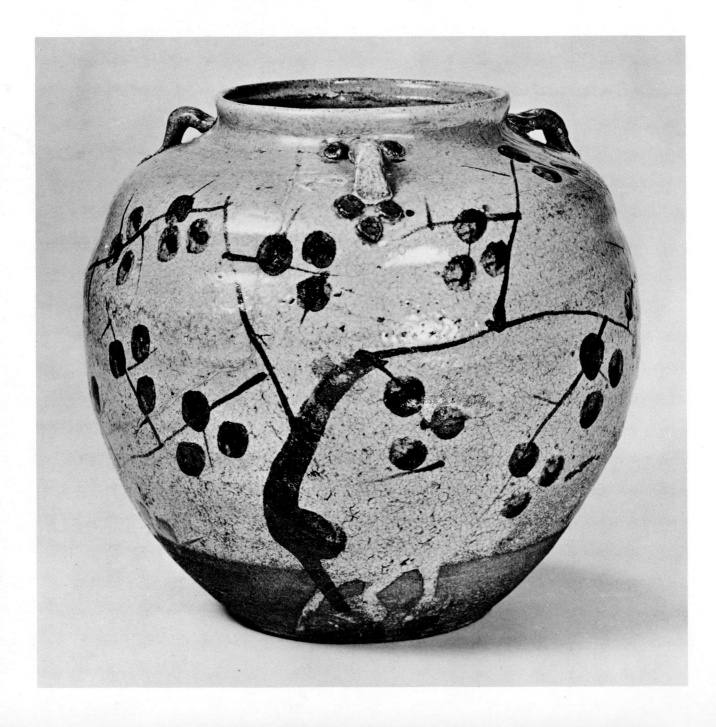

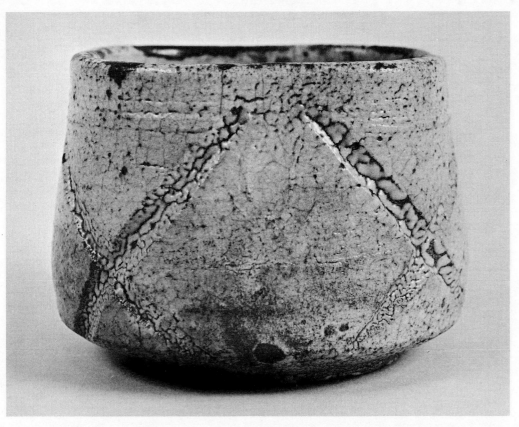

Judging from the seasonal design, this jar might well have been made for use in the *kuchikiri* ("opening the lid") tea ceremony held in early November for the ritual opening of the first jar of tea leaves harvested the preceding spring.

The large, wide-mouthed jar has three ears through which passed the silken cords for fastening a cloth-covered wooden lid. A leafless persimmon tree displaying its fruit under the cloudless sky of late autumn is painted with brush and fingertip entirely in iron pigment. The dark color is slightly muted by the smooth brown glaze into which the jar was dipped after it was painted.

64

Karatsu tea bowl, *hori-garatsu* ("incised") type

Late sixteenth century
H. 3 ⅞ in. (9.9 cm)
Tokyo National Museum

Most Karatsu tea bowls are either plain or chastely decorated with spirals and floral motifs in iron pig-ment. Although rare, the bowls with incised patterns show a robustness of both shape and décor that seem particularly close to the spirit of the early Momoyama tea ceremony style. Sherds of incised bowls similar to this example have been unearthed from the lower Handōgame kiln in the Kishidake Peaks complex, whose five kilns were active until 1594.

Like many early Mino ware tea bowls, this bowl hugs the ground on a low foot. The distinctive shallow double-edged foot ring is identical to that on other incised pieces. The walls of the low cylindrical bowl widen slightly at the thick rim. A band of Xs was carved quickly into the soft clay; feldspathic glaze was applied generously inside and out. The incised Xs and the glaze have merged in an understated decorative effect: on the smooth surfaces, the glaze has developed an attractive crackle; in the grooves, where the cutting tool roughened the raw clay surface, the imperfectly adhering glaze formed a more coarsely grained pattern. This indeed is a bowl made to be appreciated through handling, an aesthetic experience much sought after by Momoyama tea men.

65

Black Raku tea bowl

Named "Shichiri"
By Hon'ami Kōetsu (1558–1637)
Early seventeenth century
H. 3¼ in. (8.2 cm)
Gotō Art Museum, Tokyo

Under the influence of Sen no Rikyū a talented tile-maker named Chōjirō originated Raku ware in the 1570s. Rikyū had discovered the tilemaker working on Hideyoshi's sumptuous Kyoto residence, the Jūraku-dai. According to legend, Chōjirō's descendants were rewarded with the right to use the character *"raku"* from the palace name as their surname. The third generation potter, Dōnyū, instructed Hon'ami Kōetsu, who from 1615 was occupied with directing a craftsmen's community on Mount Takagamine, north of Kyoto. That this masterful designer, calligrapher (Nos. 33–35), and sword connoisseur should have included pottery among his many renowned abilities indicates not only how highly he regarded the potter's art, but also the trend toward participation in the art by amateur tea-master-potters. Kōetsu created a group of Raku tea bowls without equal. Although few in number, they are today among the most highly valued of all Japanese ceramics.

This bowl is named for one of its owners, Shichiri Hikosaemon. Its high straight walls slope down from a wide mouth to meet the base at a sharp angle. The bowl stands on a low, narrow foot. Kōetsu's special touch is apparent in the carving within the flat foot ring, concealed so that it greeted the bowl's user only after he had finished his tea and turned over the bowl to examine it. The black glaze fits like a delicate skin over the inside and outside, leaving several patches of clay covered only by a thin wash of iron.

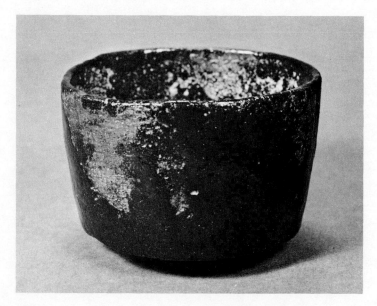

Lacquer

The art of Japanese lacquer requires extraordinary skill, training, and patience. The technique was introduced from China in the eighth century, and the basic method of production remains unaltered to the present day: first, the thick sap of the lac tree *(Rhus vernicifera)* is stored in wooden vats and is then strained through hempen cloths to remove impurities. Subsequently, the resin is heated and stirred for many hours to evaporate excess moisture, and, finally, it is colored. The object to be lacquered is usually made of wood, although many other materials, including cloth, metal, porcelain, plaited bamboo, or paper can also be used. The wood is carefully smoothed, primed, and covered with hemp cloth or paper to isolate it from the lacquer. Each coat of lacquer (there are thirty or more on a fine piece) must be perfectly smooth and dry before the next is applied. Not a grain of dust is allowed to touch the surface during the drying process. After each layer has dried, it is ground and polished.

Pieces of particularly high quality are often embellished with a variety of designs painted in colored lacquers, incised, modeled in relief, or inlaid, but the decoration that Japanese craftsmen preferred and perfected from the ninth century on is the gold lacquer *makie* ("sprinkled picture"). In the solid gold *hiramakie* ("flat" *makie*) technique favored during the Momoyama period, the sprinkled gold powder, coated with layers of transparent lacquer, is scarcely raised above the ground. The design is drawn in colorless liquid lacquer on the completed lacquer ground, and extremely fine gold or silver powder is sifted evenly over the drawing while it is still wet and adhesive. During subsequent polishing, the metal particles on the surface of the lacquer are burnished until they glisten brilliantly.

Another technique is to cover the background of a lacquered article with a thick layer of *nashiji* ("pear ground"), named for its resemblance to the granular texture of the Japanese pear. In *nashiji,* which resembles European aventurine lacquer, small irregularly shaped particles of gold, gold-silver alloy, and silver are scattered over the still-wet ground, and are covered after drying with a layer of translucent reddish yellow lacquer in which they appear to be suspended at varying depths. In the Momoyama period the *nashiji* was restricted to the actual design elements on a solid, black background, a technique known as *e-nashiji* ("pictorial" *nashiji*).

Costly decorated lacquer ware, for centuries the preserve of an elite aristocracy and powerful temples, was eagerly sought after by new classes of society in the Momoyama period. Even the most ordinary household possessions were reproduced in lacquer and were embellished with steadily increasing flamboyancy. The common people, however, had to content themselves with products of inferior workmanship, which were also exported to European markets.

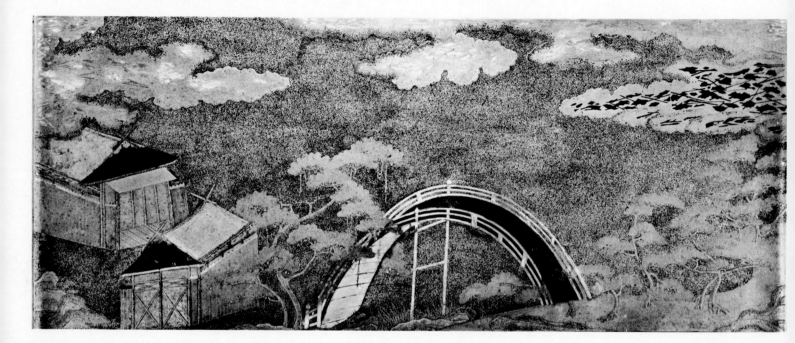

66

Writing table with design of Sumiyoshi Shrine

Around 1586–1598
Wood with gold *makie, kanagai, kirikane,* and *nashiji*
H. 9 ⅞ in. (25.1 cm) x L. 2 ft. 11 ⁹⁄₁₆ in. (90.3 cm) x
 W. 14¹⁵⁄₁₆ in. (38 cm)
Ninna-ji, Kyoto
REGISTERED IMPORTANT CULTURAL PROPERTY

Temple legend records that this low writing table was presented by Hideyoshi to the emperor Go-Yōzei, fixing its date to between 1586, when the latter ascended the throne, and 1598, when Hideyoshi died. The piece is traditional in its subject matter—the Sumiyoshi Shrine, a Shinto religious sanctuary near Osaka—and conservative in its complex mixture of several techniques characteristic of the preceding Muromachi period.

Rocks and trees are modeled in relief and then coated with metallic or colored layers of lacquer in a technique called *takamakie* (raised *makie*) and thin sheets of gold inlay *(kanagai)* appear in the bridge and parts of the roofs. Strips of cut gold *(kirikane)* have been applied to the clouds and the entire background is coated with a thin layer of *nashiji,* or "pear ground."

Despite these conservative technical features, the design is strikingly original, alive with a bold sense of abstraction. The formal devices are strong and undisguised: the deliberately exaggerated shapes of the arching bridge and the shrine walls, for example, impart a liveliness that is contained within the framework of clouds and pine foliage.

67

Set of lacquer articles

Around 1596
Wood with black lacquer and gold *makie*
Stationery box *(bunko)* with design of autumn plants
 and bamboo
H. 10½ in. (26.7 cm) x W. 12³⁄₁₆ in. (31 cm) x
 L. 19¹³⁄₁₆ in. (50.3 cm)
Three tables *(kakeban)* with design of paulownia and
 reeds
H. 9⁷⁄₁₆ in. (24 cm) x W. 13¾ in. (35 cm) x
 L. 13¾ in. (35 cm)
Ten bowls with design of paulownia and reeds
H. 2¹³⁄₁₆ in. (7.2 cm) x D. 5½ in. (14 cm)
Kōdai-ji, Kyoto
REGISTERED IMPORTANT CULTURAL PROPERTY

This group of articles is part of a larger set of lacquer commissioned by Hideyoshi and his principal wife, Kita no Mandokoro, for their Fushimi Castle. With assistance from Hideyoshi's successor, Tokugawa Ieyasu, Hideyoshi's widow had the temple Kōdai-ji erected in Kyoto in 1605, seven years after Hideyoshi's death. She lived there as a nun until her death in 1624. The mausoleum of this temple, built for the repose of her husband's soul, is entirely outfitted with ornate lacquer architectural decorations, as well as furniture and utensils that she had brought from the castle. The date 1596, the year Fushimi was rebuilt following a severe earthquake and a decade earlier than the founding of Kōdai-ji, was recently discovered inscribed on the inner door of one of the lacquer shrines that houses wooden portrait statues of Hideyoshi and his wife.

The Kōdai-ji *makie,* as these lacquer pieces are collectively known, are so representative of their period that the very name is now used to designate any Momoyama lacquers in this style. Primary characteristics of Kōdai-ji lacquer are the motifs of flowering autumn plants, including *suzuki,* or pampas grasses, and chrysanthemum and paulownia-leaf crests, which were adopted by Hideyoshi.

Unlike earlier periods, when such field grasses were an integral part of a landscape setting with symbolic or literary overtones, during the Momoyama era the designs were frankly isolated and exploited for the sensuous visual beauty of their gracefully curving lines. The decoration, uncompli-

cated but extravagant, is consciously adapted to the shape of the utensil.

Technically, the Kōdai-ji lacquers are rather simple; the intricate high relief, cut gold, and inlay décor favored earlier has been replaced with plain, flat gold lacquer designs *(hiramakie).* These are often contrasted with designs of sprinkled reddish gold *e-nashiji* to create nuances of color and texture.

The stationery box, used as a container for letters, writing paper, and books, was probably never far from Kita no Mandokoro's side. The design on the lid and four sides is composed of diagonally bisected patterns, half with strong vertical bamboo trunks on a *nashiji* ground and half with lightly swaying autumn plants and grasses on a solid black ground. The stunning contrast of the two areas, which are totally different in color, rhythm, and motif, was a new invention called *katami-gawari* ("alternating sides") that was much favored around 1600 by artists working not only in lacquer but also in ceramics and textiles.

As remarkable as it may seem, these ten bowls with covers and high stands were intended as practical eating utensils for soup or other delicacies. Each bowl was hollowed on a lathe to fit perfectly into the curvature of the hand. A lavish gold lacquer design of reeds and paulownia crests matches that of the tables from this same group. So many golden surfaces might seem vulgar by traditional aesthetic standards, but they were a perfect manifestation of Hideyoshi's wealth and his love of ostentatious display. Franciscan missionaries who were granted an audience with the ruler report that they were taken to "a chamber completely lined with gold plates and on his orders . . . were given food to eat with gold utensils—even the chopsticks were of gold" (St. Pedro Bautista Glanquez, "Audience with Hideyoshi at Nagoya, 1593," in Cooper, *They Came to Japan,* p. 112). It is interesting to consider that Hideyoshi would have felt equally comfortable dining from these gold lacquer bowls as from the simple Yellow Seto ceramic dish (No. 58) intended for the ceremonial *kaiseki* meal of ritual tea.

The *kakeban,* four-legged rectangular trays for lacquered wooden bowls and similar eating utensils, were placed on the floor in front of the seated guests. Although the sizes of the three tables here

differ, they form a complete set from which Hideyoshi must frequently have dined. The *makie* design, identical to that on the ten bowls, shows reeds at the edge of a golden pond whose rippling waves break against the rocky shore in a score of frothy little whitecaps. As though loath to leave a single empty space, the artist fills the *nashiji* background with the paulownia-leaf medallion of the Toyotomi family, executed in thin sheets of gold. The shape of the table emphasizes a continuous sequence of curves, and the legs bulge outward with an air of regal self-assurance.

In the Momoyama period banquets of three tables replaced those of five or seven tables. The highest table, placed at the center, had the covered bowl of rice in its left-hand corner. A typical banquet hosted by Hideyoshi would have included some twenty dishes, many of them hot broths flavored with prized fish or the meat of a swan or wild duck. Slices of raw fish dipped in a hot sauce of horseradish were as great a favorite in Momoyama times as in present-day Japan.

It was a mark of special hospitality if the host served his guests a roasted bird taken by his hawk. This was not eaten with chopsticks but with two fingers and was first raised above the head toward the hawk's owner as a sign of respect. Entertainment at such banquets included music, plays, and liberal servings of wine accompanied by salty side dishes of fish.

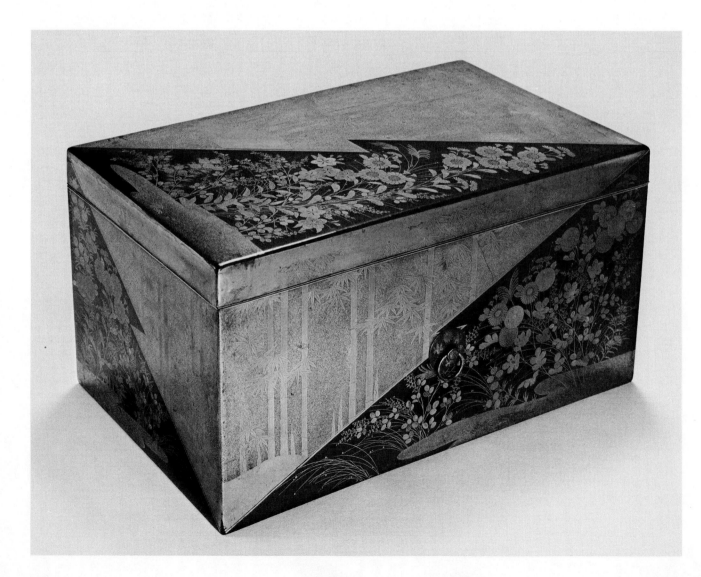

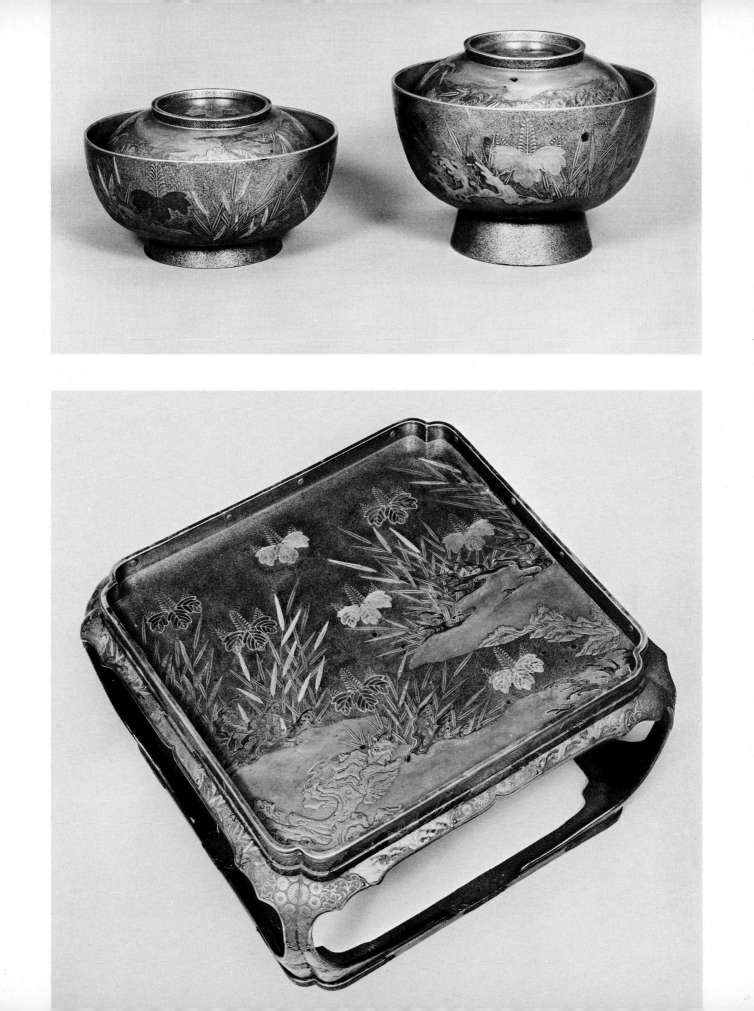

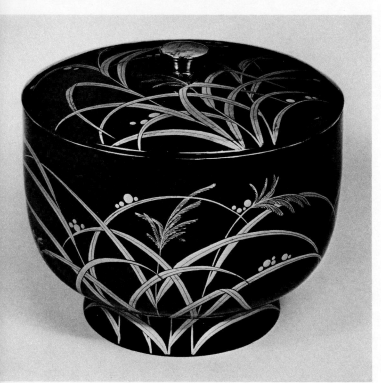

68

Rice bowl with design of autumn grasses

About 1600
Wood with black lacquer and gold *makie*
H. 7 1/16 in. (18 cm) x D. 7 7/8 in. (20 cm)
Private collection: Sugimoto Hiroko, Osaka

This large bowl was probably used to hold cooked
rice. A decoration of feathery pampas grasses is
executed in *hiramakie* on a surface of black lacquer.
Heavy with the morning dew, they are blown by
the wind in the autumn fields, a poetic image with
great appeal to the Japanese, who are keenly sensi-
tive to the changing seasons. The harmony of décor
and shape expresses well the new concept of func-
tional beauty that characterizes many of the arts of
this period.

The veins are drawn in fine and fluid lines that
were scratched through the surface of the wet lac-
quer with a needle. This technique, called *harigaki*
("needle drawing") is often seen on lacquers of the
Kōdai-ji style.

69

Sake container with design of autumn plants, paulownia, and chrysanthemum

Around 1600
Wood with black lacquer and gold *makie*
H. 5 1/4 in. (13.3 cm) x L. 9 11/16 in.
 (24.6 cm) x W. 6 15/16 in. (17.6 cm)
Private collection: Imadegawa Yūko, Shiga Prefecture

Sake containers called *chōshi,* with upright semi-
circular wooden handles, were used to pour wine
into cups at formal banquets. The rich decoration
of this example is typical of the lacquers in the
Kōdai-ji style; naturalistic autumn plants includ-
ing chrysanthemum, bush clover, pampas grasses
touched with dew, and fringed pinks (*nadeshiko*)
are combined with chrysanthemum and paulownia-
leaf family crests.

In typical Momoyama style the artist has played
off the linear movement of the bent grasses against
static planar elements such as the closed heraldic
shape of the crest. The contrast is one not only of
line and plane, but of natural and stylized forms.
Sophisticated variations in color are achieved by
interspersing designs of solid powdered gold (*hira-
makie*) with those of more loosely scattered gold
(*e-nashiji*). A third technique, *harigaki,* is used to
delineate contours and veins in the blossoms.

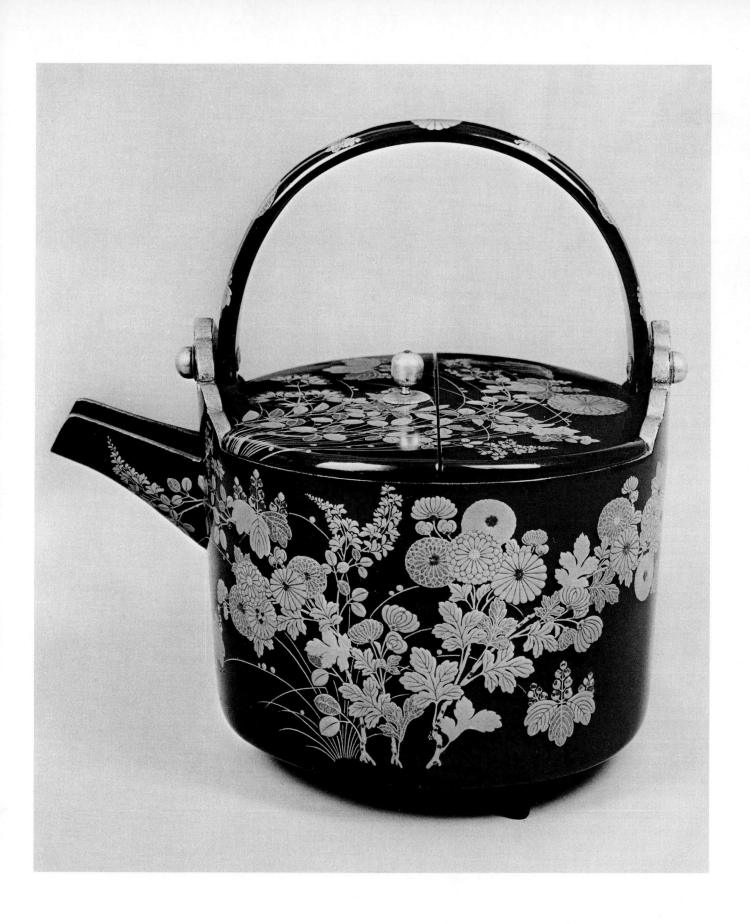

Tiered food box with design of grapevine and squirrel

First third of the seventeenth century
Cypress wood with black lacquer and gold *makie*
H. 9 ⅞ in. (25.2 cm) x D. 10 ⅜ in. (26.4 cm)
Tokyo National Museum

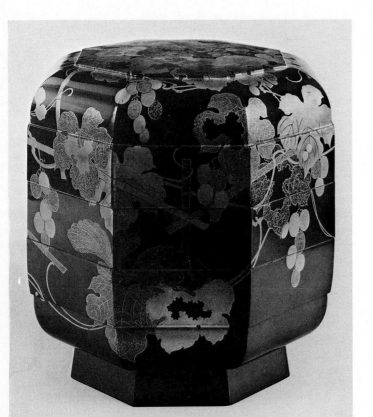

From contemporary genre paintings such as Naganobu's Merrymaking under the Cherry Blossoms (No. 27), we know that lunches were elegantly packaged in tiered lacquer food boxes for picnic outings to scenic spots around the capital. This three-layered octagonal box probably served not only as a food container but as a treasured possession to be displayed prominently in the *tokonoma,* a recessed ceremonial alcove, of a feudal mansion. Both its shape and its subject matter of squirrels on a grapevine have Chinese origins, but in style it shows the progressive refinement of Kōdai-ji *makie* in the early seventeenth century. As many as four shades of color are suggested by the use of two tones of flat gold, reddish *e-nashiji,* and an occasional exceptionally loose scattering of gold particles. Against a glistening black ground the thick clusters of ripe grapes and stylized rounded leaves, interconnected by delicate vine tendrils, curl around the soft, pliant shape of the box.

Although the furry texture of the oddly rodent-like squirrels and the worm-eaten leaves are almost realistic, the bamboo poles of the trellis, for example, seem to float without visible support either from the ground or one another, and the bulging leaves take on an almost heraldic formality, their enormous worm holes making intriguing patterns of solid color. There is infinite variation in the arrangement of the clusters of grapes, with each grape overlapping the next only slightly. The confident swinging rhythm of the vine itself binds the eight sides and lid into a smoothly continuous composition.

The squirrel and grapevine motif often recurs later on in the Edo period, but by then the tendrils are tight little springs, the leaves jagged and more carefully detailed, and the composition as a whole less buoyant and refreshing.

71

Writing box with New Year's design

Seventeenth century
Lacquer with gold *makie* and inlay of gold, silver, and lead
H. 2 in. (5.1 cm) x W. 8⅝ in. (22 cm) x L. 9⁷⁄₁₆ in.
 (23.9 cm)
Tokyo National Museum

Black lacquer boxes decorated with gold and silver designs were used by Japanese of the upper classes to store their writing implements. At the upper left of the compartmentalized interior of this box is the copper water dropper, used to pour water into the depressed end of the smooth stone slab. A fragrant stick of black ink was rubbed over the wet stone to form a liquid ink. The writing brushes and seals were housed in the right half of the interior and a pointed punch for closing letters may have been stored in the depression at the right edge.

The iconography of the lid décor is that of the New Year's *Sagichō* ceremony. A ritual to exorcise evil spirits, the *Sagichō* has been celebrated since at least the thirteenth century on the fifteenth and eighteenth day of the first month in the eastern garden of the Seiryō-den hall of the Imperial Palace. The artist shows two suspended folding fans, one with a design of plum, the other with cranes in flight over a river, as well as ferns and bamboo leaves bundled with bamboo sheaths and tied with ribbons. In the ceremony these bundles included poems written on paper strips called *tanzaku* and the first lucky writings (*kissho*) of the New Year. The latter had first been presented to the emperor on the lid of a writing box that a high court dignitary slid beneath the bamboo blinds of the imperial enclosure.

The right half of the interior has a gold *makie* design of a plum branch and the folded envelope of a *tanzaku*, inscribed in copper inlay with *"kissho toshitokujin"* ("lucky first writing and god of the year's lucky direction").

In addition to gold *makie*, the lacquer is decorated with inlays of such disparate metals as gold, silver, and lead, a technique innovated by the versatile artist and craftsman Hon'ami Kōetsu (Nos. 33–35, 65).

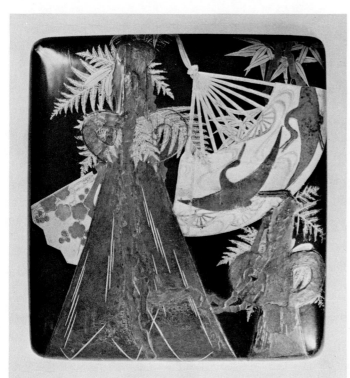 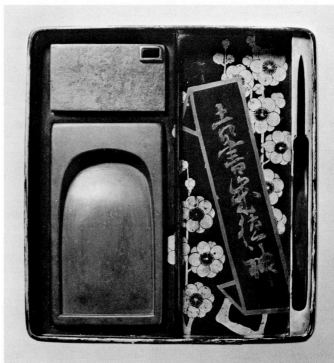

Arms and Armor

A warrior might indulge himself with paintings, theater, and the tea ceremony, but his honor, even his life, depended on his sword. It was his most prized possession, and a particularly fine example might take the place of a grant of land when a victorious daimyo rewarded his retainer. For each aspect of sword production and care there arose specialists who passed the secrets of their trade to hereditary successors. The most important of these were the sword appraisers, the ultimate connoisseurs of a weapon's quality and age, and their certificates of authentication were eagerly sought by every proud collector. The most prestigious of these sword judges were the Hon'ami family, including Kōetsu, known to us also for his calligraphy and ceramics (Nos. 33–36, 65).

Decorative sword fittings date back to the fifteenth century, and during the sixteenth century, when metalworking became better appreciated as a craft, there was an even greater demand for ornamentation of the sword. For the first time, makers of sword guards, for example, were proud to sign their names. The finest of these craftsmen worked exclusively for a single daimyo patron.

Hosokawa Tadaoki (1564–1645) is an outstanding example of the keen aesthetic sensitivity of Momoyama generals. He was not only a warrior but also a poet and a man of tea on close terms with Sen no Rikyū. In 1619 he retired in favor of his son Tadatoshi (1586–1641) and took the name Sansai. In 1632 both moved to Higo Province where Tadaoki encouraged local swordsmiths and sword guard craftsmen like Hayashi Matashichi (No. 78). Today the Hosokawa family is still closely associated with the study and preservation of Japanese arms and armor.

Some metalworkers specialized exclusively in the tiniest details of mountings, including the paired metal ornaments on the hilt called *menuki*. Sword guard makers experimented with new materials, including brass, copper, and *shakudō* (an alloy of copper and gold), and with inlay of gold and silver, as well as cloisonné enameling. Strongly influenced by the proximity of European traders and imported goods in Nagasaki and Hirado in Kyūshū, many of the new

techniques developed in the far western regions. In Higo Province, Matashichi began as a gun-smith but then developed a style of sword guard exhibiting a uniquely Japanese sensibility.

A warrior's pride in his swords was clearly augmented by Hideyoshi's policy of disarming both the peasants and the urban populace in an effort to restrict the bearing of arms to the samurai class. His nationwide "sword hunt" of 1588 contributed to the gradual stratification of social classes, including a clear separation of samurai, peasant, artisan, and merchant. In genre paintings like Activities in the Capital (No. 28) handsome young warriors parade in the streets of Kyoto. In the words of a Spanish trader: "When they go out, they gird themselves with both [long and short swords] and strut around as arrogantly as if they were the only people in the world" (Bernardino de Avila Giron, "Weapons," in Cooper, *They Came to Japan,* p. 142).

The battles of the Momoyama period, whether in Japan or Korea, were among the largest and bloodiest ever fought. Over 200,000 men were mobilized for the first invasion of Korea, and a comparable number were in the field for the final great Battle at Sekigahara in 1600, when Ieyasu and his supporters defeated the allies of the Toyotomi.

Contact with Europeans contributed to an abrupt change in the nature of warfare in Japan in the sixteenth century. The introduction of matchlock guns by the Portuguese in 1543, combined with the widespread use of small hand cannons, necessitated strongly fortified castles and hastened the conclusion of civil warfare and the unification of the country.

Hand to hand combat by small bands of roving warriors was replaced by mass tactical maneuvers staged by daimyo commanding thousands of soldiers. Superior firepower was a crucial element in the success of such a military campaign. In a typical battle formation firearms led the first three lines of defense, with the front rows stepping back to reload after each shot. In the Battle of Sekigahara more than a third of the men in some regiments carried firearms. The fourth line of defense, protecting the artillery, was made up of archers, followed by soldiers with long spears, mounted troops with swords and halberds, and finally the thousands of foot soldiers. The general, in his costly suit of armor (No. 79) was well protected at the rear.

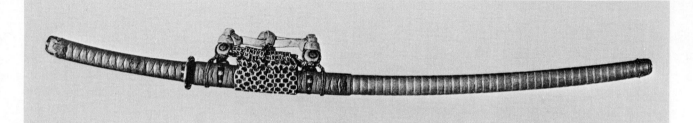

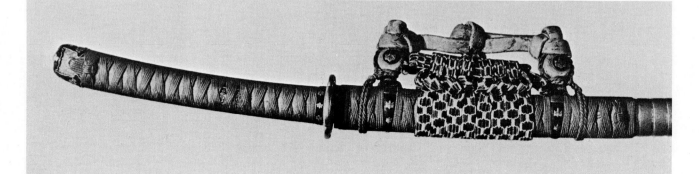

72

Scabbard and hilt for a long sword

Late sixteenth century
Wood with silk, deerskin, gold, and *shakudō*
L. 3 ft. 7 ³⁄₁₆ in. (109.7 cm)
Gokōgū Shrine, Kyoto
REGISTERED IMPORTANT CULTURAL PROPERTY

It is reported that this mounting, together with its blade, was presented by Hideyoshi as an offering to Gokōgū Shrine in 1590, the year he unified the country. Its opulence was undoubtedly intended to stimulate admiration and envy among its owner's rivals, for only the wealthiest warlord could have afforded a sword whose ribbed wooden scabbard was covered in sheets of gold. The blade (not included here) was made in the thirteenth century, considered by Japanese connoisseurs to have been the finest period of blade manufacture: it is inscribed with the date 1294.

In this "braid-bound" *(itomaki)* mounting the wooden hilt and the upper part of the scabbard were first encased in gold silk and then wrapped with brilliant purple flat silk braid. The matched metal fittings feature the owner's paulownia crest in gold relief over a ground of *shakudō*. A small pair of metal ornaments *(menuki)* are secured by the braid to each side of the hilt. Attached to the upper end of the scabbard are a pair of "hangers," projections with slots for a long silk brocade belt worn around the waist. The long sword was suspended horizontally from this belt. Soft deerskin strengthens the silk at the spot where it would have rubbed against the wearer's side.

The long sword *(tachi)* had been the principal weapon of small bands of mounted warriors since the Heian period (ninth–twelfth centuries) but was largely replaced in the fourteenth and fifteenth centuries by the lighter *katana* type of sword (see No. 73). By the late sixteenth century a sword such as this one was only worn by a high-ranking daimyo either with his full battle armor or for important ceremonial functions such as a visit to court (see No. 2).

126

73

Mountings with wisteria design for a pair of large and small swords

Late sixteenth century
Lacquer and silver on wood
L. *uchigatana* 3 ft. 4 15⁄16 in. (104 cm)
L. *wakizashi* 2 ft. 3 ⅛ in. (69 cm)
Private collection: Miyazaki Kazue, Kanagawa Prefecture
REGISTERED IMPORTANT ART OBJECT

During the fifteenth century the *uchigatana,* a sword with a blade slightly smaller and different in shape than that of the *tachi* (No. 72), gained in popularity. By the Momoyama period it was commonly paired with a short sword, or dirk, called *wakizashi.* Known as *daishō,* or "large and small," the two swords were given identical metal fittings and matching scabbards. While lesser samurai armed themselves with simply decorated scabbards often finished with black lacquer, high ranking military figures, eager to impress onlookers with their wealth, position, and discriminating taste, commissioned more striking effects.

The wooden scabbards of this *uchigatana* and *wakizashi* are embellished with long tassels of wisteria blossoms in thin sheets of silver inlaid in red lacquer. The fittings are also crafted entirely in silver. The hilts are covered with red-lacquered rayfish skin and then wrapped with black silk braid which passes through the side of the pommel cap and is fastened with a neat knot. The silver rings at the upper end of the scabbard are a very unusual feature that shows the influence of European saber styles.

The swords were worn thrust through a samurai's silk or cotton sash, loosely attached to it by cords passing through metal rings. The longer *uchigatana* was carried across the left hip, while the shorter *wakizashi* crossed over the stomach. The *wakizashi* proved especially practical for fighting indoors.

Though elegant, this pair may actually have been carried into battle. It is more likely, however, that they were worn as emblems of social status in the manner of the swords of the young dancers in Naganobu's Merrymaking under the Cherry Blossoms (No. 27) or the samurai in the pleasure quarters in Activities in the Capital (No. 28).

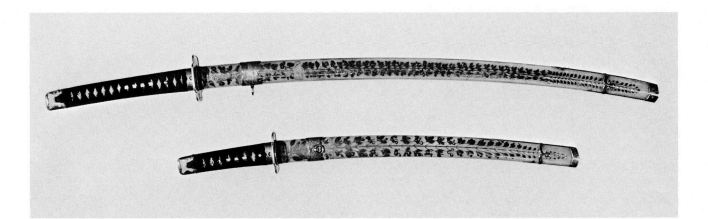

74

Sword guard with Kasuga landscape design

Kaneie (active mid-sixteenth century)
Mid-sixteenth century
Iron with gold, silver, and copper inlays
H. 3 5⁄16 in. (8.4 cm) x W. 3 3⁄16 in. (8.1 cm)
Eisei Bunko, Tokyo
REGISTERED IMPORTANT CULTURAL PROPERTY

Inserted between the hilt and blade of a sword to protect the swordsman's hand, sword guards *(tsuba)* have been used in Japan since at least the

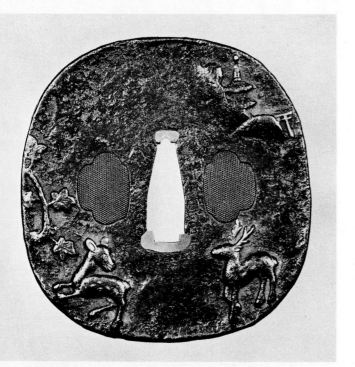

sixth century. They generally take the form of a flat metal disk with a wedge-shaped opening in the center for the tang of the blade. Guards made after the mid-fifteenth century often have two additional semicircular or trilobed perforations to accommodate a small utility knife *(kozuka)* and a skewerlike implement called *kōgai* that may have been used to rearrange a warrior's hair. Both *kozuka* and *kōgai* were slipped through the guard into small receptacles on either side of the scabbard.

Early sword guards were sometimes ornamented with hammered or incised designs, but schools of metalworkers specializing in their decoration did not emerge until the mid-Muromachi period. At that time openwork guards *(sukashi-tsuba)* became popular among high-ranking samurai who had given up the cumbersome long sword in favor of the lighter *uchigatana* (No. 73). Soon metal inlays were added to create more elegant guards and by the late Momoyama and early Edo periods, when finely mounted swords also served as badges of rank, sword guards had become prized possessions.

A rounded square shape of rough iron with a silvery black patina achieved by a secret process, this guard is carved with a relief design suggesting the autumn landscape of Kasuga near the old capital of Nara. Partially visible behind a hill at the upper right, a sacred gate *(torii)* and a pagoda symbolize the Kasuga Shrine and nearby Kōfuku-ji, both constructed by the Fujiwara family in the eighth century. The design is completed by a pair of deer, the emblematic animals of the shrine, and the branch of a maple that appears in full on the reverse. The design is enriched by inlays: copper for the gateway, silver for the deer, and gold for the maple. Additional traces of gold make all the motifs stand out more sharply. At some point the guard was mounted on a sword whose scabbard was not designed to include the *kozuka* and *kōgai,* and the implement openings on the guard were filled in with metal inserts stippled with a dotted pattern called "fish roe" *(nanako).*

A signature, "Kaneie, of Fushimi in Jōshū [Yamashiro Province]," has been engraved around the tang hole. A sword guard craftsman from the town south of Kyoto where Hideyoshi later built Fushimi Castle, Kaneie I was apparently active in the middle of the sixteenth century and is ranked with Nobuie (No. 75) and Umetada Myōju (No. 76) as one of the three finest sword guard designers. He was famous for originating the "painting style" of sword guard decoration which combined motifs in a pictorial fashion. His Kasuga landscape design has a delightfully ingenuous quality perfectly suited to the coarse texture and rough outline of the guard.

75

Sword guard with design of three commas

Nobuie (about 1485–1564)
Mid-sixteenth century
Iron
D. 3 ⅜ in. (8.5 cm)
Tokyo National Museum
REGISTERED IMPORTANT CULTURAL PROPERTY

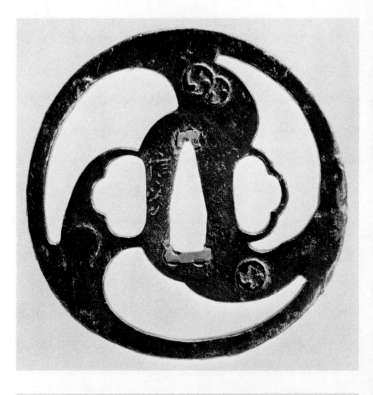

This circular iron guard is ornamented with a spiral design of three openwork comma shapes interspersed with tiny triple-comma and chrysanthemum motifs carved in relief. The "comma" (*tomoe*) pattern was probably used as a crest by the guard's owner and would have appeared on his armor and banner. To the left of the tang opening is inscribed the name "Nobuie."

Nobuie worked in the province of Owari, where sword guard makers had been producing fine openwork guards with sober, usually symmetrical designs since the middle of the Muromachi period. Nobuie's light openwork iron guards, often decorated with hairline inlay, continue this Owari tradition and are often considered the epitome of the art. In spite of the growing popularity of elaborate inlay, simple pieces such as this which rely solely on the clever interplay of solid and open shapes appealed to more conservative military men.

Famous since the Edo period, this guard was a treasured possession handed down through generations of the daimyo household of Kuroda.

76

Sword guard with design of grapevines and trellis

Umetada Myōju (1558–1632)
Late sixteenth century
Brass with inlay of gold, silver, and *shakudō*
H. 3 in. (7.6 cm) x W. 2 ⅞ in. (7.3 cm)
Private collection: Mori Eiichi, Kanagawa Prefecture
REGISTERED IMPORTANT ART OBJECT

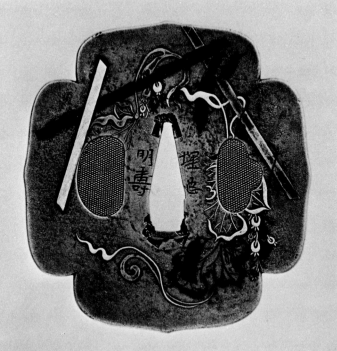

Although the early Momoyama warriors preferred the strong simplicity of guards like Nobuie's (No.

75), their younger contemporaries evinced a taste for embellishment. With its modulated and fluid outlines, the inlaid vine decoration on this guard suggests painting rather than metalwork. Leaves and tendrils wind gracefully beside the sharp straight bars of the grape trellis, in a refined manner that brings to mind the Kōdai-ji-style lacquers (No. 70). Like the lacquer artist, Umetada Myōju sought variety in color tones; the flush inlays on the brass ground are done in gold, silver, and an alloy of copper and gold called *shakudō*. The tri-lobed skewer opening is playfully incorporated into the design by golden grape leaves whose contours resemble the cusped quatrefoil outline of the guard.

Active in the capital, where he was known primarily as a master swordsmith, Myōju was also a craftsman of elegant sword guards whose work is considered equal to that of Kaneie (No. 74) and Nobuie (No. 75).

77

Sword guard with floral design in cloisonné

Hirata School
Early seventeenth century
Iron with gold and colored enamels
H. 3 ¼ in. (8.3 cm) x W. 3 ¼ in. (8.2 cm)
Private collection: Watanabe Kunio, Tokyo

Modish Momoyama samurai whose taste for color was not satisfied by the rich metal inlays of Umetada Myōju (No. 76), could commission sword fittings decorated with cloisonné *(shippō),* a technique in which wire-bordered designs were filled with brilliantly colored glassy enamels. On this circular guard, a random pattern of clouds and flowers executed in multicolored cloisonné has been combined with a symmetrical openwork design of flower and half-moon shapes. The dark gray ground, with its crisp perforations and raised rim, conveys an impression of strength and sobriety that accentuates the light-hearted quality of the colored enamels outlined in strips of gold. Free-form turquoise clouds envelop dainty stylized flowers whose symmetrically arranged petals are filled with red, white, yellow, or darker blue enamel in decorative alternation. Among these cloud forms are a variety of exquisite spirals, curls, and circles of plain or twisted gold and silver wire.

Although there are examples of cloisonné preserved in the eighth-century Shōsōin storehouse in Nara, they may not have been made in Japan. In any case, cloisonné was not used again until the Momoyama period, when a Kyoto craftsman named Hirata Dōjin, who is said to have learned the technique from Korean artisans, employed it for sword fittings. Handed down from father to son, the processes Dōjin used remained a closely guarded secret in the Hirata family until the end of the Edo period.

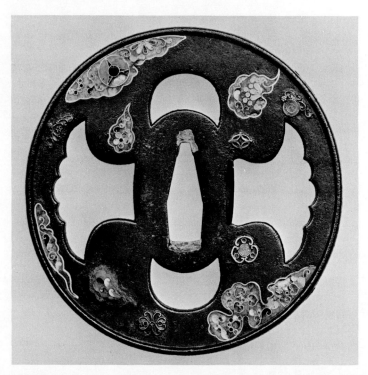

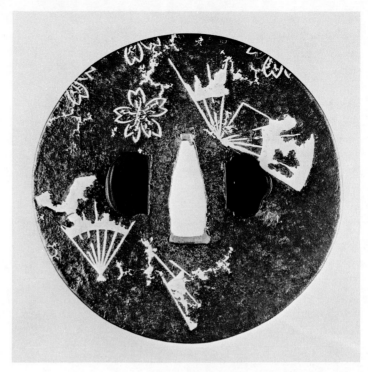

Like most of the works of the first few generations of the Hirata school, this guard is unsigned, but its source is unmistakable. The fanciful decorations, the juxtaposition of symmetrical and free-form motifs, the combination of transparent and opaque enamels, and the small patterns executed exclusively with wire are all hallmarks of the Hirata style.

78

Sword guard with design of scattered torn fans

Hayashi Matashichi (1608–1691)
First half of the seventeenth century
Iron with gold inlay and *shakudō*
H. 3 ¼ in. (8.4 cm) x W. 3 ⅜ in. (8.5 cm)
Eisei Bunko, Tokyo

A lacy pattern of torn fans and drifting cherry blossoms in gold inlay decorates both sides of this round guard in striking contrast to the hammered texture and dark patina of the iron ground. Unconfined by a rim, the fans and blossoms spill over the smooth edges of the guard as if scattered by the wind. The copper-gold alloy *shakudō,* treated to assume a lustrous black tone, was used to fill in the side openings.

The guard is not signed, but it has long been accepted as the work of Hayashi Matashichi, who was active in the early Edo period. Although his family had been gunsmiths for three generations and he himself produced several guns with fine gold inlay decorations, Matashichi turned to the making of sword ornaments, founding the Hayashi line of sword guard craftsmen in the village of Kasuga near the city of Kumamoto in Higo Province. Located in Kyūshū far from the capital, the Higo metalworkers developed a distinctive style of gold and silver inlay.

In creating this elegant guard for Hosokawa Tadaoki (1564–1645), the daimyo of Higo, whose cherry blossom crest appears in the design, Matashichi used an inlay technique that may well have had foreign origins. Called *nunome,* or "texture," the technique involves cutting a cross-hatched design into the ground and then hammering foil or wire over the pattern until it is caught by the spurs raised in cross-hatching. The scattered fragments around the fan illustrate another style of inlay known as "frayed" *(hotsure)* or "worm-eaten" *(mushikui),* because it resembles crumbling scraps of worm-eaten paper. Both *nunome* and *mushikui* inlays were characteristic of Higo metalwork and were rarely used elsewhere in Japan.

79

Cuirass and shoulder guards of a suit of armor

1570s
Iron with silk braid, leather, sharkskin, and gold leaf
Cuirass: H. 3 ft. 3⅜ in. (100 cm) x W. 14⅛ in. (36 cm) x
 D. 11¹³⁄₁₆ in. (30 cm)
Private collection: Haga Jissei, Tokyo
Shoulder guards: H. 3 ft. 3⅜ in. (100 cm) x W. 11¹³⁄₁₆ in.
 (30 cm)
Uesugi Shrine, Yamagata Prefecture

Although this cuirass (*dōmaru*) and its large shoulder guards (*ōsode*) are now in separate collections, they were originally presented as a set by Nobunaga to his bellicose rival from the eastern province of Echigo, Uesugi Kenshin (1530–1578). As part of the attempt to win Kenshin over to his side, Nobunaga is also said to have sent him screens of the *Tale of Genji* and Activities in and around the Capital painted by Kanō Eitoku. These gifts were at best only temporarily effective, and Kenshin died while advancing with his army to fight Nobunaga.

The armor is constructed in small hinged lamellae of iron and leather laced into horizontal strips with leather thongs. These strips were sealed with lacquer and covered with gold leaf and laced together vertically with woven silk braid in vermillion, purple, white, and light green.

The cuirass is made in two parts. The larger section wraps around three-quarters of the body and leaves the right side exposed. This gap is filled by the second section, an iron plate with its own pendant skirt piece.

At the top of the breast section is a solid iron strip called *munaita* (breastplate), covered with sharkskin and studded with cherry-blossom-shaped rivets. Cords passing through perforations in this breastplate connect with the toggles of cords hanging from the padded leather shoulder straps that have, in turn, rings at the front and center for fastening the shoulder guards. The rings on the outside of the shoulder guards were used to secure the bow carried across the warrior's back.

The mounted samurai would have protected his head with a fancy helmet and ferocious face mask, his arms and shins with chain mail and thin strips of iron plate, and his thighs with plated armor hung from the waist. He also would have worn soft doeskin gloves (see No. 29) to protect his hand from the bowstring. In early times the mounted bowman with his colorfully laced armor was the hero of all great battles. The epics speak of these formidable archers striding forward and shooting their twenty-four arrows in rapid succession, mortally wounding an enemy with almost every shot.

Kenshin, in the early years of the Momoyama period, was already arming his conscript army with matchlock muskets, and it is unlikely that he wore this fine suit for actual combat. The style of armor preferred in his time was much more practical, employing a solid full-length breastplate that could withstand bullets, and smaller, less cumbersome shoulder guards that permitted greater freedom of movement.

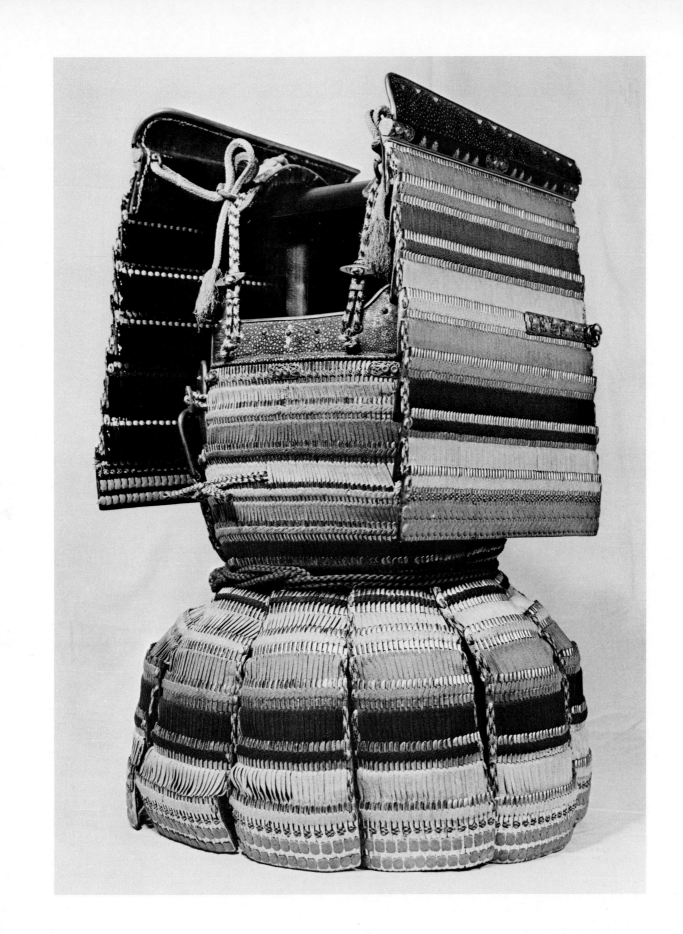

Selected Bibliography

GENERAL

Boxer, C. R. *The Christian Century in Japan, 1549–1650.* Berkeley: 1967.

Castile, Rand. *The Way of Tea.* New York and Tokyo: 1971.

Cooper, S. J., Michael. *Rodrigues the Interpreter.* New York and Tokyo: 1974.

———, ed. *The Southern Barbarians: The First Europeans in Japan.* Tokyo and Palo Alto: 1971.

———, ed. *They Came to Japan: An Anthology of European Reports on Japan, 1543–1640.* Berkeley: 1965.

———, ed. and trans. *This Island of Japan: João Rodrigues' Account of 16th-Century Japan.* Tokyo and New York: 1973.

Dening, Walter. *A New Life of Toyotomi Hideyoshi.* Tokyo: 1904.

Elison, George. *Deus Destroyed: The Image of Christianity in Early Modern Japan.* Cambridge, Mass.: 1973.

Fujiwaka Asako. *Chanoyu and Hideyoshi.* Tokyo: 1957.

Hall, John W. *Japan: From Prehistory to Modern Times.* New York: 1970.

Keene, Donald, ed. and trans. *Anthology of Japanese Literature.* New York: 1955.

Kodama Kōta, compiler. *Azuchi-Momoyama Jidai.* Zusetsu Nihon Bunkashi Taikei, vol. 8. Tokyo: 1956–1958.

Murasaki Shikubu. *The Tale of Genji.* Translated by Arthur Waley. 1 vol. (Houghton Mifflin ed.). Boston: n.d.

Okamoto Yoshitomo. *The Namban Art of Japan.* Translated by Ronald K. Jones. The Heibonsha Survey of Japanese Art, vol. 19. New York and Tokyo: 1972.

Sadler, A. L. *The Maker of Modern Japan: The Life of Tokugawa Ieyasu.* London: 1937.

Sansom, Sir George. *A History of Japan.* 3 vols. Stanford: 1961.

Tani, Shin'ichi, and Sugase, Tadashi. *Namban Art: A Loan Exhibition from Japanese Collections.* Washington: 1973.

Varley, H. Paul with Morris, Ivan and Nobuko. *Samurai.* New York: 1970.

Webb, Herschel. *The Japanese Imperial Institution in the Tokugawa Period.* New York: 1968.

PAINTING

Akiyama Terukazu. *Japanese Painting.* Lausanne: 1961.

Doi Tsugiyoshi. *Hasegawa Tohaku.* Nihon no Bijutsu, no. 87. Tokyo: 1973.

———. *Momoyama.* Nihon no Kaigakan, vol. 6. Tokyo: 1969.

———. *Momoyama no Shohekiga ("Wall and Screen Paintings of the Momoyama Period").* Nihon no Bijutsu, vol. 14. Tokyo: 1967.

———. *Motonobu, Eitoku.* Suiboku Bijutsu Taikei, vol. 8. Tokyo: 1974.

Grilli, Elise. *Golden Screen Paintings of Japan.* New York: n.d.

Kondo Ichitaro. *Japanese Genre Painting: The Lively Art of Renaissance Japan.* Translated by Roy Andrew Miller. Rutland and Tokyo: 1961.

Kyoto National Museum. *Chūsei Shōbyōga ("Sliding and Folding Screens").* Kyoto: 1969.

———. *Rakuchū-Rakugai Zu ("Pictures of Sights in and around Kyoto").* Tokyo: 1966.

Matsushita Takaaki. *Ink Painting.* Translated and adapted by Martin Collcutt. Arts of Japan, vol. 7. New York and Tokyo: 1974.

Mizuo Hiroshi. *Edo Painting: Sōtatsu and Korin.* Translated by John Shields. The Heibonsha Survey of Japanese Art, vol. 18. New York and Tokyo: 1972.

Murase, Miyeko. *Byōbu: Japanese Screens from New York Collections.* New York: 1971.

Noma Seiroku. *The Arts of Japan: Late Medieval to Modern.* Vol. 2. Translated and adapted by Glenn Webb. Tokyo: 1967.

Paine, Robert, and Soper, Alexander. *The Art and Architecture of Japan.* Baltimore: 1955.

Rosenfield, John, and Cranston, Edwin and Fumiko. *The Courtly Tradition in Japanese Art and Literature.* Cambridge, Mass.: 1973.

Rosenfield, John, and Shimada, Shūjirō. *Traditions of Japanese Art: Selections from the Kimiko and John Powers Collection.* Cambridge, Mass.: 1970.

Shirahata Yoshi. *Jidai Byōbu ("Masterpieces of Folding Screens")*. Kyoto: 1974.

———. *Shōzō-ga ("Portraiture")*. Nihon no Bijutsu, no. 8. Tokyo: 1966.

Takeda Tsuneo. *Kanō Eitoku*. Nihon no Bijutsu, no. 94. Tokyo: 1974.

———. *Momoyama Hyaku-so ("Catalogue of One Hundred Pairs of Folding Screens of the Momoyama Period")*. 24 vols. Kyoto: 1974.

———. *Shōheiga ("Wall and Screen Painting")*. Genshoku Nihon no Bijutsu, vol. 13. Tokyo: 1967.

———. *Tōhaku, Yūshō*. Suiboku Bijutsu Taikei, vol. 9. Tokyo: 1973.

Tanaka Ichimatsu, et al., eds. *Shōheiga Zenshū ("Wall and Screen Painting")*. 10 vols. Tokyo: 1966.

Yamane Yūzō. *Momoyama Genre Painting*. Translated by John Shields. The Heibonsha Survey of Japanese Art, vol. 17. New York and Tokyo: 1973.

———. *Sōtatsu*. Tokyo. 1962.

———. *Sōtatsu to Kōrin*. Genshoku Nihon no Bijutsu, vol. 14. Tokyo: 1969.

Yamato Bunka-kan. *Yamato Bunka 56 ("Special Issue Devoted to Japanese Portrait Paintings of Women of the Sixteenth and Seventeenth Centuries")*. 1972.

CALLIGRAPHY

Hayashiya Tatsusaburō, et al. *Kōetsu*. Tokyo: 1964.

Komatsu Shigemi. *Nihon Shoryū Zenshi*. Tokyo: 1970.

Shodō Zenshū ("Complete Collection of Chinese and Japanese Calligraphy"). Tokyo: vol. 20, 1957; vol. 22, 1960.

NŌ THEATER AND MASKS

Kameda Tsutomu, et al. *Men to Shōzō ("Masks and Portraiture")*. Genshoku Nihon no Bijutsu, vol. 23. Tokyo: 1971.

Keene, Donald. *Nō: The Classical Theatre of Japan*. Tokyo and Palo Alto: 1966.

Nakamura Yasuo. *Noh: The Classical Theater*. Translated by Don Kenney. New York: 1971.

Perzynski, Friedrich. *Japanische Masken: Nō und Kyōgen*. Berlin and Leipzig: 1925.

TEXTILES

Minnich, Helen. *Japanese Costumes*. Rutland and Tokyo: 1963.

Nishimura Hyōbu. *Orimono ("Textiles")*. Nihon no Bijutsu, no. 12.

Noma Seiroku. *Japanese Costume and Textile Art*. Translated and adapted by Armin Nikovskis. The Heibonsha Survey of Japanese Art. Tokyo and New York: forthcoming.

Tokyo National Museum. *Japanese Textile Art* (special exhibition). Tokyo: 1973.

Yamanobe Tomoyuki. *Some ("Dyeing")*. Nihon no Bijutsu, no. 7. Tokyo: 1966.

———. *Senshoku, Shikkō, Kinkō ("Dyeing and Weaving, Lacquerwork, and Metalwork")*. Genshoku Nihon no Bijutsu, vol. 20. Tokyo: 1969.

CERAMICS

Fujioka Ryōichi. *Shino and Oribe Ceramics*. Translated and adapted by Samuel Morse. Arts of Japan. New York and Tokyo: forthcoming.

———. *Tea Ceremony Utensils*. Translated and adapted by Louise Cort. Arts of Japan, vol. 3. New York and Tokyo: 1973.

Koyama Fujio. *Heritage of Japanese Ceramics*. Translated and adapted by John Figgess. New York, Tokyo, and Kyoto: 1973.

Mikami Tsugio. *Art of Japanese Ceramics*. Translated by Ann Herring. The Heibonsha Survey of Japanese Art, vol. 29. New York and Tokyo: 1972.

Seattle Art Museum. *Ceramic Art of Japan: One Hundred Masterpieces from Japanese Collections*. Seattle: 1972.

LACQUER

Herberts, K. *Oriental Lacquer: Art and Technique*. New York: 1963.

Kyoto National Museum. *Kodai-ji Maki-e*. Kyoto: 1971.

Von Ragué, Beatrix. *Geschichte der Japanischen Lackkunst*. Berlin: 1967.

ARMS AND ARMOR

Masayuki Sasano. *Early Japanese Sword Guards: Sakashi Tsuba*. Translated by Richard Gage. Tokyo and San Francisco: 1972.

Ozaki Motoharu. *Katchu to Token ("Armor and Swords")*. Genshoku Nihon no Bijutsu, vol. 21. Tokyo: 1970.

Robinson, B. W. *The Art of the Japanese Sword*. London: 1961.

Robinson, H. Russell. *Oriental Armour*. London: 1967.

ARCHITECTURE

Fujioka Michio. *Shiro to Shoin ("Castles and Audience Halls")*. Genshoku Nihon no Bijutsu, vol. 12. Tokyo: 1968.

Kawakami Mitsugu and Nakamura Masuo. *Katsura Rikyū to Chashitsu ("Katsura Detached Palace and Tea Rooms")*. Genshoku Nihon no Bijutsu, vol. 15. Tokyo: 1967.

Kirby, Jr., John B. *From Castle to Teahouse: Japanese Architecture of the Momoyama Period*. Rutland: 1962.

Kiyoshi Hirai. *Feudal Architecture of Japan*. Translated by Hiroaki Saito and Jeannine Ciliotta. The Heibonsha Survey of Japanese Art, vol. 13. New York and Tokyo: 1973.